I CAN DRAW!

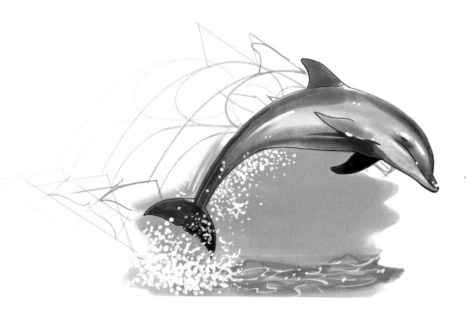

Artwork by Terry Longhurst

Text by Amanda O'Neill

Design by Chris Scollen and Sarah Williams

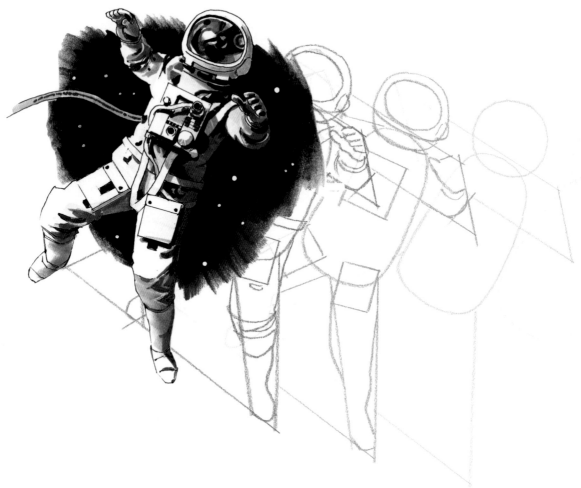

This is a Parragon book
This edition published in 2006

Parragon
Queen Street House
4 Queen Street
Bath BA1 1HE, UK

About this book

Everybody can enjoy drawing, but sometimes it's hard to know where to begin. The subject you want to draw can look very complicated. This book shows you how to start, by breaking down your subject into a series of simple shapes.

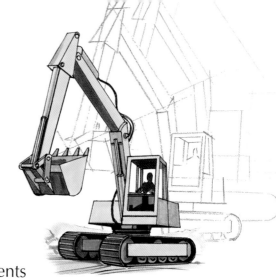

The tools you need are very simple. The basic requirements are paper and pencils. Very thin paper wears through if you have to rub out a line, so choose paper that is thick enough to work on. Pencils come with different leads, from very hard to very soft. Very hard (3H) pencils give a clean, thin line which is best for finishing drawings. Very soft (3B) ones give a thicker, darker line. You will probably find a medium (HB) pencil most useful.

If you want to colour in your drawing, you have the choice of paints, coloured inks, or felt-tip pens. Fine felt-tips are useful for drawing outlines, thick felt-tips are better for colouring in.

The most important tool you have is your own eyes. The mistake many people make is to draw what they think something looks like, instead of really looking at it carefully first. Half the secret of making your drawing look good is getting the proportions right. Study your subject before you start, and break it down in your mind into sections. Check how much bigger, or longer, or shorter, one part is than another. Notice where one part joins another, and at what angle. See where there are flowing curves, and where there are straight lines.

The step-by-step drawings in this book show you exactly how to do this. Each subject is broken down into easy stages, so you can build up your drawing one piece at a time. Look carefully at each shape before – and after – you draw it. If you find you have drawn it the wrong size or in the wrong place, correct it before you go on. Then the next shape will fit into place, and piece by piece you can build up a fantastic picture.

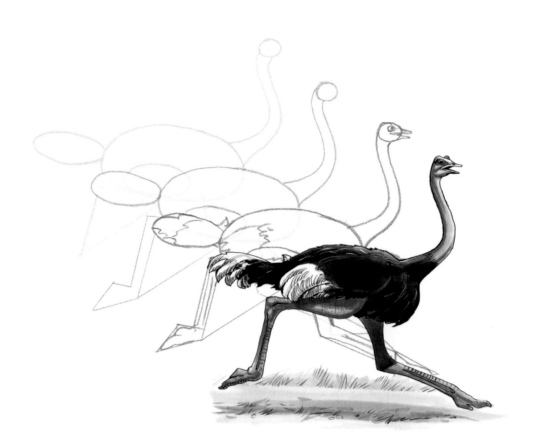

Contents

Stegosaurus

This giant plant-eater was well protected against enemies. It was the size of a tank, armour-plated, and armed with a spiked tail. The big upright plates down its back may have been just for display, to make it look even bigger, or they may have been solar panels, to soak up the Sun's heat.

Three circles of different sizes form the heavy body and small head. This little head held a brain the size of a walnut – perhaps the smallest brain of any dinosaur.

1

Join the tops of the two bigger circles to form the arched back. Another small circle forms the top of the front leg.

2

3

Add a curving line for the tail. Now draw in the shape of the top of the back leg.

Finish off the body shape and add the first row of back plates, making them bigger as you go up the body. Shape the head and tail.

4

Long sharp spikes make the tail a deadly weapon for self-defence.

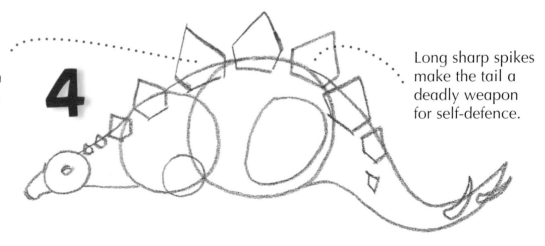

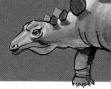

5

Remember to tuck the second row of back plates behind the first.

The legs are short, thick and strong, to carry all that weight. They weren't built for speed.

This living tank needs plenty of fuel, so the mouth is large to grab huge mouthfuls of plants.

6

7

Finish off your outline and draw in creases in the skin at the joints where the legs meet the body.

The name means 'plated reptile'. You can see why from the upright plates down its neck, back and tail.

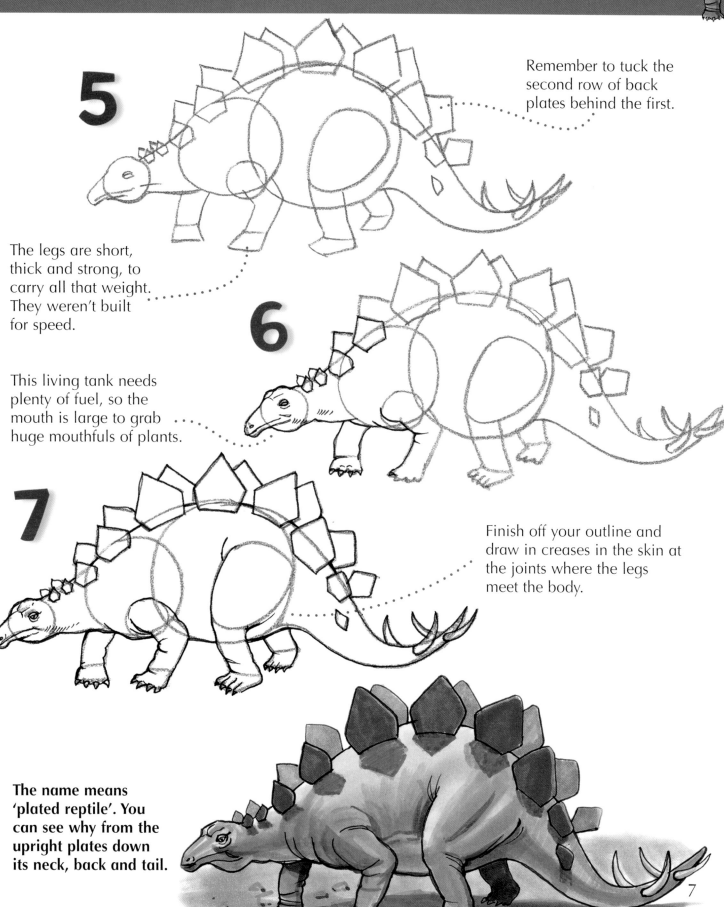

Tyrannosaurus

Tyrannosaurus was one of the biggest meat-eaters ever to live on Earth. It was so tall that a man would only come up to its knee, and it weighed as much as seven cars. It ran on two powerful legs to chase its prey, and its mouth was armed with teeth each as long as a man's hand.

1

Make this shape big, for a giant head that could have swallowed you whole!

The circles form the body, which leans forward from its back legs.

2

Link up your head and body with a thick neck. Draw in a long egg shape for the top of the powerful hind leg.

3

This arm section is quite small, for the arms are tiny. But the tail is enormous, to help balance the body.

4

The hind legs are massive and powerful – pillars to carry the animal's weight. But the arms are thin and so short they cannot even reach the mouth.

5 Finish off the head with an eye and two rows of sharp teeth.

6 The useless-looking arms end in hands with long clawed fingers.

7 Finish off your outline. The hind feet stand on three strong toes with large claws.

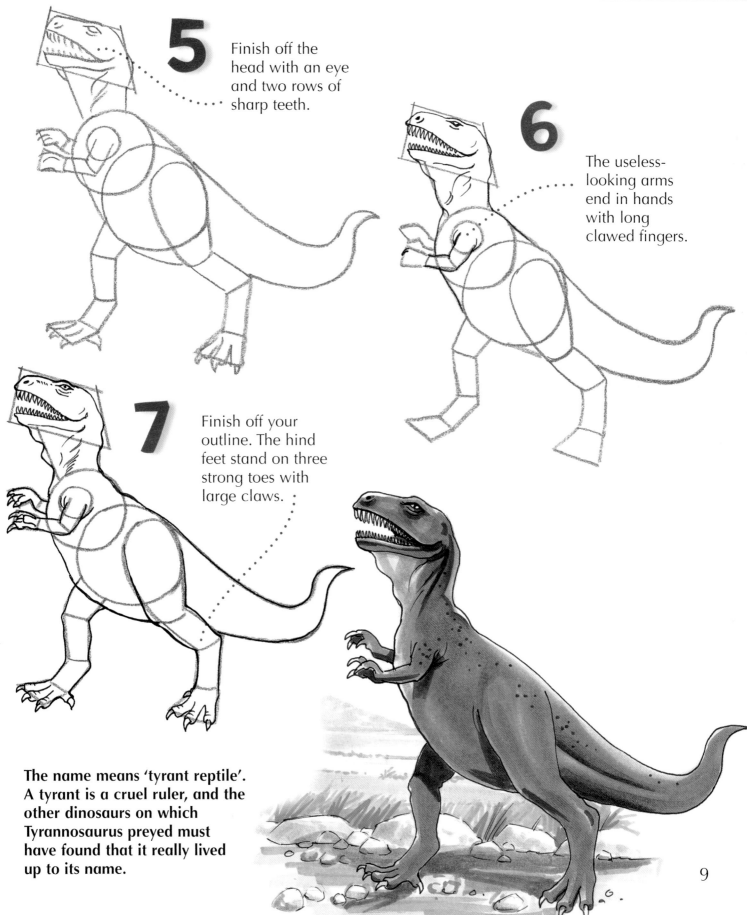

The name means 'tyrant reptile'. A tyrant is a cruel ruler, and the other dinosaurs on which Tyrannosaurus preyed must have found that it really lived up to its name.

Deinonychus

Deinonychus means 'terrible claw' and the long claw on its hind foot was a truly terrible weapon. The clawed toe operated on a special hinge to slash down like a knife. This meat-eater was quite small for a dinosaur – not much taller than a man. It probably hunted in packs to tackle large prey.

1

Two ovals form the head and body.

2

Draw another oval within the body to make the top of the hind leg, taking up about half of the space.

You need a surprisingly long, flowing line for the tail.

3

The hind leg is long and strong, helping Deinonychus to run fast after its prey.

The skull is quite large and heavy for such a small dinosaur.

4

The tail stands out stiffly behind the body to keep Deinonychus perfectly balanced while running.

Strong arms with three long, clawed fingers are designed for grabbing prey.

5

Tidy up the shape of the head and put some teeth in that big mouth.

The 'terrible claw' is held high above the two walking claws. This saves it from being worn down and blunted by scraping on the ground.

The raised back leg flows smoothly from the oval of the thigh.

6

7

The outline is complete and ready to fill in.

A streamlined build and long legs made Deinonychus both swift and agile. It also had quite a large brain, making it a crafty hunter. Slow lumbering grass-eaters stood little chance of escape!

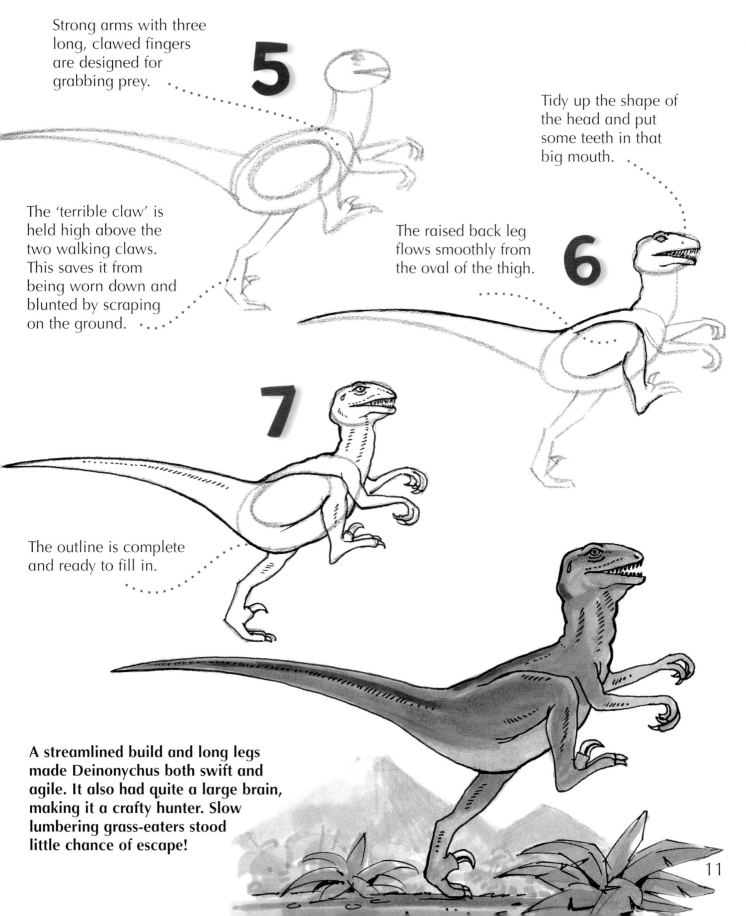

Triceratops

Despite its fearsome appearance, Triceratops was a harmless plant-eater. The huge horns that give it its name ('three-horned face') were for defence, not attack. The huge bony frill behind its head was also protection, guarding its neck from attack from behind.

1

Start with the body, and draw two smaller ovals for the tops of the legs.

2

The unusual shape of the head includes the neck frill.

3

Triceratops' head, including the bony neck-frill, was about the size of a door.

The legs are thick and strong – Triceratops weighed as much as two elephants.

4

Add a line for the tail, and sketch in the two legs on the other side of the body.

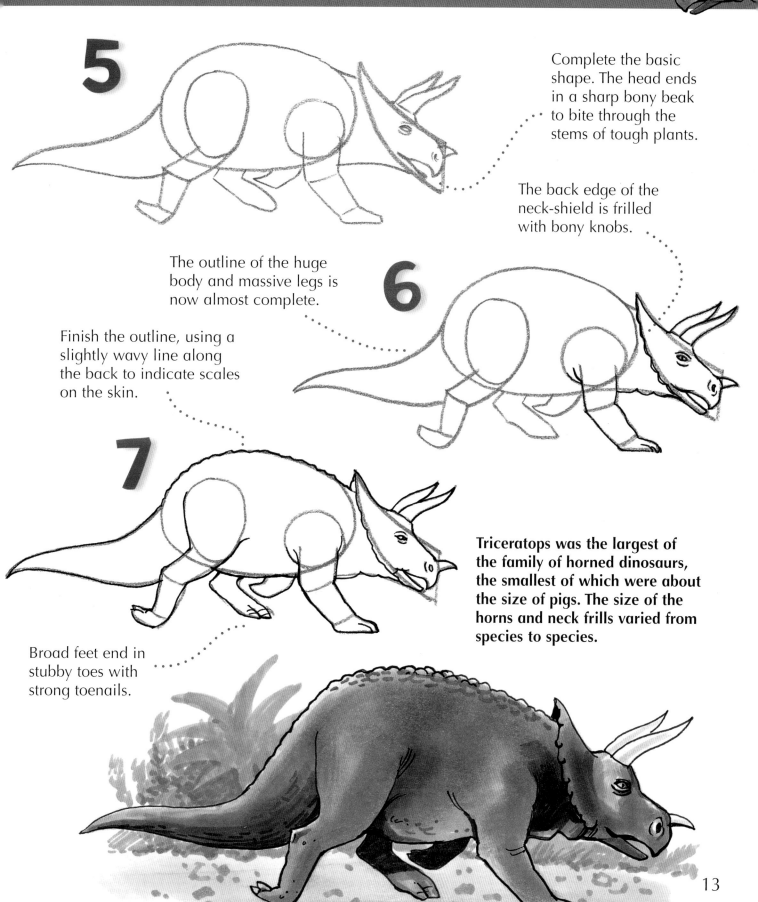

5

Complete the basic shape. The head ends in a sharp bony beak to bite through the stems of tough plants.

The back edge of the neck-shield is frilled with bony knobs.

The outline of the huge body and massive legs is now almost complete.

6

Finish the outline, using a slightly wavy line along the back to indicate scales on the skin.

7

Triceratops was the largest of the family of horned dinosaurs, the smallest of which were about the size of pigs. The size of the horns and neck frills varied from species to species.

Broad feet end in stubby toes with strong toenails.

13

Hadrosaur

Hadrosaurs are nicknamed 'duckbilled dinosaurs' because of their broad horny beaks. They are also known as 'helmet heads' from their strange crests. There were several species with differing crests: this one also has a backward-pointing horn on its head.

1

The head and body are joined by a long neck.

2

Mark the leg joints. The hind legs are much bigger than the front ones.

The tail is longer than the head and neck, giving the Hadrosaur quite a bottom-heavy shape.

3

Complete the neck and add a tall crest on the top of the head.

4

The Hadrosaur stands upright on strong hind legs.

The arms are short, with quite large hands.

Complete the head shape by adding the horn and beak.

5

Finish the outlines of head and neck. A little shading makes the neck look much more solid.

6

Draw in the shape of the hind leg and the broad toes.

7

The crest was probably a sort of trumpet! It was hollow, and the dinosaur's breathing tubes ran through it. When it blew down its nose, it would have produced a loud booming noise.

Fill in the rest of the outline and add more shading.

The various species of Hadrosaur were all plant eaters. This one tackled its food with jaws like grindstones, fitted out with hundreds of tiny teeth to mash up tough stems.

Parksosaurus

Not all dinosaurs were giants, and this one, if you ignore the tail, was only about the size of a big dog. In many ways it was the dinosaur version of today's deer and antelopes: a plant-eater, it lived in herds, and relied on its speed to escape enemies.

1

These two ovals form the head and hindquarters.

2

Add the front of the body, a line for the neck, and the thigh section.

3

Finish the neck and add the second thigh.

The tail is a little longer than the head and body put together.

4

The forearm is quite short.

The hindlegs are longer, making them ideal for fast running.

Fill out the details of the head, and sketch in the remaining legs. ·········

6

5

Parksosaurus belongs to a group called ornithopods – 'bird-foot dinosaurs'. Look at the shape of its hind feet to see why!

Finish drawing the foreparts, detailing the head and forearms. The eye is set high on the head, and the jaws are beak-like.

7

Fill in your outline. The outstretched legs give the impression of speed. ·········

We can only guess at dinosaur colours. Parksosaurus was probably coloured to blend in with the bushes on which it fed.

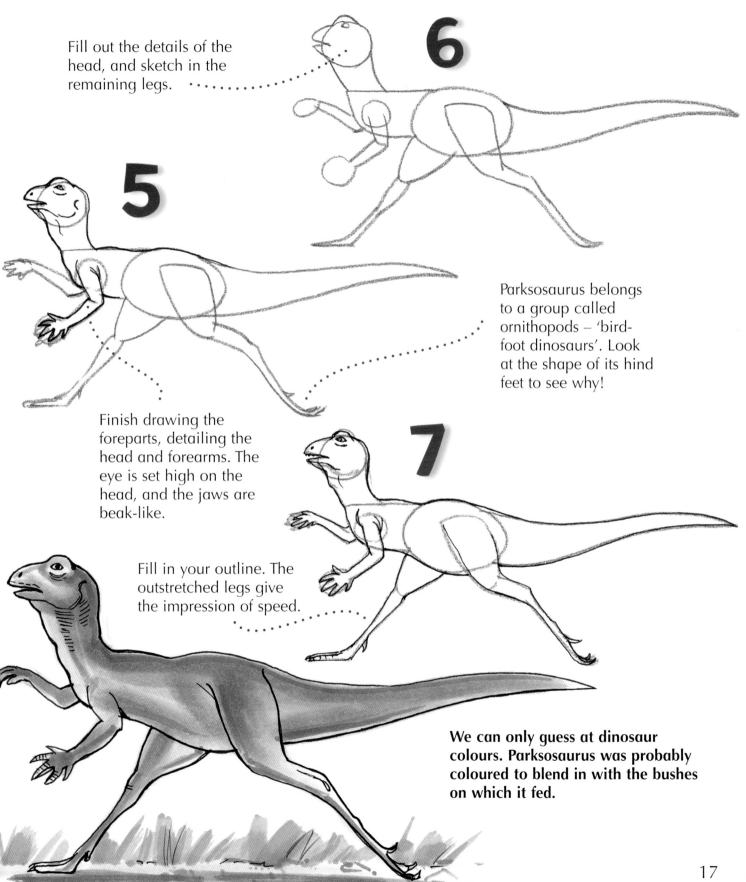

Parasaurolophus

Parasaurolophus had perhaps the oddest head of any dinosaur. Its long narrow crest stuck out for about two metres beyond the back of its head. With air passages running through it, the crest probably helped the dinosaur to make sounds.

The crest continues the line of the top of the head.

1

This oval forms the body.

Attach the head to the body and draw in the leg sections.

2

The tail is thick and strong, tapering towards the tip.

3

Complete the neck, curving the lower part round into the chest.

4

Add a curve to the end of the tail, and start to draw in the thick strong hindlegs.

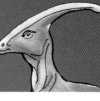

5

Draw in the legs to complete the shape, and start sketching in the face.

6

The crest runs all the way down to the nostrils.

Sturdy legs and feet support the weight.

Draw in the toes, which are quite long.

7

Now you can ink over your final lines, remembering to keep the curves smooth.

Scientists once thought the crest was a snorkel to help the dinosaur swim underwater – until they realized it had no hole in it to let air in!

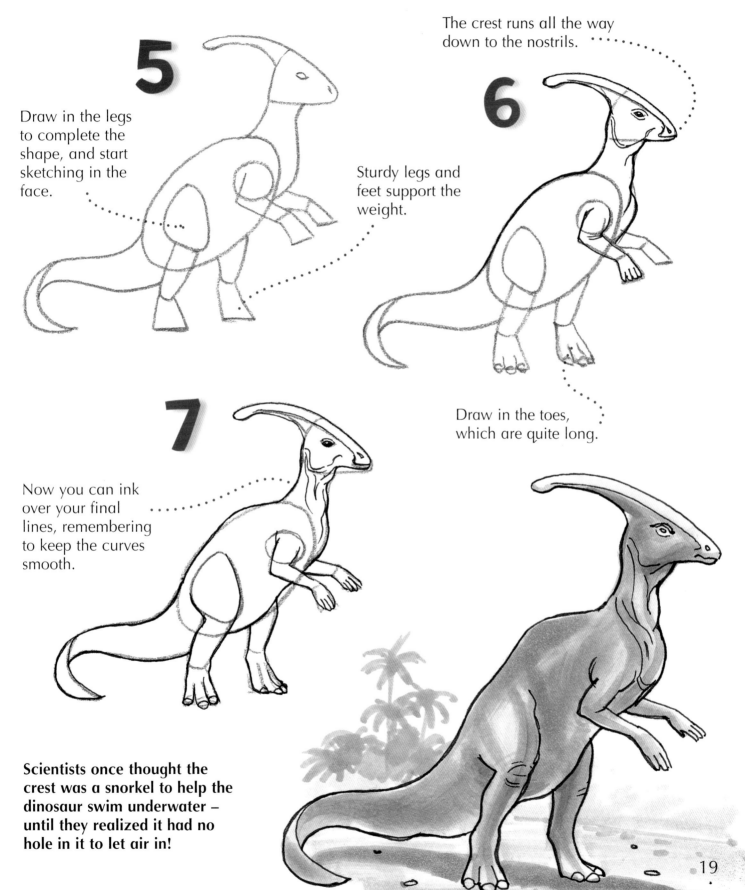

Pteranodon

When dinosaurs ruled the earth, flying reptiles, or pterosaurs, ruled the skies. They came in many shapes and sizes. Some were as small as sparrows, but Pteranodon was a giant, about the size of a glider. In fact, scientists think it flew by gliding – it was probably too big to flap its wings.

These two shapes will form the body and hind legs.

1

The head, with its open jaws, will fit into this long box shape.

2

A long bony crest probably helped to balance the heavy head in flight.

3

The legs are tiny – not the legs of a creature that does much walking.

Add the first wing. It is made of leathery skin attached to the arm and finger bones.

4

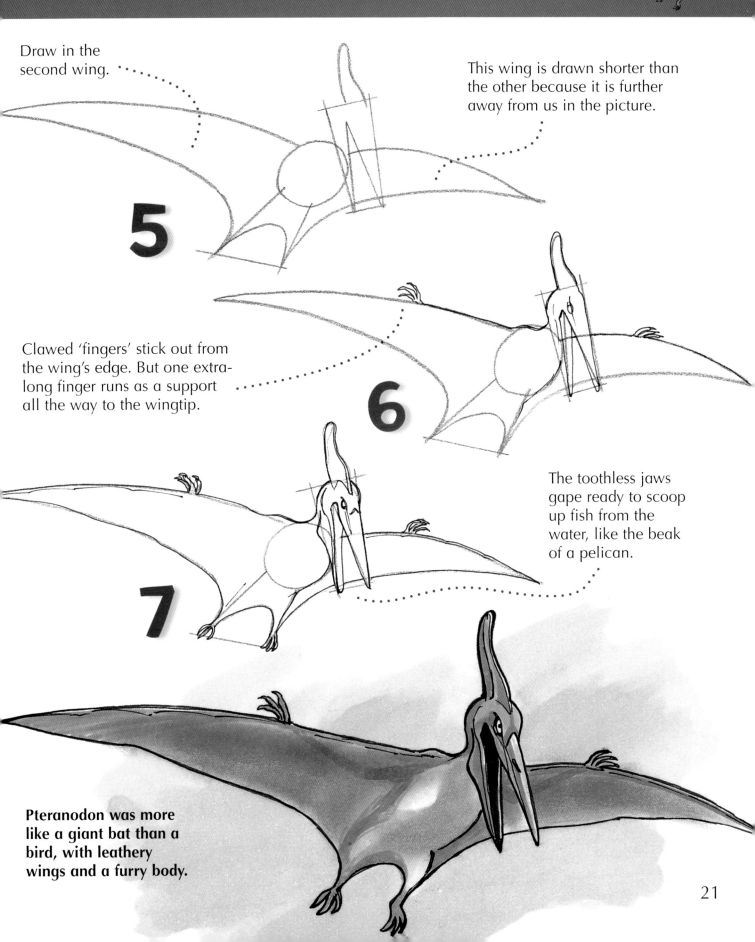

5 Draw in the second wing.

This wing is drawn shorter than the other because it is further away from us in the picture.

6 Clawed 'fingers' stick out from the wing's edge. But one extra-long finger runs as a support all the way to the wingtip.

The toothless jaws gape ready to scoop up fish from the water, like the beak of a pelican.

7

Pteranodon was more like a giant bat than a bird, with leathery wings and a furry body.

21

Camptosaurus

This big, slow-moving plant-eater probably spent most of its time on all fours. But when danger threatened, it ran on two legs. It could also rear up on its hind legs to reach high branches, and then its smaller forelegs served as arms to grasp the food.

1 These two simple shapes form the body.

The head is flattened, with not much room to house a large brain.

2 Add the thigh section for the powerful hind leg.

3 Link up the shapes, and then add the shoulder joint.

4 The long, thick tail served as a useful balance when Camptosaurus ran on two legs.

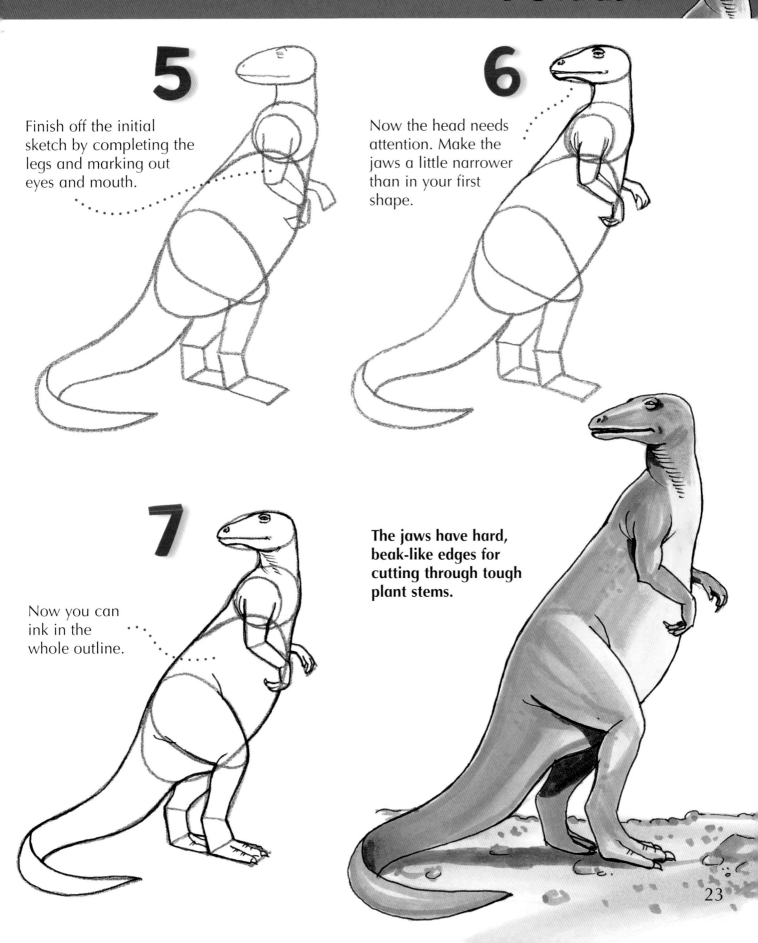

5

Finish off the initial sketch by completing the legs and marking out eyes and mouth.

6

Now the head needs attention. Make the jaws a little narrower than in your first shape.

7

Now you can ink in the whole outline.

The jaws have hard, beak-like edges for cutting through tough plant stems.

Compsognathus

Not all dinosaurs were giants: this little hunter was about the size of a small dog, and lived on small prey like insects and lizards. It swallowed its food whole – in fact, the first Compsognathus fossil ever found had a whole lizard skeleton lying in its stomach.

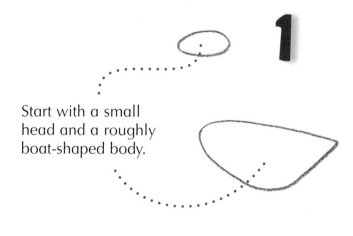

1

Start with a small head and a roughly boat-shaped body.

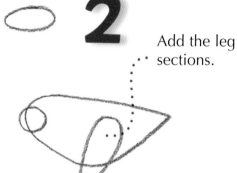

2

Add the leg sections.

3

The long snaky neck allows the head to dart out and snatch small prey.

For the tail, draw a flowing curve slightly longer than the head and body combined.

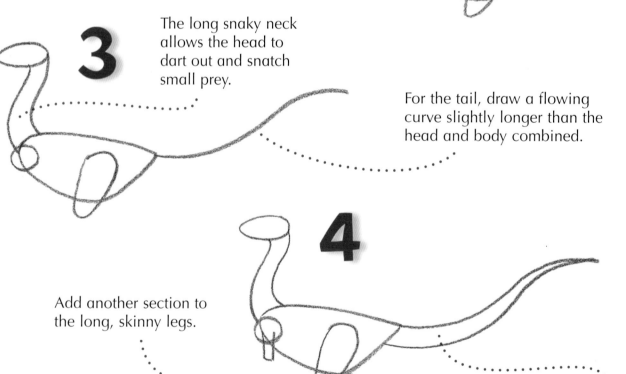

4

Add another section to the long, skinny legs.

The tail is slender, bony and whip-like.

5

Complete your sketch by finishing the legs. The little dinosaur is lightly built for speed.

Compsognathus means 'pretty jaw' but these jaws are more business-like than pretty. They are lined with sharp, cutting teeth.

6

The hands have long, gripping fingers with sharp claws.

Start to smooth out the flowing curves of the outline and add some detail to your drawing.

7

Some of the big dinosaurs, like Brachiosaurus, were more than 300 times the size of their little cousin.

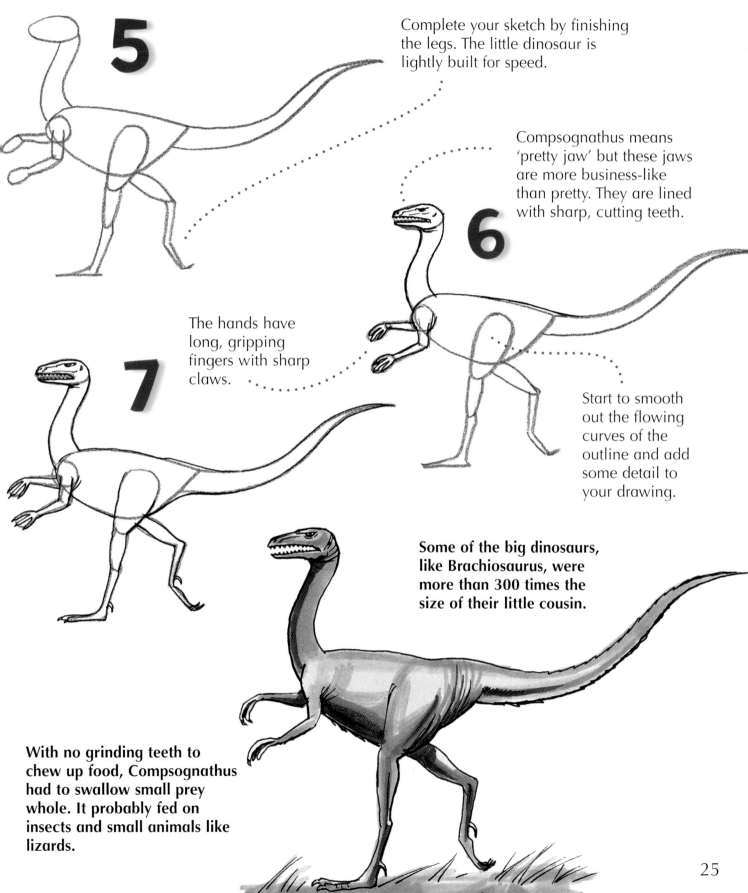

With no grinding teeth to chew up food, Compsognathus had to swallow small prey whole. It probably fed on insects and small animals like lizards.

Hydrotherosaurus

Here we have a real 'sea monster'. It belonged to the family of plesiosaurs ('ribbon reptiles' – from their long, narrow shape), which were all adapted to a life at sea. It swam like a fish, but, unlike a fish, had to come to the surface to breathe.

1 Start with the small head, long thin neck, and short, flattish body.

2 Add a line for the tail, which is about the same length as the neck.

3 Now complete the tail and neck, remembering to keep the 'ribbon' shape.

4 Sketch in the eyes and mouth.

The limbs are large, paddle-shaped flippers.

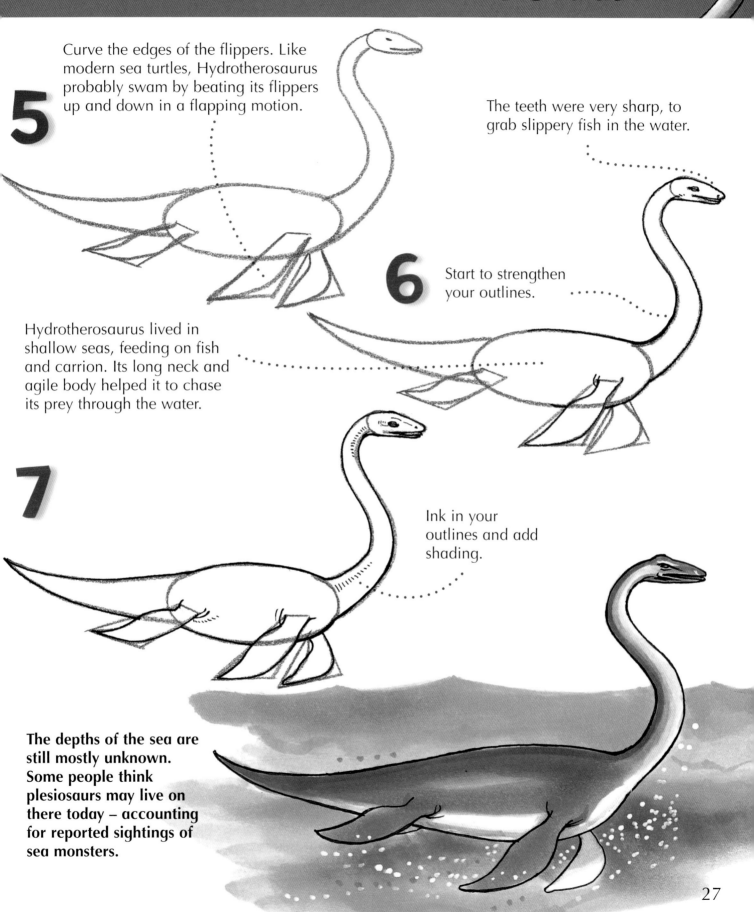

5 Curve the edges of the flippers. Like modern sea turtles, Hydrotherosaurus probably swam by beating its flippers up and down in a flapping motion.

The teeth were very sharp, to grab slippery fish in the water.

Hydrotherosaurus lived in shallow seas, feeding on fish and carrion. Its long neck and agile body helped it to chase its prey through the water.

6 Start to strengthen your outlines.

7

Ink in your outlines and add shading.

The depths of the sea are still mostly unknown. Some people think plesiosaurs may live on there today – accounting for reported sightings of sea monsters.

27

Diplodocus

Diplodocus was not the biggest dinosaur, but it was one of the longest. It was as long as a tennis court, though most of its length was neck and tail. It was built like a suspension bridge, with its long body supported on column-like legs.

1 Start with head and body shapes. The head is tiny compared to the body – in fact, it was hardly bigger than a modern horse's head.

2 Draw a medium-sized oval below the head as a guideline for the curve of the neck.

3 Now draw the neck around your oval.

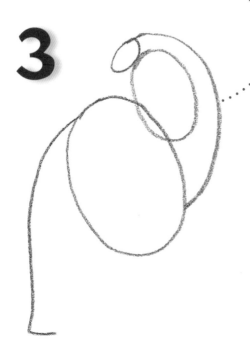

4 Even longer than the neck, the tail is made up of more than 70 separate bones.

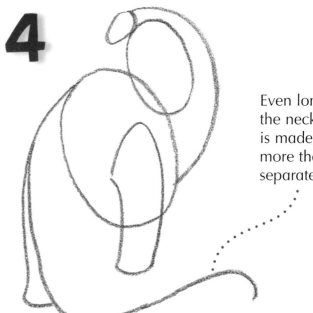

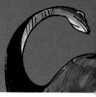

5

The long neck had muscles like the steel cables of a crane to help lift the head.

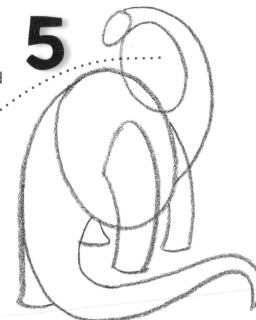

The jaws had teeth only at the front, to strip leaves from branches. Diplodocus must have spent its whole life eating, to take in enough food for its needs!

6

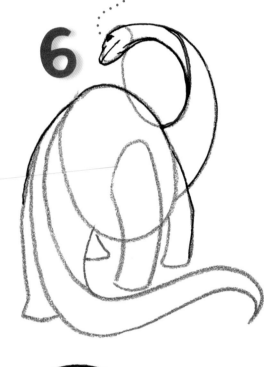

7

Ink in your outlines, adding shading to give weight to the huge legs and tail.

This huge plant-eater lived around 150 million years ago. Its name means 'double beam' – it refers to the shape of its tail bones.

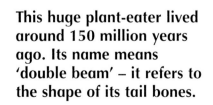

Ornithomimus

This elegant little hunter was the dinosaur version of a modern ostrich – in fact its name means 'bird-mimic'. Like an ostrich, it was a fast runner, depending on its speed to escape enemies. It probably lived on insects, lizards – and other dinosaurs' eggs.

1

These three simple shapes form the oval body, small round head and long slender neck.

2

The top of the hind leg is big and strong to support a runner's legs. The upper arm is quite small, and round.

3

The underside of the neck curves smoothly on to the circle of the forelimb.

4

The long tail was probably used for balancing. Add the next section of the hindlegs.

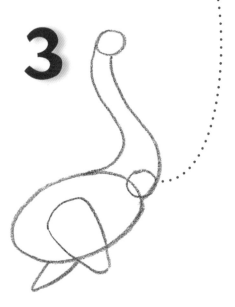

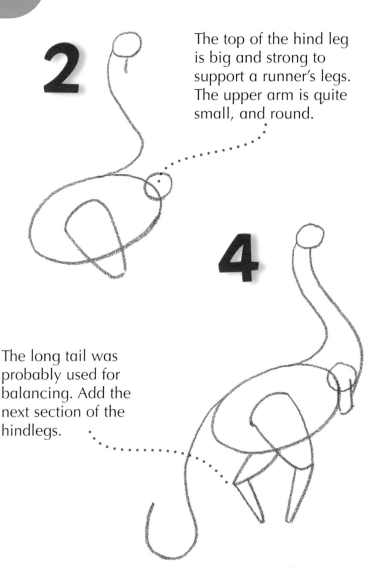

5

Finish the stilt-like legs, long arms and strong tail. Give the tiny head a bird-like beak.

6

The head really does look like a bird's. The eyes are large, like an ostrich's. Ornithomimus had no teeth, pecking at food with its sharp-edged beak instead.

7

Add a little shading to give the body form and solidity.

Ornithomimus had no natural weapons to defend itself against the giant meat-eaters that hunted it. But its speed and agility would usually have kept it out of trouble.

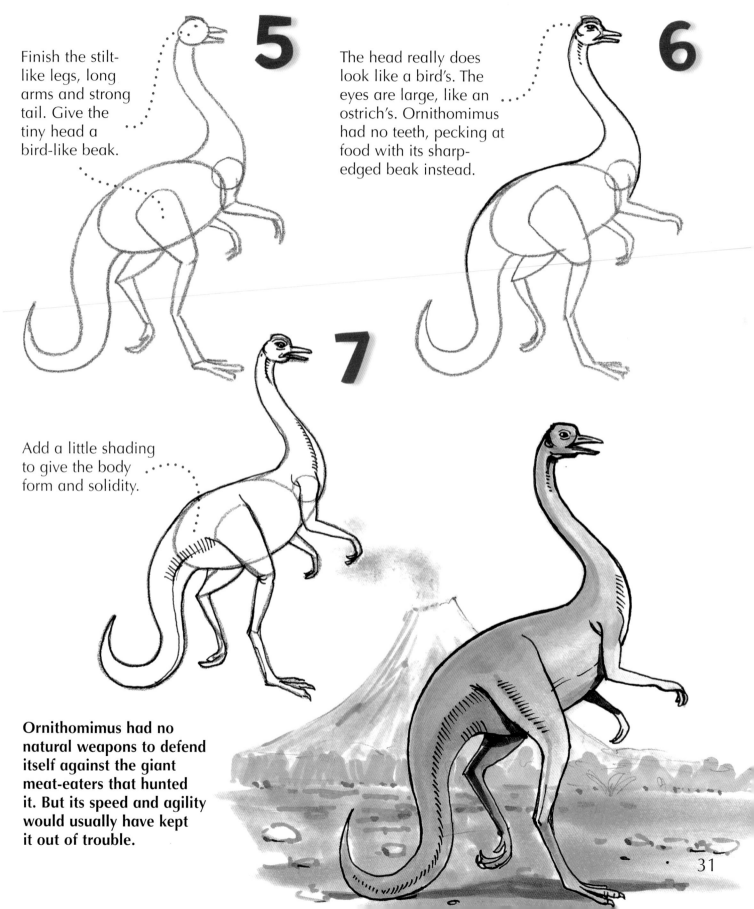

31

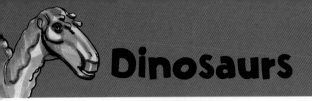

Maiasaura

Maiasaura got its name, 'good mother reptile', from the discovery of its 'nursery'. This species lived in groups. The females built earth-mound nests in which they laid their eggs, and guarded their young until the baby dinosaurs could look after themselves.

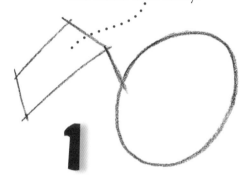

Two simple shapes form the head and body.

1

Draw the neck, and add the thigh of the hind leg.

2

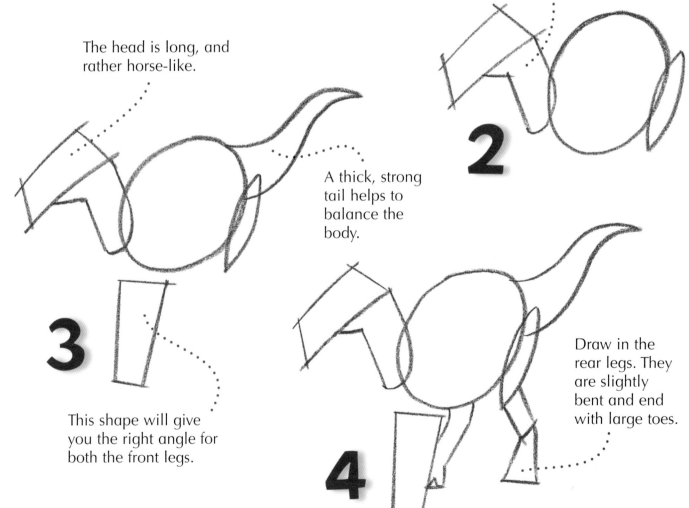

The head is long, and rather horse-like.

A thick, strong tail helps to balance the body.

3

This shape will give you the right angle for both the front legs.

Draw in the rear legs. They are slightly bent and end with large toes.

4

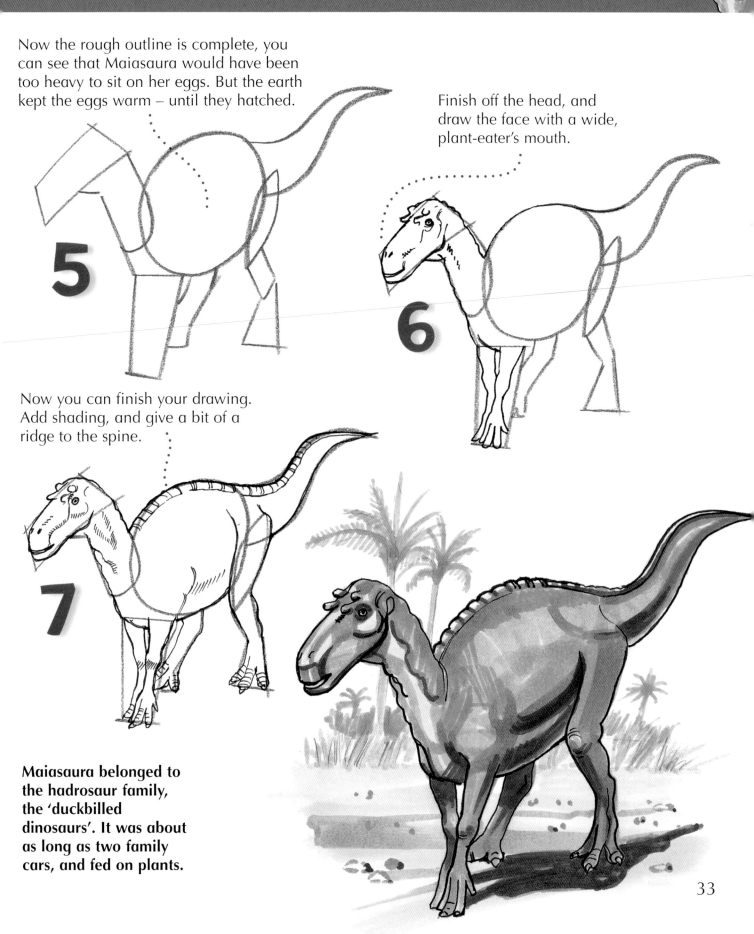

Now the rough outline is complete, you can see that Maiasaura would have been too heavy to sit on her eggs. But the earth kept the eggs warm – until they hatched.

Finish off the head, and draw the face with a wide, plant-eater's mouth.

Now you can finish your drawing. Add shading, and give a bit of a ridge to the spine.

Maiasaura belonged to the hadrosaur family, the 'duckbilled dinosaurs'. It was about as long as two family cars, and fed on plants.

33

Edaphosaurus

This curious-looking creature had a long sail on top of its back. This was made up of tall spines growing from the backbone, and covered with skin. It may have been a 'solar panel' to trap the Sun's heat, or it may have been mainly for display.

1

Start with a long oval body and a small head.

2

Add circles to mark out the leg sections.

3

Draw the tail. Now we have an animal shaped rather like a modern lizard.

4

The 'sail' is about the same size as the body.

The legs are short and are held close to the body.

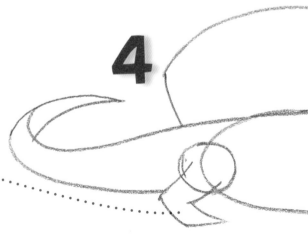

5

The head is long and flat, with a wide mouth which held teeth that could grind up plants

The long bony spines within the sail show up clearly, like the teeth of a comb.

6

7

The eye is quite large and placed well forward on the head.

Finish off the short, fat legs with small claws.

You can see a similar 'sail back' on a lizard which is alive today, the basilisk. It is a small member of the iguana family.

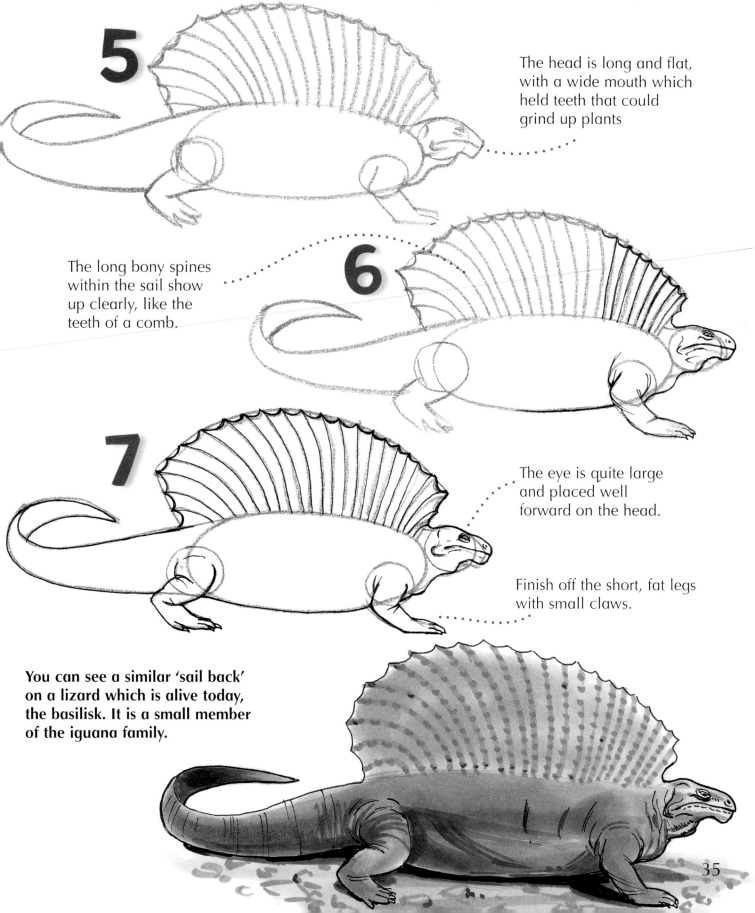

Iguanodon

Iguanodon ('iguana-tooth') lived about 120 million years ago, and was one of the first dinosaurs ever discovered. A huge beast as long as a London bus, it lived in large herds. At one site in Belgium, the bones of around 30 iguanadons were found together.

1

Start off with these three shapes for the head and body.

2

Join the head to the body, and sketch in a curved line for the tail.

3

Mark out the upper sections of the legs and arms.

4

Iguanodon could reach high branches to feed. It had no front teeth, but nipped off twigs with its beak. Broad teeth at the back of the mouth ground up its chewy diet.

Add the strong hindlegs and large feet.

5

The short arms may have helped the animal to walk some of the time, since four fingers end in tiny hoofs, not claws.

That circle gives full weight to the powerful hindquarters.

6

The head is long and rather horse-like.

The thick tail helped to support the body.

7

The hind feet have three large toes, each ending in a mini-hoof. Iguanodon could run quite fast on these.

Its size meant Iguanodon probably had few enemies, but it was not unarmed. Its thumbs were sharp spikes that may have served for self-defence.

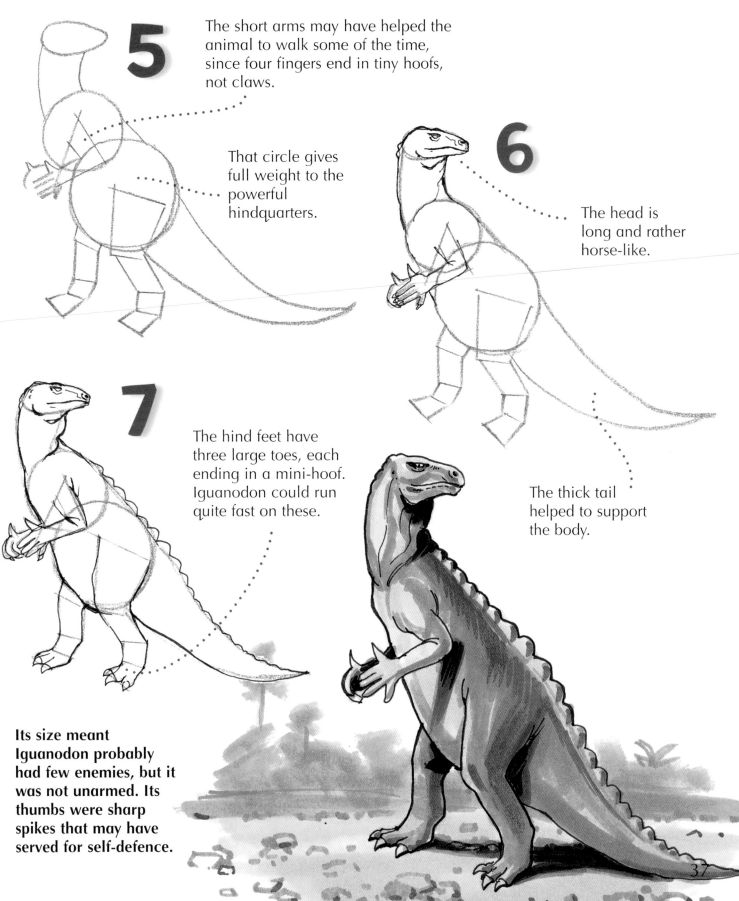

37

Cow

Dairy cows provide us with milk, which is used to make butter and cheese. There are various breeds, most easily told apart by the colour. The big, black and white Friesian is one of the most common.

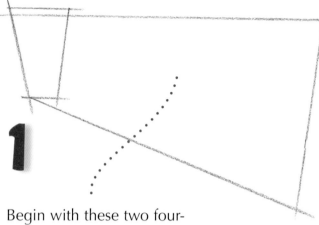

1 Begin with these two four-sided shapes. Note that the head is so much smaller than the deep body.

2 Remember to set the small oval (which will become the knee) close to the chest. This will ensure that the forelegs are in the right position.

The triangle forms the deep chest and top of the leg.

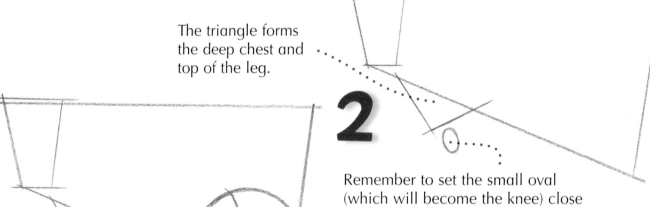

3 Draw a circle measuring half the depth of the body. This marks the site of the udder, half of which will be hidden by the hind leg.

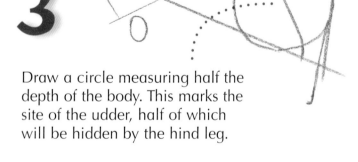

The forelegs are quite straight, but the short, strong hind legs are slightly slanted. The front feet are level with each other, but one hind foot is drawn slightly forward to support the weight of the body.

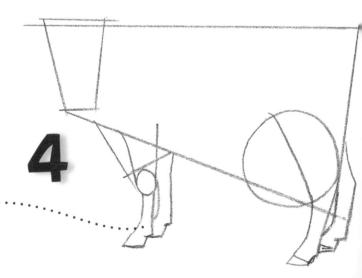

4

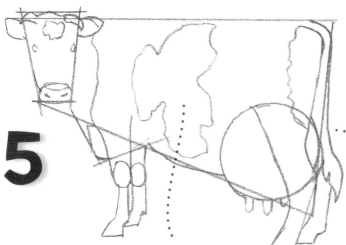

The tail hangs straight down like an old-fashioned bell rope, with a silky tuft at the end.

5 Sketch in the black and white markings. They can be any shape you like – no two cows are marked exactly alike.

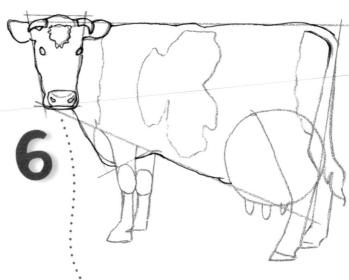

6 Add details of the face, spacing the eyes and ears well apart. Decide whether your cow has horns – many breeds are born hornless ('polled') or have their horns removed.

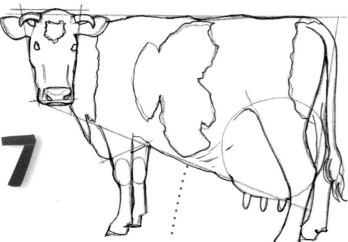

7 Start tidying up the outline and add final details. The line of the chest and underside needs to be worked on carefully.

There's a good reason why the cow's body is so large. It houses four stomachs to help the cow process enormous amounts of food and drink. In a single week an adult cow can eat her own weight in grass!

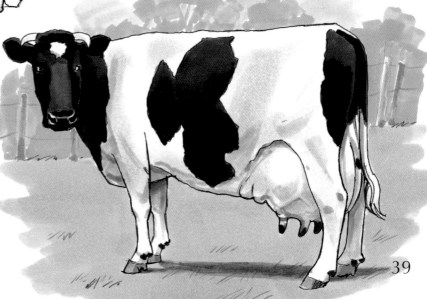

Sheep

Sheep are farmed around the world for wool and meat (lamb or mutton). The many breeds are divided into three groups: shortwools (mainly for meat), longwools (mainly for wool) and hill breeds – tough animals which can cope with poor grazing and harsh weather.

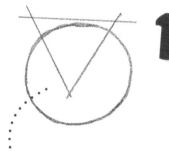

1

Start off with a circle and a triangle for the neck and face.

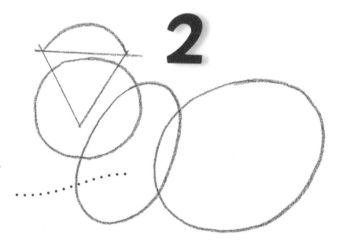

2

Two ovals form the body. Apart from the face, this shortwool sheep is made up of rounded shapes.

The head starts to take shape when you round off the top and add a pair of ears.

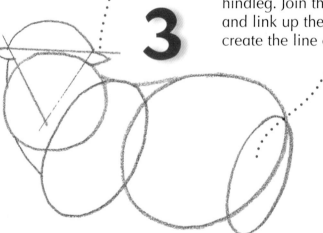

3

Another oval provides the top of the hindleg. Join the neck to the chest, and link up the two body ovals to create the line of the back.

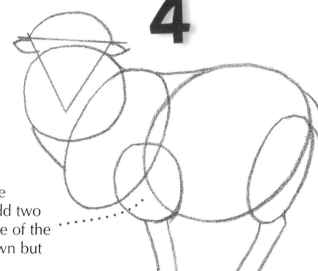

4

Draw an egg shape where the foreleg joins the body, and add two legs and a tail. Note the angle of the legs – not straight up and down but slanted inwards for balance.

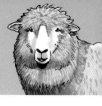

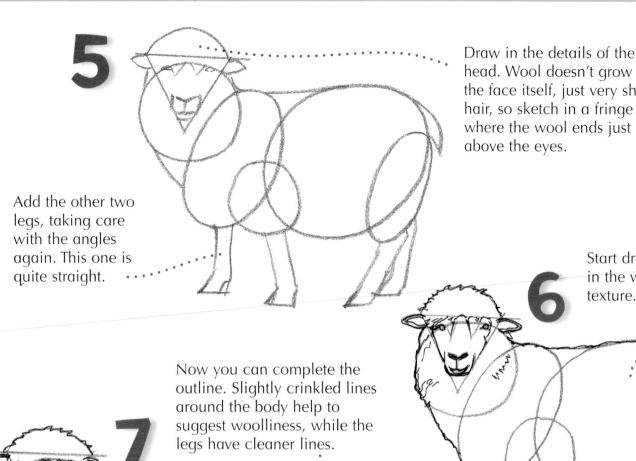

5

Draw in the details of the head. Wool doesn't grow on the face itself, just very short hair, so sketch in a fringe where the wool ends just above the eyes.

Add the other two legs, taking care with the angles again. This one is quite straight.

Start drawing in the woolly texture.

6

Now you can complete the outline. Slightly crinkled lines around the body help to suggest woolliness, while the legs have cleaner lines.

7

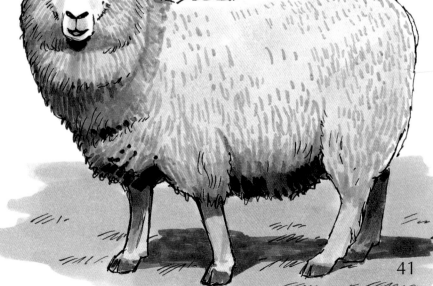

The sheep looks very rounded and solid, but this shape is mainly created by the thick, curly wool. In summer, when its fleece is shorn, you can see its real shape – which is unexpectedly lighter and leggier, more like a goat.

Chicken

Fifty years ago, every farmyard had a flock of chickens pecking around to provide eggs and meat. Today, hens are often kept indoors in huge 'factory' farms. But some farms keep 'free range' chickens outdoors where they can enjoy fresh air and space.

Naturally, the chicken starts with an egg! This egg shape will become its body.

1

Add a curving line for the neck, and a much smaller egg for the head.

2

Complete the neck, and add the comb (the fleshy growth, like a crest, on top of the head).

3

The top of the leg will be covered in feathers when the drawing is complete.

Add tail and legs, and the chicken begins to appear. Don't put the legs too far forward!

4

The beak is quite small and pointed.

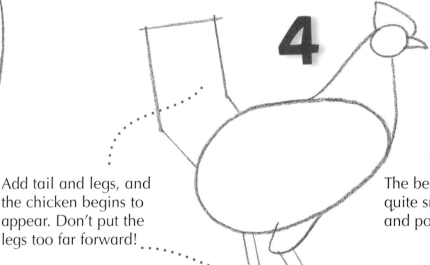

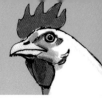

5

Fill in some detail. Bring the head to life by adding the eye and the wattle (another fleshy growth hanging below the beak). Sketch in wings and toes.

6

The comb has a jagged edge – like the teeth of a hair-comb.

Now you can add some form to the wings.

7

A chicken has several thousand feathers, but you don't need to draw all of them! Instead, suggest a feathery texture with a little shading.

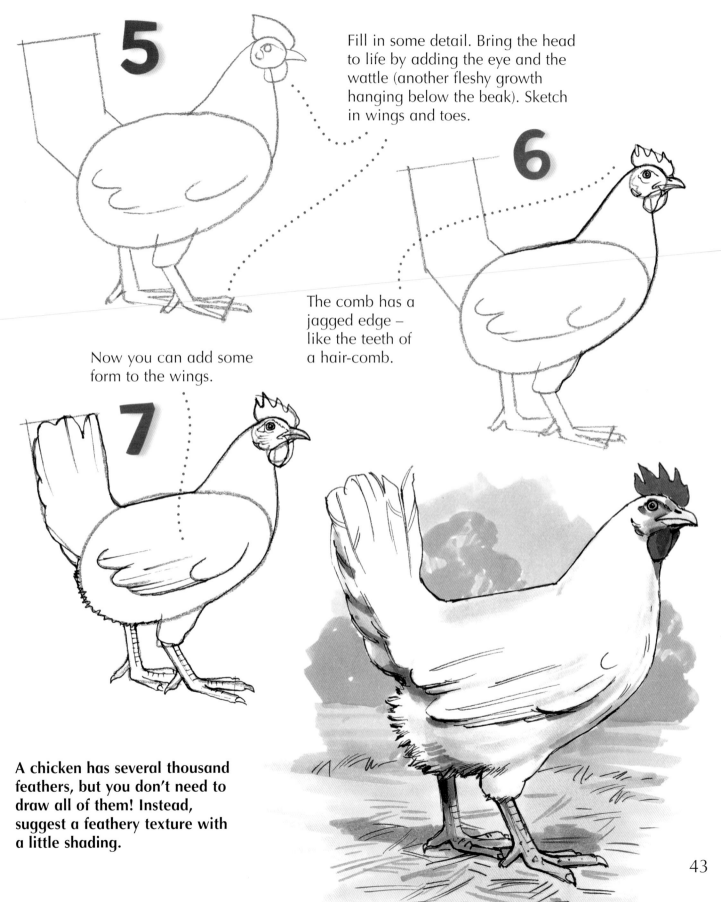

43

Horse

In your great-grandparents' day, horses were very important on the farm. Horse power was the only power available for ploughing, harrowing, carting and other heavy work. Today they have been replaced by machinery, and are mostly kept just for riding.

1

Take care with the spacing of the first two shapes.

2

The top of this oval needs to be a little lower than the shield-like shapes on either side.

3

Complete the neck and back. Add a circle at the point where the foreleg will begin.

Three more lines running from the head circle give the shape of the muzzle.

4

Horses have bony legs with knobbly knees. Mark out the position of the leg joints with small rounded shapes. Sketch in the tail.

44

5

When the legs are added, body and legs form a rough square. If it's a rectangle, either the body or the legs are too long! Draw in the face, ears and mane, and add some shape to the tail.

6

The long, strong neck is heavily muscled. A line down the throat will show you where to add shading.

7

Finish off your outline. Now it really begins to look like a horse. This one is eating grass, so draw the mouth slightly open.

Horses come in a wonderful range of colours – black, grey, all shades of brown, or even spotted – the choice is yours. You may like to add markings such as a tar or blaze on the face, or white 'stockings'.

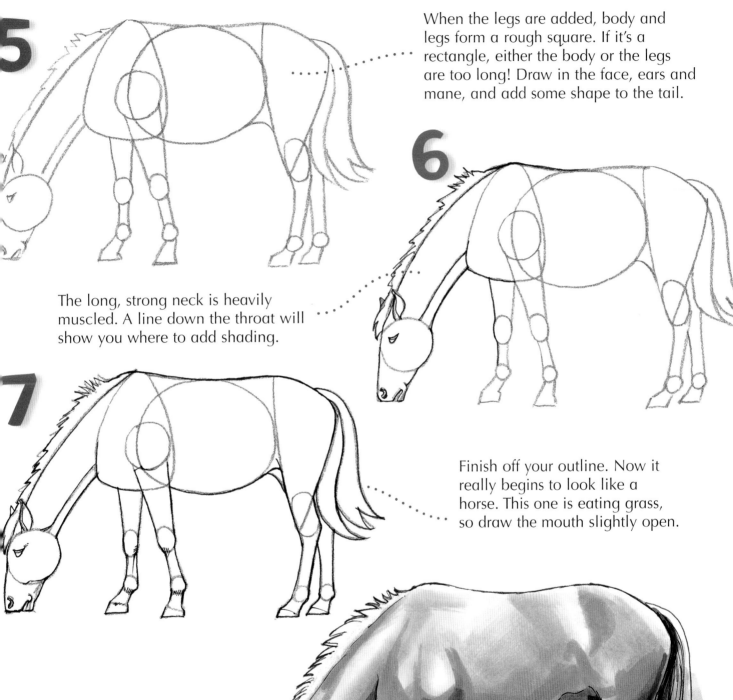

45

Duck

Farmyard ducks are bigger and clumsier than their wild relative, the Mallard. They are kept for their eggs, which are bigger than hens' eggs, and for meat. Ducks enjoy dabbling in the water for their food, but they also feed on land, nibbling grass and digging up worms and grubs.

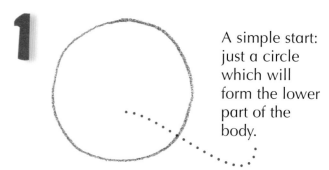

1 A simple start: just a circle which will form the lower part of the body.

2 A small circle (the head) needs to be spaced well above the others.

Link a large circle with a slightly smaller one to complete the body form.

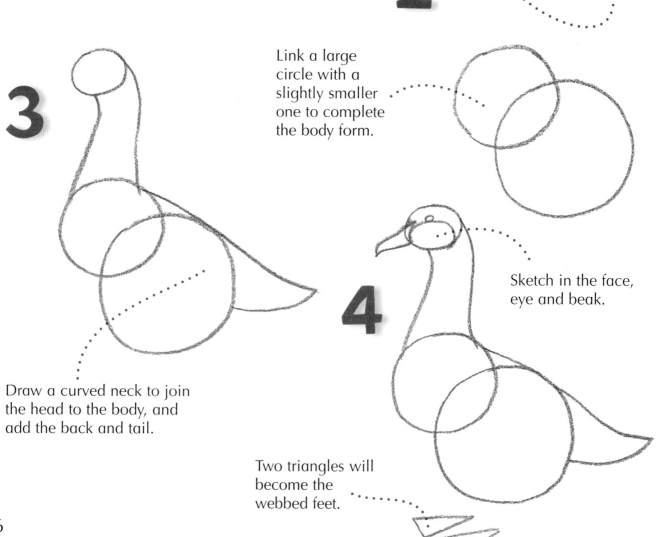

3 Draw a curved neck to join the head to the body, and add the back and tail.

4 Sketch in the face, eye and beak.

Two triangles will become the webbed feet.

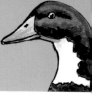

5 Now you can fill in some detail. Put in the breast and legs, and sketch wing and tail feathers.

6 The wings, neatly folded, take up less than half the body space.

The male duck, or drake, has a smart white collar.

The body is heavy and set low to the ground.

7 Complete your outline, and add some detail to the legs and webbed feet.

The drake is more handsomely coloured than his mate. She wears dull colours to help her hide from hunters when she is sitting on her eggs.

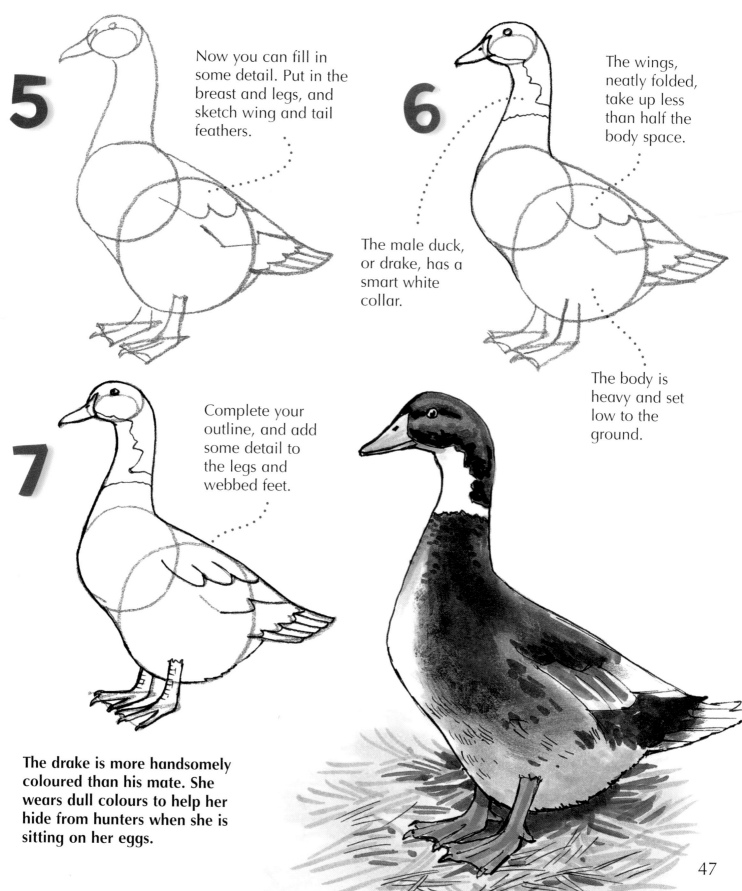

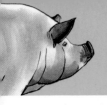

Pig

There is an old saying that every part of the pig can be used except its squeal! As well as meat, pigs provide leather and even bristles for brushes. They were once also valued as bulldozers to clear rough land, grubbing up roots and plants with their snouts.

We say 'as fat as a pig', so start with two fat circles.

1

This looks more complicated than it is! Add two more simple shapes to create the head and the top of a front leg.

2

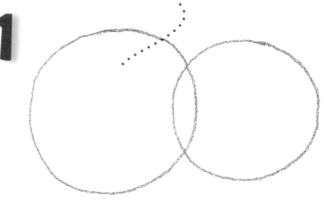

Pop on a pair of ears, and suddenly the shapes start to make sense. Level off the back, and add a curve at the rear for the top of the second hindleg.

3

4

Two more additions make your sketch much more piggy. Put in the tops of the legs, and draw a nose. This snout turns up like a little teapot spout.

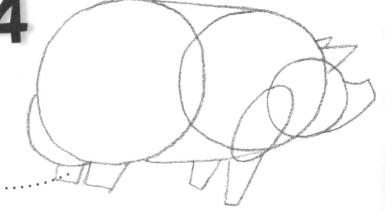

48

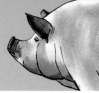

5

Now you can add a few details. Place the small eye just in front of the ears, level with the tip of the snout.

6

With completed legs and a loosely curled tail, the pig's outline is all there. Round off the belly in front of the hindleg.

7

Your pig is ready for you to finish off the outline.

Pigs don't have to be pink! Some breeds are black, some ginger, some spotted, and some (Saddlebacks) have a white band across a dark body. In fact, pink pigs have a problem – like us, they can suffer from sunburn in the summer!

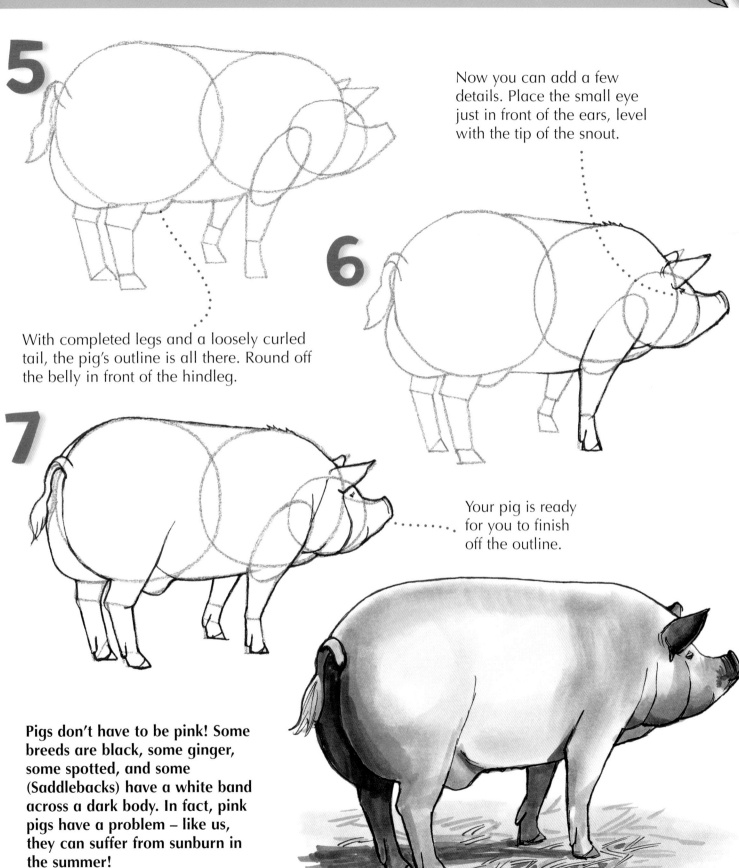

49

Cat

No farmyard would be complete without its cats. Most farms house whole families of cats to keep down the numbers of rats and mice. They are experts at pest control, a job they have done since they started work in the grain stores of Ancient Egypt thousands of years ago!

1 Start off with three circles spaced like this.

2 Join up the circles with a line for the back and neck. Put in another small circle which will help to shape the shoulder.

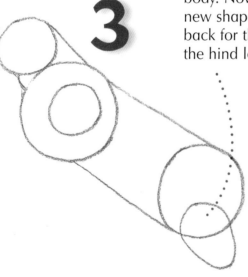

3 Complete the outlines of neck and body. Now add this new shape at the back for the top of the hind leg.

Add four ovals for the paws. With sharp claws to give grip, these paws are all the climbing gear a cat needs.

4 The long tail is held out behind to help the cat keep its balance.

6

Draw in the legs and give the cat a face and ears. The muzzle is very short, so the roundness of the head is still obvious. Add two lines to make the branch of the tree.

5

Add the final details. Ears and eyes point forwards, following the line of the nose.

7

Finish off your outline, keeping to sleek, smooth lines except along the fluffy belly.

A wavy line marks the border between the tabby colouring and the white underparts.

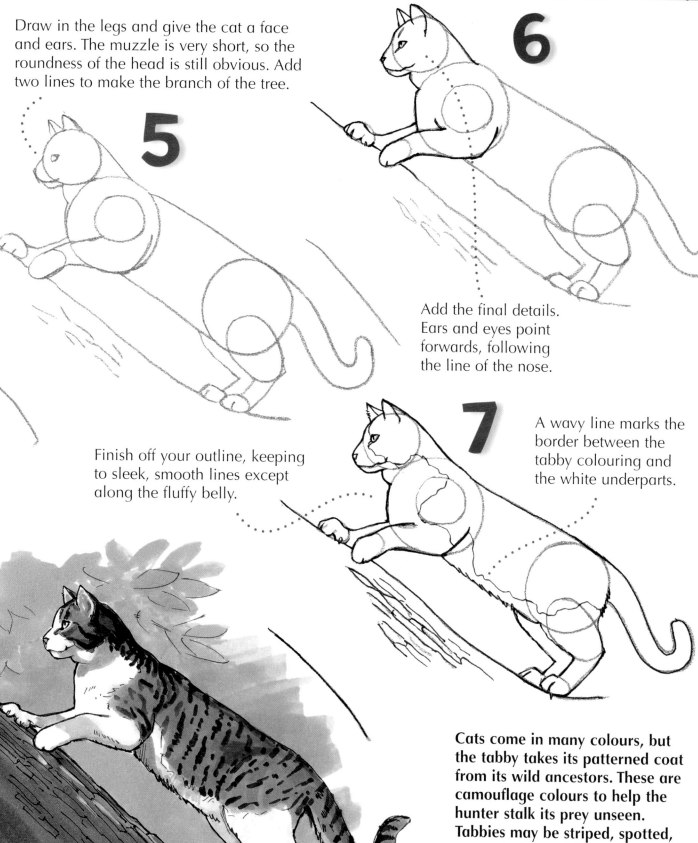

Cats come in many colours, but the tabby takes its patterned coat from its wild ancestors. These are camouflage colours to help the hunter stalk its prey unseen. Tabbies may be striped, spotted, or marked in swirling patterns.

Calf

Most cows give birth to a calf every year. Calves can be born at any time of year, but most will be born in the spring and early summer, when there is warmth and plenty of green food. Dairy cows are often mated to beef bulls to produce calves that look like neither parent.

Start with these two shapes for the head and body.

1

Two rounded shapes mark the joints where the front legs join the chest.

2

3

A calf's legs have knobbly joints, so mark out the knees with three more rounded shapes.

Adding eyes and ears gives the calf a recognizable face. Now two small circles mark the joints above the hoofs of the forelegs.

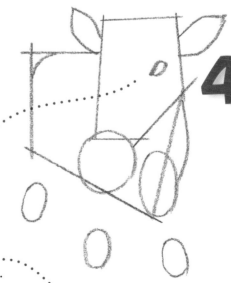

4

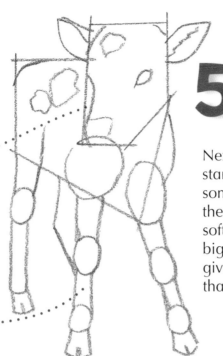

5

Now work on the five-sided shape used for the head. Let the longest side curve inwards, to separate the muzzle from the broader forehead.

Join the joint circles to make the legs, and draw in the body markings.

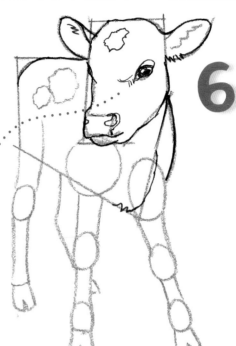

6

Next you can start adding some detail to the head. Large, soft eyes and a big nose help to give the face that 'baby' look.

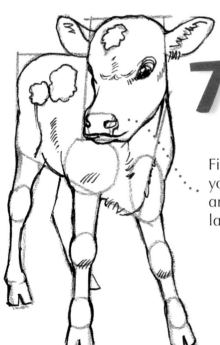

7

Finish off your outline and fill in the last details.

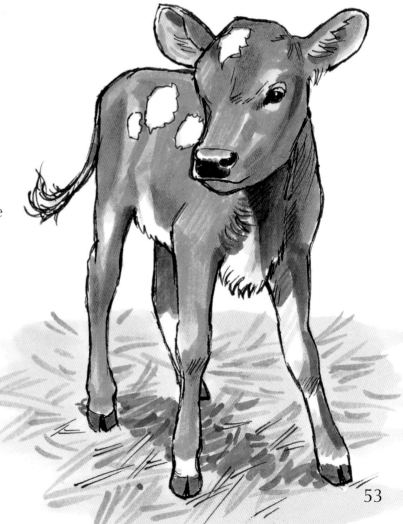

The young calf is not just a smaller version of a cow. It is all head and legs, with a small body and quite a spindly appearance.

Bull

The powerful bull may weigh as much as a family car. He can also be very fierce, and can outrun a man, so he is one of the most dangerous animals on the farm. In fact, not many farmers keep their own bulls any more. Where they do, look out for warning notices, 'BEWARE OF THE BULL'.

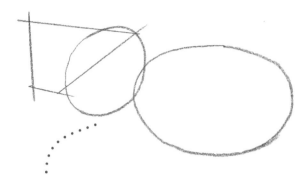

1 Head, neck and body begin with these three shapes. They are all connected, so that the thick neck will flow into the heavy shoulders.

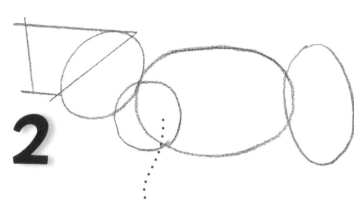

2 Two more simple shapes help to establish the head and the body.

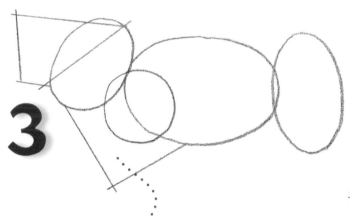

3 This triangle will become the deep chest and top of a leg.

A single flowing line forms the top of the back and a high, waving tail.

4 Now sketch in the lines of a bent leg and two ovals to mark the joints of the other foreleg.

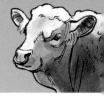

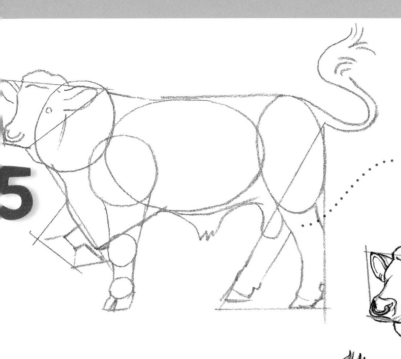

5

It is quite easy now to turn all these strange shapes into the recognizable outline of a bull. Make sure the legs look thick enough to support that massive body.

6

Tidy up your drawing, concentrating on the head. Also remember that the hooves are not solid, like a horse's, but divided into two parts.

7

Now you can ink over your final outline. The bull comes to life, standing there pawing the ground.

Use shading to bring out the powerful muscles. Beef cattle like this bull are a different shape from dairy cattle, deeper in body, more short-legged and with a shorter head. However, bulls are rarely raised for meat but are kept for breeding purposes.

Lamb

Most lambs are born in the early spring. They are among the most playful of baby animals, gambolling through the fields. Ewes usually have twins. Amazingly, no matter how many lambs there are in the flock, every mother can pick out the voice of her own lamb from all the bleating.

1

These two shapes form the head and body.

2

Add three small ovals for the knees, and join the back one to the body to form the top of a hindleg.

The body slants away from us, because the back feet are further away than the front ones.

3

Three small circles form the ankle joints. Now you can start drawing in the legs.

4

Three legs are completed. Draw the little cloven (divided) hoofs.

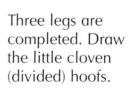

56

5

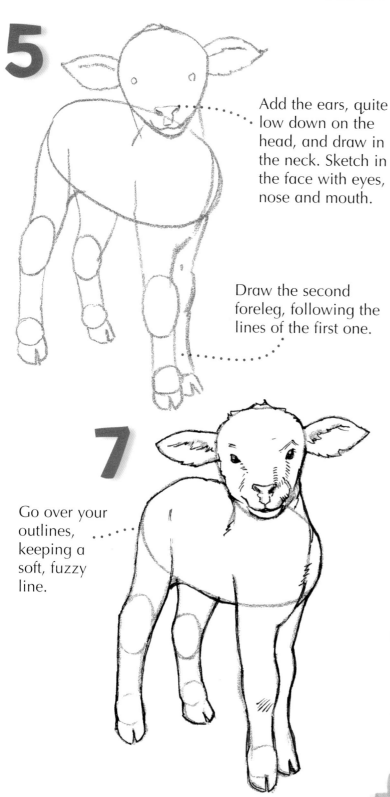

Add the ears, quite low down on the head, and draw in the neck. Sketch in the face with eyes, nose and mouth.

Draw the second foreleg, following the lines of the first one.

6

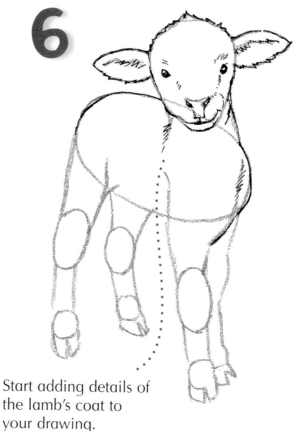

Start adding details of the lamb's coat to your drawing.

7

Go over your outlines, keeping a soft, fuzzy line.

Lambs' wool is very short and curly. You can hint at it in your drawing with shading.

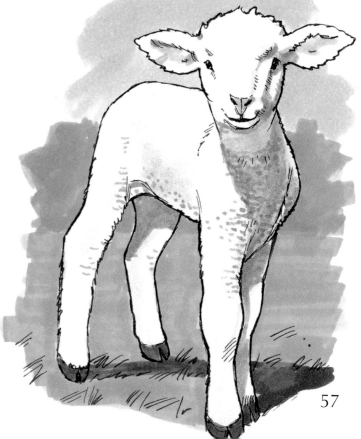

Cockerel

Farmers have developed many breeds of chicken, differing in size, shape, and colour. In a few breeds, the hen and cockerel look very similar. But usually the cockerel is much better looking. He has brighter colours, a longer tail, and a taller comb than his hens.

1

A circle and an oval joined by a short curved line give us the body and tail.

2

Another curved line links the two shapes. Add an egg shape at the bottom to form the top of a leg.

3

Now draw a thick neck of the same height to balance the tail. The small head perches on top of the neck.

4

Join the head on to the neck. Add another small circle under the head for a wattle (the dangling fleshy growth below the beak).

The legs are quite short and thick, the toes very long.

58

5

Fill in the details of the face. The eye is surrounded by a bright circle of bare skin. The beak is open to crow.

6

Now you can start dressing the cockerel in his finery - tail feathers, wings, and the cape of plumage over his neck.

Finish off your drawing. A few carefully placed lines suggest the way the neck feathers hang downwards.

7

In the days before clocks were common, the cockerel saved people from over-sleeping. His habit of crowing at sunrise made him a useful alarm clock!

The wing feathers are draped gracefully over the body.

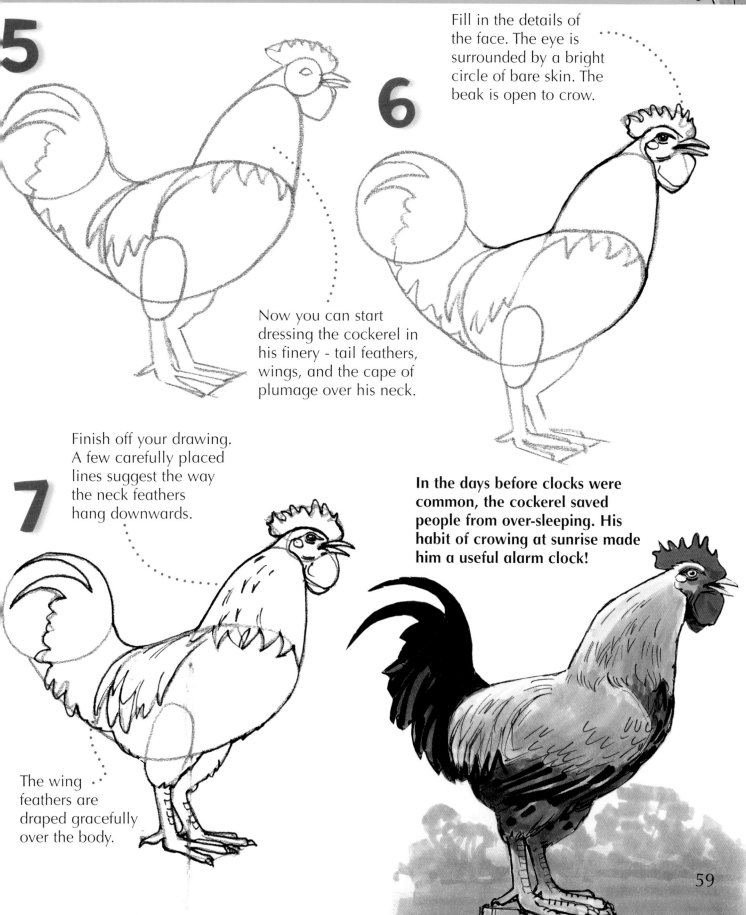

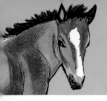

On the Farm

Foal

A foal is standing up and learning to walk within an hour of its birth. Its legs are almost as long as its mother's, looking quite comical attached to its small body. In the wild it has to keep up with adult horses from the start, so it needs these long legs.

These three simple shapes are the starting point.

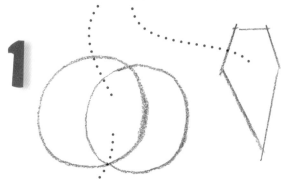

1

Link the circles closely to make a short body.

The head is widest between the eyes, narrowest at the muzzle.

2

Add an oval for the shoulder, and join the head to the body with a curved neck line.

3

These four small ovals form the upper leg joints.

4

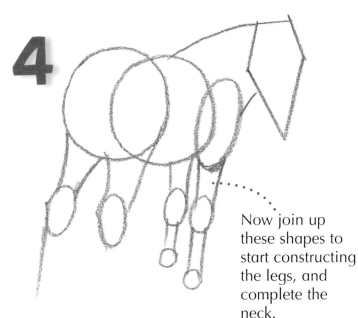

Now join up these shapes to start constructing the legs, and complete the neck.

60

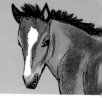

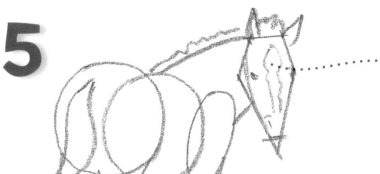

5

Sketch in the face, adding ears and a little tufty mane. Make the end of the muzzle blunter, and mark in a white blaze down the face.

Complete the legs, and add a short, bottle-brush tail. The foal has not yet grown the flowing hair of an adult tail.

These ovals help to mark out the leg joints.

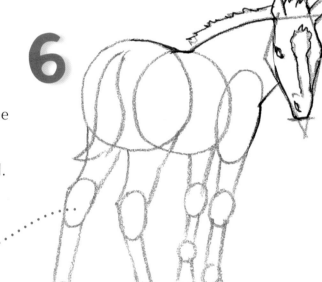

6

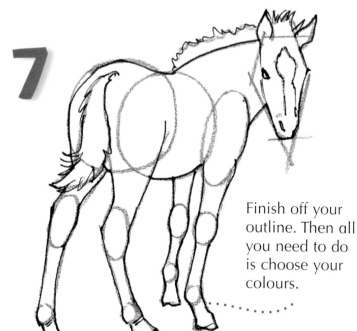

7

Finish off your outline. Then all you need to do is choose your colours.

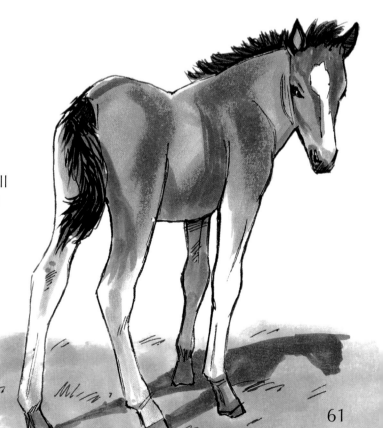

Foals are on their feet almost as soon as they are born, but they need plenty of rest and spend a lot of time lying down.

61

Goose

Geese give us eggs and meat, and are also great 'watchdogs'. They will sound the alarm if a stranger appears, and may even attack. In olden times they were most valued for their feathers, which were used for arrow flights, quill pens, and stuffing for mattresses.

1 Start with two simple shapes joined by a curving line. Make sure the big oval for the body is not upright, but slanted to the left a little.

2 Complete the neck, making it wider near the body – like a teapot spout. Add a little triangle for a tail.

3 Drawing the wing in three sections helps to shape it.

The goose stands upright, ready to flap its wings and honk an alarm.

Be careful not to make the beak too small.

4

The second wing is simpler: a square between two triangles.

5 Put in the eye, high on the head, and add details to the beak.

6 Finish the outlines. The neck, body and tops of the wings flow in smooth lines. The underside of the wings and tail are crinkled to show the feathers.

Triangles will give you the shape for the webbed feet – made not just for swimming but for easy walking on wet mud.

Smooth your outlines neatly and add detail to help form the wings.

7

The webbed feet are tough and leathery, with strong claws.

Spreading his wings to make himself look bigger, this goose is warning a visitor not to come too close. Geese can be quite fierce when defending their homes, especially if they have young goslings to protect.

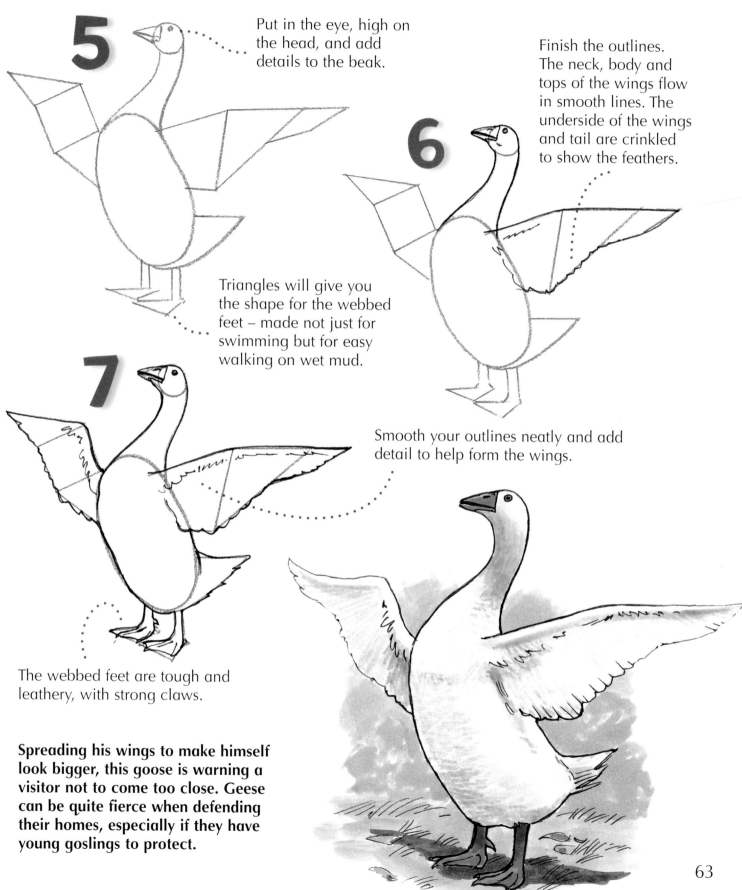

Piglet

Piglets are among the most playful creatures in the farmyard. Sows usually have large litters, and the newborn piglets are tiny. For the first few days they just eat and sleep. Soon they are big enough to chase each other round and climb all over their huge mother.

1

Start your drawing with these two simple shapes: an oval and a triangle.

2

Divide the triangle with a line to mark out where the side of the face will be drawn.

When you add the shapes that will become neck and shoulder, it starts looking complicated...

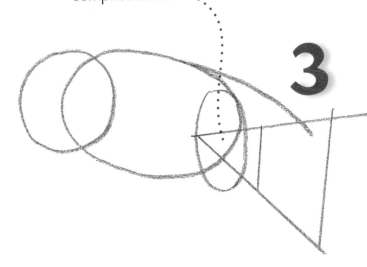

3

...but add the legs, and your drawing suddenly starts to make sense.

Add a small oval, which will become the piglet's flat, sensitive snout.

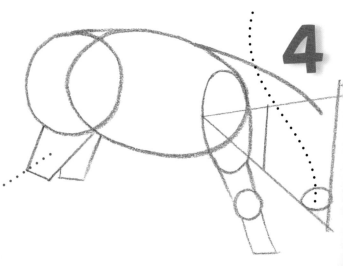

4

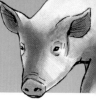

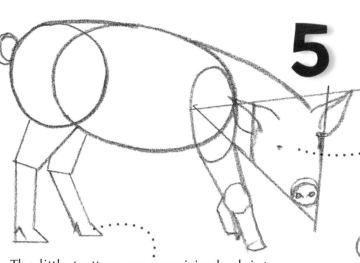

5

Piglets are curious creatures. The head is turned to see what you are doing. Draw in the large ears, open nostrils and small eyes.

Compare the light, slender shape of the piglet with the heavy body of an adult pig.

6

The little trotters are surprisingly dainty, with two toes forming a cloven hoof. Don't forget the curly tail.

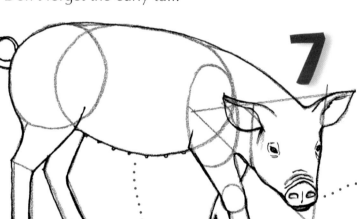

7

That large nose has a wonderful sense of smell. In the 1980s a German pig named Louise was trained as a police 'sniffer dog' to sniff out drugs. She was a great success!

Draw your outlines carefully and add detail to your piglet.

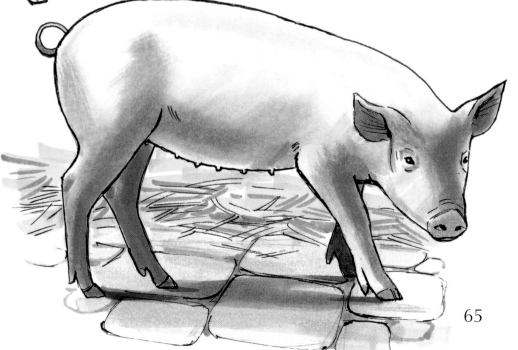

Pigs are often said to be dirty, but, given the chance, they are very clean animals. This piglet's pink skin is spotless.

Sheepdog

It takes a special kind of dog to control several hundred sheep. The clever, tireless Border Collie was made for the job. He is so keen on herding that if he has no sheep to work, he will round up chickens in the farmyard or even members of his human 'family'.

1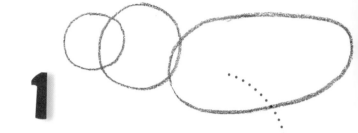

These three rounded shapes form the head, neck and powerful body of your sheepdog.

Join the neck to the body, and mark out the shapes which will form the hindquarters and curling tail.

2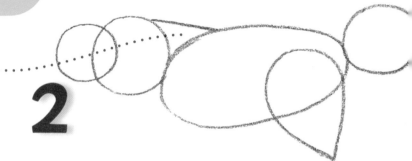

3

Pricked ears and a long muzzle help to give a keen expression. Add a small oval which will be a foreleg joint.

The tail swirls upward at the end and fits within the circle you have already drawn.

Start to draw in the legs to suggest that the sheepdog is slightly crouched as it runs.

4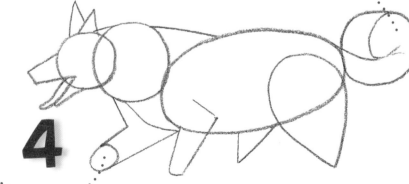

5 Finish off the legs and complete the face by adding an eye.

A sheepdog runs many miles in a working day. He keeps his feet low as he runs, to save energy, in a smooth, fast gallop.

6 Start to draw in more detail and give your outlines a soft edge to look like fur. The neck is quite long, strong, muscular and slightly arched.

This collie has a thick, weatherproof coat. Draw in fringes at the back of the legs, and make the tail bushy.

7 Add wavy lines to show where your sheepdog will have patches of black and white in his fur.

Most Border Collies are black and white. They are not supposed to have too much white on them – farmers used to believe that sheep would ignore a white dog, thinking it was just another sheep!

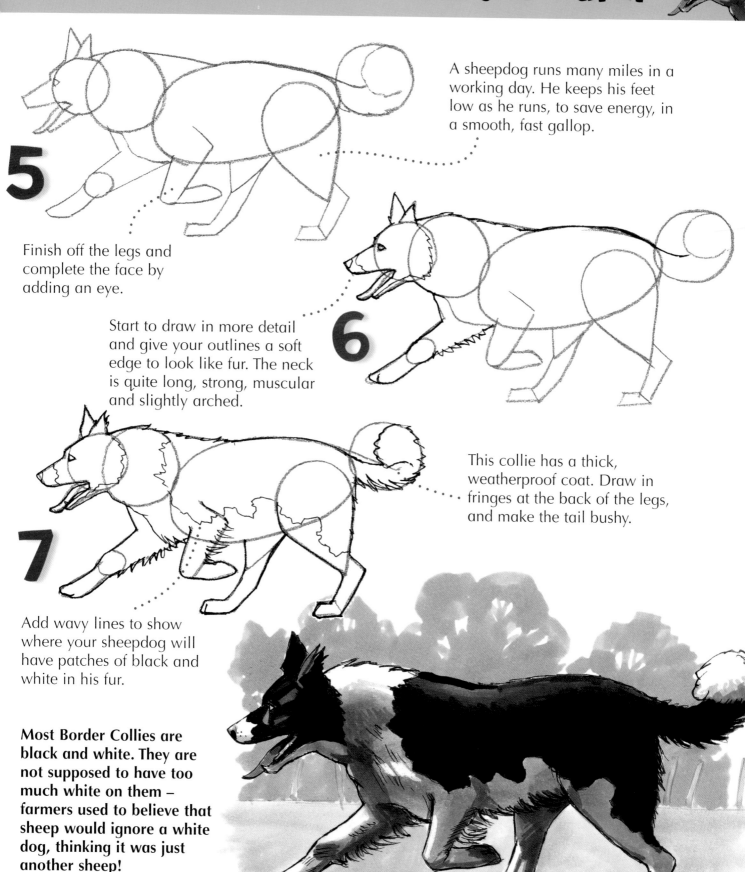

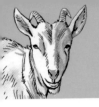

Goat

Goats used to be called 'the poor man's cow', because they can survive on less space and poorer grazing than cattle. But they are also harder work, because they like lots of attention. They produce less milk than cows, but it is valued by many people because it is more easily digested.

1 Start with these two shapes: a triangle and an oval.

A big oval for the body is drawn at a slanting angle, cutting through the smaller oval.

2

Goats have quite short tails. Draw it standing up like a flag.

3

Draw the top of the front leg first. This big four-sided shape is the basis for both hindlegs.

Goats are really much the same shape as sheep. It is only their coats that make them look so different.

4

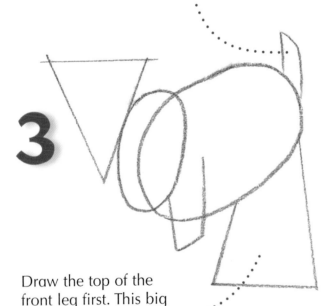

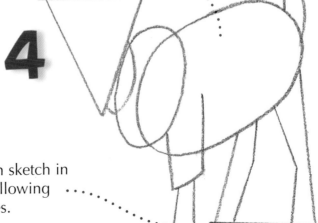

Now you can sketch in three legs, following the guidelines.

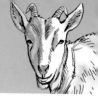

5

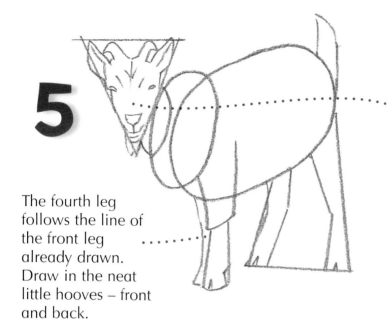

Draw the goat's head and face within the guide triangle. The small horns fit neatly between the larger ears.

The fourth leg follows the line of the front leg already drawn. Draw in the neat little hooves – front and back.

6

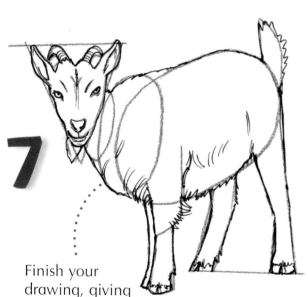

Goats are intelligent, curious creatures. Try to show this in the goat's expression as you add more detail to your drawing.

7

Finish your drawing, giving the coat a soft, shaggy texture.

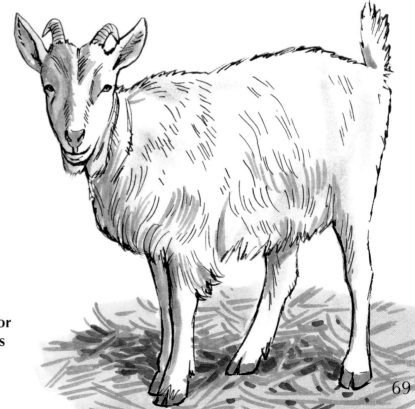

Goats may have been the first farm animals. Stone Age men kept them for meat and milk, and also used goatskins for making clothes, water bottles and even as the waterproof skins of their boats.

Ferrari F50

Supercars like this are more like racers than ordinary, passenger vehicles. This F50 is built with the same care as Ferrari's famous racing cars, with sleek, aggressive lines and a powerful engine.

1

Be careful to get these first shapes right.

2 Start to build up the front of the car. The powerful bonnet takes up much of the drawing.

Draw in arched shapes for the wheels.

3

This is a long, low car, so be careful not to make the roof too high.

Smooth, flowing curves reduce air resistance and increase speed.

Now add the spoiler on the back of the car.

4

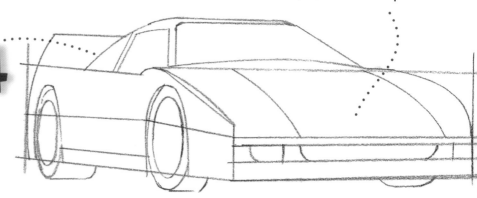

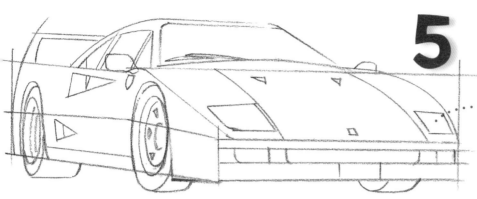

5

The headlamps are flush with the bonnet, so they do not break up its smooth lines.

The sloping windscreen has a single huge wiper.

6

This scoop directs air to cool the massive rear-mounted V12 engine.

The engine is housed behind the driver, above the rear wheels. This makes the car perfectly balanced.

7

Now you can ink in your outlines.

Speed limits on the roads mean few drivers will get the chance to try out this supercar's top speed of 325km/h.

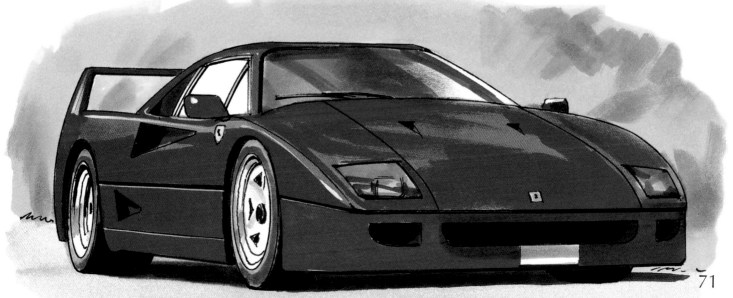

Excavator

A familiar vehicle on construction sites, the earthmover clears the ground of rubble and moves vast quantities of soil to enable foundation work to begin. A skilled operator sits in the central cab which pivots full circle on the sturdy 'caterpillar' tracks.

1

Begin your sketch with these three simple shapes

The front of the 'caterpillar' tracks appear wider as they are closer to us.

2

The bucket is mounted at the front end of the mechanical arm.

The large triangle will become the huge jointed metal arm of the vehicle.

3

The cab is positioned centrally over the two 'caterpillar' tracks.

4

The swivelling cab is set at a different angle from the earthmover base.

Start to form the bucket.

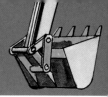

5

Carefully build up the drawing with more construction lines. Remember that everything about this vehicle is heavy and angular.

6

Begin to draw the outline in ink – use a ruler to help guide you.

Add detail to the 'caterpillar' tracks.

7

The figure of the driver in the cab can be left as a silhouette.

Each track is composed of horizontal treads – the vehicle moves just like an army tank.

Light and dark shades will give the impression of three-dimensional structures. Small details such as bolts and electrical cables along the arm will add to the realism.

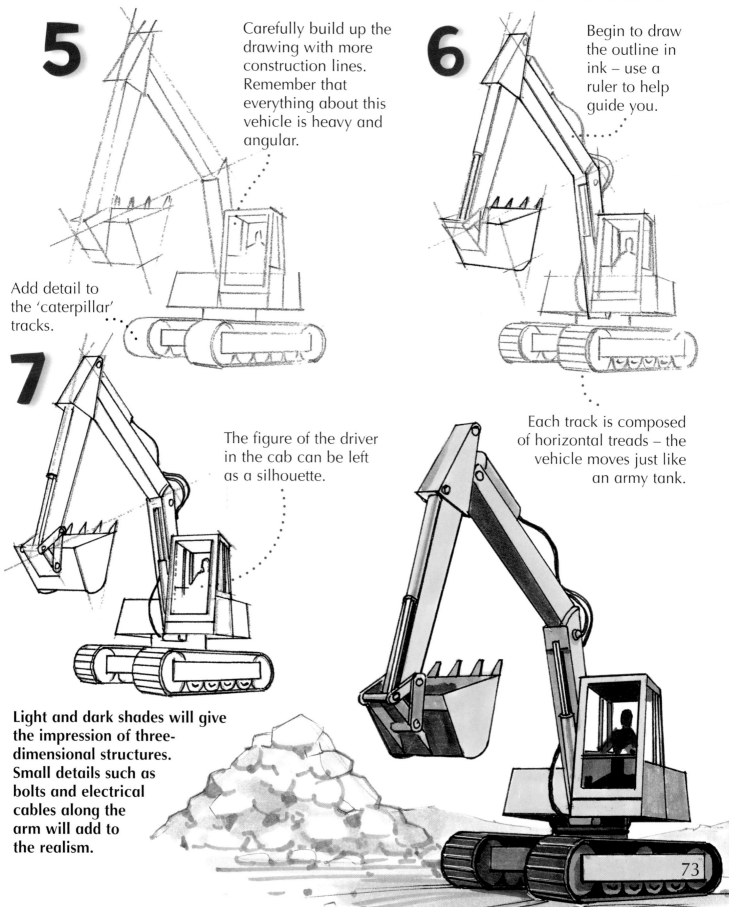

Mercedes-Benz Truck

Trucks carry nearly all the goods and materials we use. They are big, heavy vehicles, but modern trucks like this are still as streamlined as possible.

1 Start with this regular shape, and divide it into five bands. Be careful to make each band the right width!

2 At the top is the air deflector. It directs the airstream over the vehicle, so improving the aerodynamics of the truck.

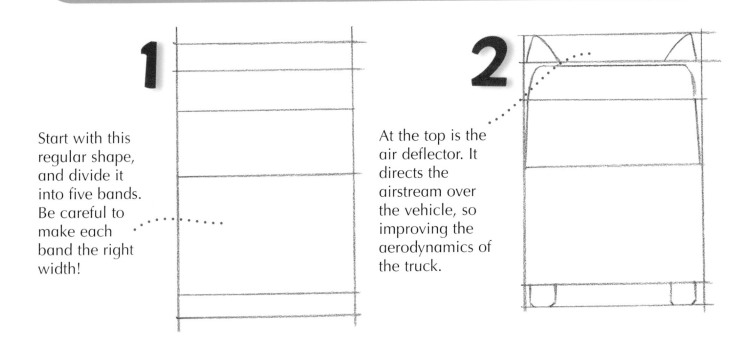

3 Round off the corners of the roof.

4 Add the big wing mirrors.

Start filling in the details of the lights and radiator.

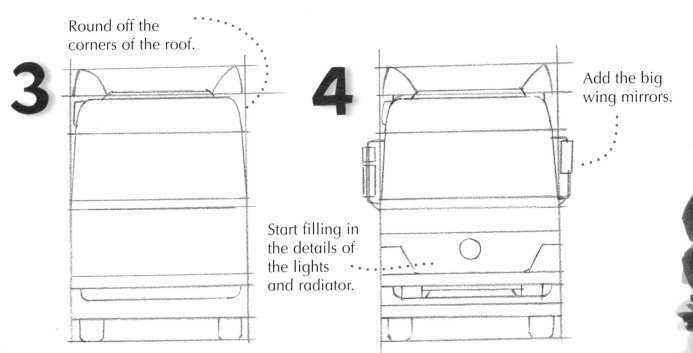

5

The Mercedes-Benz badge is a three-pointed 'rising star'.

6

Trucks like this are designed for long-distance driving. So the cab is also a little bedroom, complete with bunk, where the driver can sleep at night.

7

Now you can ink in your outlines.

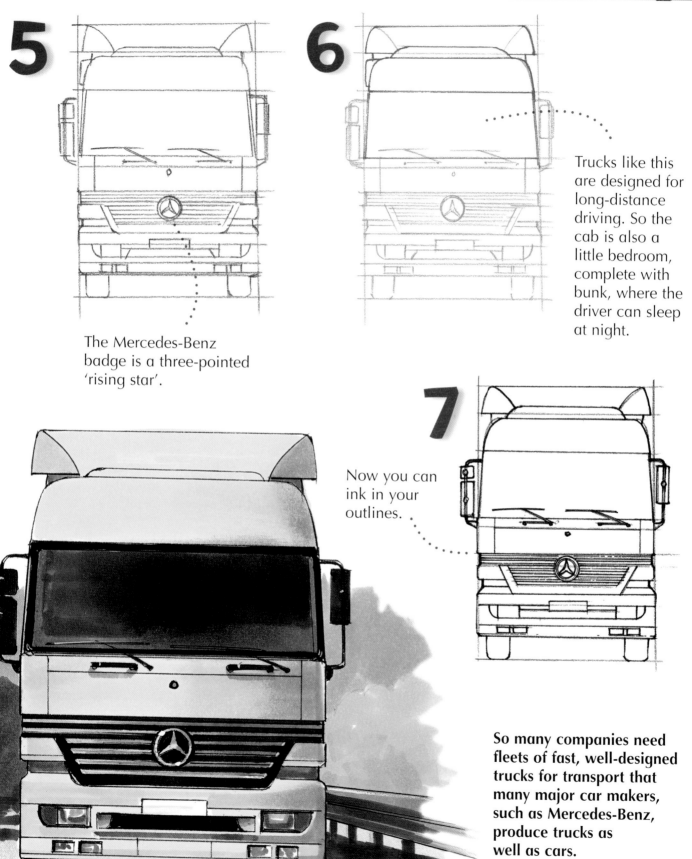

So many companies need fleets of fast, well-designed trucks for transport that many major car makers, such as Mercedes-Benz, produce trucks as well as cars.

Cadillac Coupe de Ville

Big luxury cars like this were popular in America in the 1950s. Made for maximum comfort in long-distance travel along America's highways, they looked wonderful, but used incredible amounts of fuel. When petrol became more expensive, they went out of fashion.

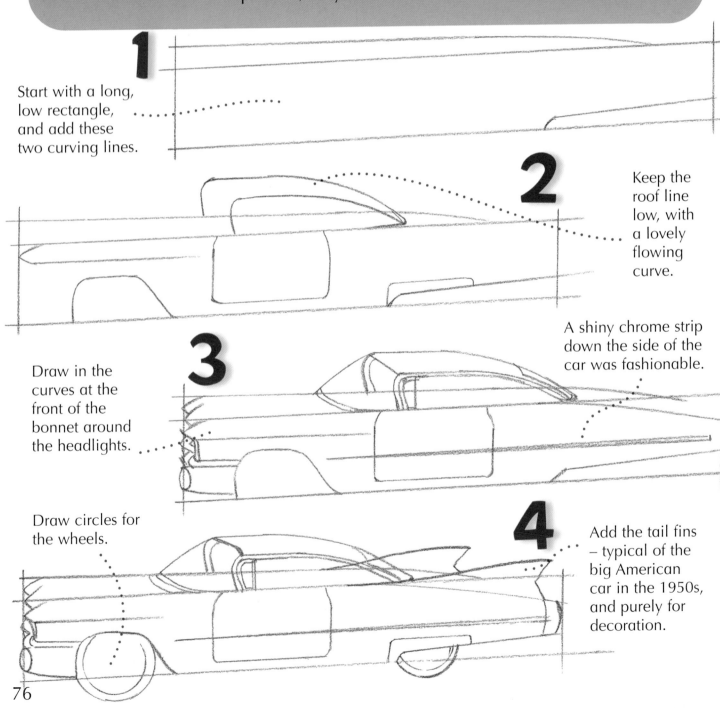

1

Start with a long, low rectangle, and add these two curving lines.

2

Keep the roof line low, with a lovely flowing curve.

A shiny chrome strip down the side of the car was fashionable.

3

Draw in the curves at the front of the bonnet around the headlights.

4

Draw circles for the wheels.

Add the tail fins – typical of the big American car in the 1950s, and purely for decoration.

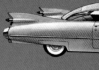

The large hubcaps carry the famous Cadillac badge.

5

The taillights are set into the fins, looking like little space-age torpedoes.

Only part of the seats and steering wheel can be seen from this angle.

6

The 'wrap-around' windscreen curves round to the sides of the car, adding to the sleek look.

The side window has no central pillar to break up the sweeping lines of the car.

7

This is a big car, nearly 6 metres long, and very heavy. It was for cars like this that power steering was invented.

The Coupe de Ville had all the luxury features of its time – from electric windows and reclining seats to power steering and braking.

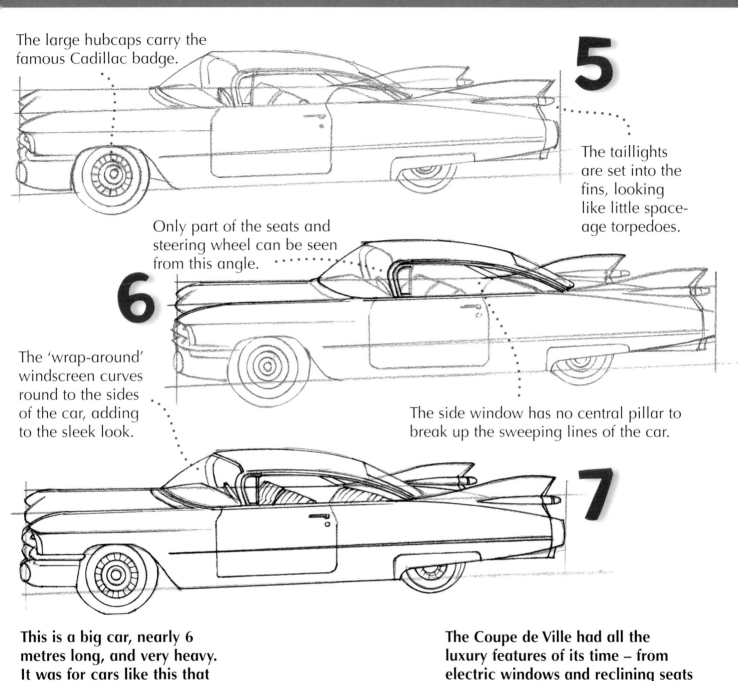

Transporter

This type of truck consists of two parts. The front part is a 'tractor unit' containing the engine and driver's cab. The back part is a flatbed trailer to carry the load. They are attached by an articulated joint. Different types of container can be fitted on to the flat base of the trailer.

1

Start with these simple box shapes.

Add more lines for the front of the truck. It looks complicated, but it is all made up of simple straight lines.

2

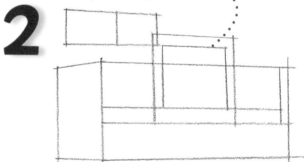

Start shaping the back of the tractor unit, and add the wheels. Now you can see where your drawing is going!

3

A big rig needs big headlights.

The long exhaust pipe is fitted with filters to clean the exhaust fumes before they are released.

Add the long, low trailer. The rear wheels look tiny because they are so far away.

4

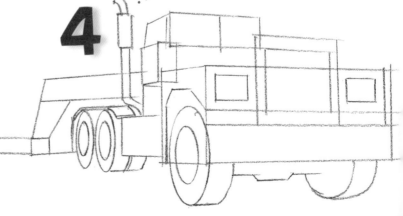

Various kinds of trailer can be fitted to the tractor unit. This is a low-loader, built very close to the ground, which is used to carry heavy loads.

5

Giant rigs like this drive long distances, so the driver's cab is built for comfort – and safety. A special dial on the dashboard, the tachograph, records speed, length of journey and how often the driver stops for a rest.

6

Curve the corners of the radiator grille.

The axle between the rear wheels of the tractor unit carries the massive weight of both the truck and its load.

7

Finish inking in your outline.

From this angle, this impressive transporter looks every inch the giant it is. It can carry loads that nothing else on the road can handle.

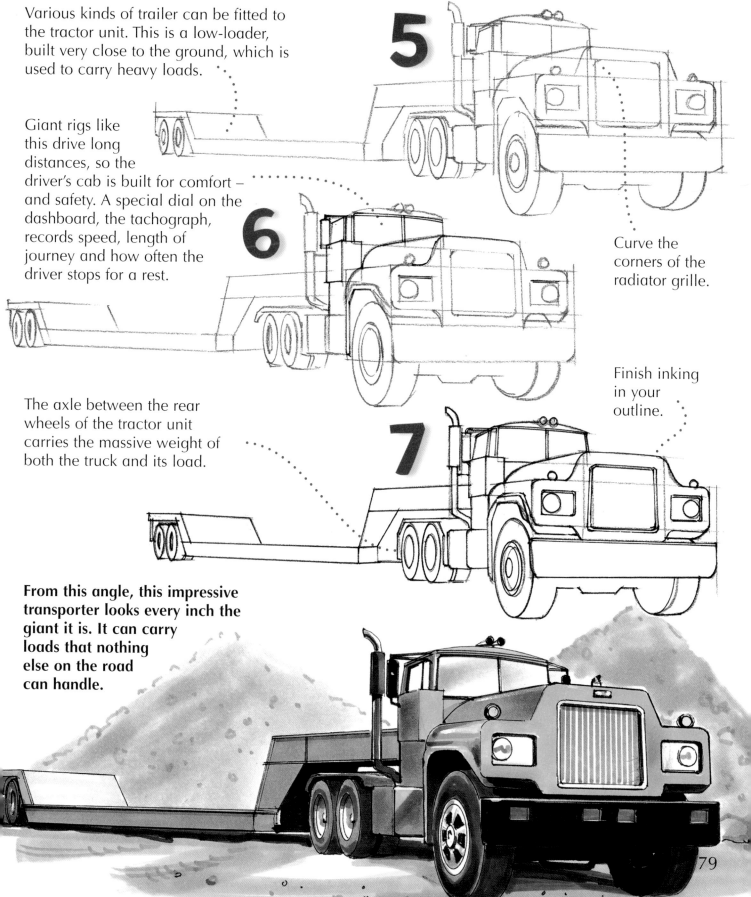

Classic Car (Rover 10)

A 'classic car' is a collector's item. They are often vintage (at least 50 years old) and were 'top of the range' models when they were new. You are more likely to see old cars like this at vintage car rallies than on the road.

1

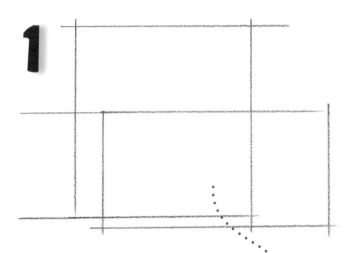

The drawing starts with straight lines. Begin with these two overlapping boxes.

Start adding detail to your two boxes with some more straight lines. Can you see shapes like the bumper and the windscreen beginning to emerge?

2

3

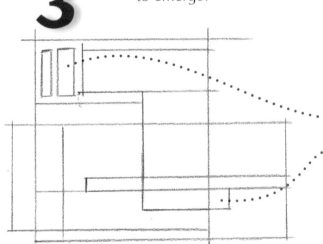

Yet more straight lines help to form details like rear windows and the front number-plate.

4

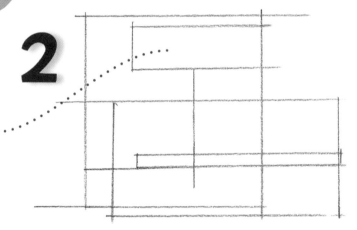

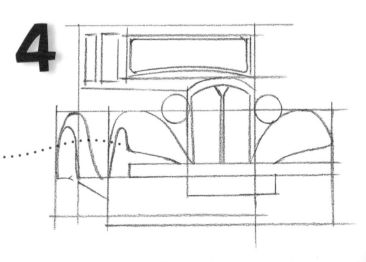

Now it's time for some curves at last! Your straight lines give guidance for the sweeping curves of the wheel arches and wings. Add more curves for the top of the radiator grille and the base of the windscreen.

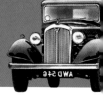

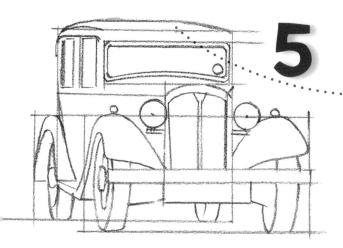

5

Adding the detail is quite easy, once the lines are in. Give a gentle curve to the roof, and start shaping the windows.

The small sidelights are set up on the wings, well away from the big, round headlights.

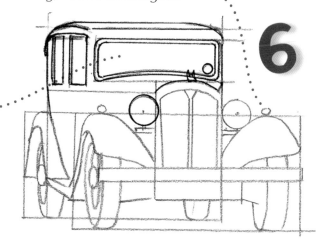

6

The windscreen is very narrow when you compare it with that of a modern car. With an equally narrow rear window, the driver had a much poorer view of the road than we expect today.

7

Ink in your outlines. Even with its curved wheel arches and wings, this is still very much a box-shaped car, designed long before anyone knew about streamlining.

When you see a classic car like this, you know it has probably taken months of loving work to restore it to working order. Not only the engine parts, but the bodywork, seats, and even the dashboard may have needed repairing or replacing.

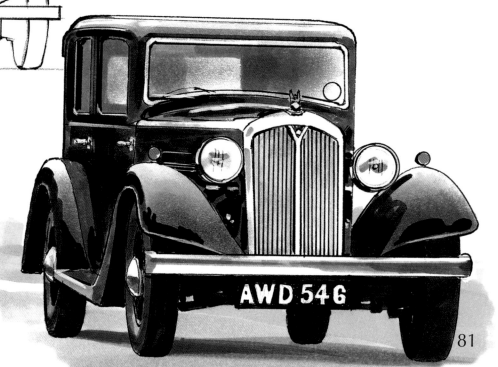

AWD 546

Digger

Tractors can be fitted out with all kinds of machinery for different jobs. They may carry a broad shovel-like blade, for a bulldozer, or a scoop, like this digger. The digger is used to excavate and clear piles of earth and rubble. You will see it on building sites and at road works.

Start with these two shapes – rather like a pram minus its wheels.

1

Four slanting lines form the foundation lines for the digging scoop at the front.

2

Now start filling in the cab, with its roof, door and window. The driver needs a good view in all directions when controlling a large, powerful machine like this.

3

This tractor moves on crawler tracks instead of wheels. The tracks loop around two large axles, marked by these circles.

Start filling in the details of the digging bucket, drawing in the huge bolts that hold the sections together.

4

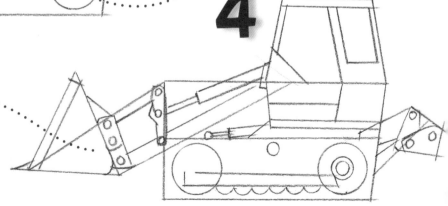

The driver can raise and lower the scoop using controls in his cab.

5

The back is fitted with giant 'claws', used to help flatten and spread the scoop's load when it is tipped out.

6

Link the two big wheels with a system of rods and a chain – like a giant bicycle chain. A motor turns the driving roller that powers the chain.

The 'arms' that move the scoop are activated by hydraulic rams, which provide the power needed.

7

Now you can draw in the caterpillar track – a huge, flexible belt that allows the tractor to move easily over bumpy ground.

Crawler tractors are ideal where ground is soft or uneven. The tracks help to spread the weight of the vehicle evenly and stop the soil getting compacted.

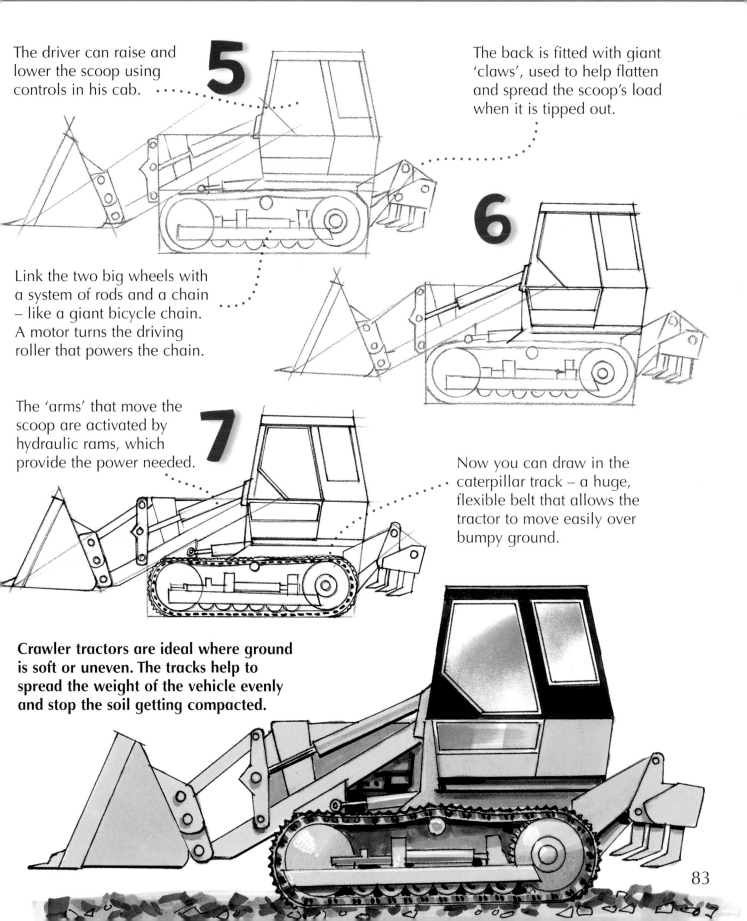

Trucks and Cars

Land Rover Defender

The Land Rover first appeared in 1948 as a tough 'workhorse' based on the army jeep. Made for rough ground, heavy loads and needing little maintenance, it proved ideal for farmers and the military. Later models included luxury versions like the Discovery and Range Rover.

Start with a long box, split up into sections.

Add the wheels. An upright rectangle on the back forms the spare tyre, stored here rather than underneath to leave plenty of ground clearance below for driving on uneven terrain.

Continue building up the shape with straight lines. Neither the front nor the back overhangs the wheels much, keeping the shape tidy and compact.

The windscreen is flat and slants backwards.

Draw the wheel arches, using straight lines, not curves. They are set quite high above the wheels.

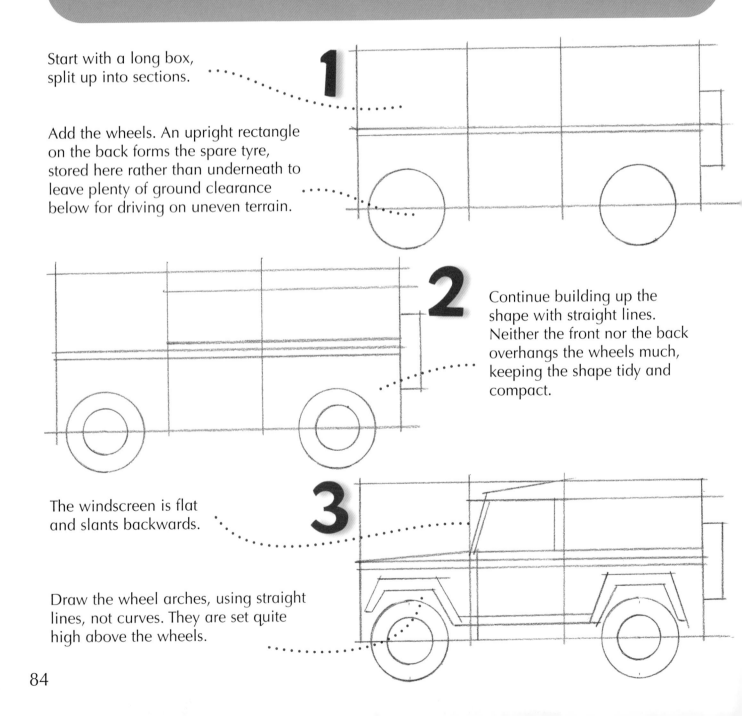

4 The outline is complete, so now fill in the details. You may see some variation in Defenders on the road: they come with five different body types and three wheelbases, designed for different needs.

Early Land Rovers were all light green – to use up a bulk buy of surplus green paint from the Royal Air Force!

The no-nonsense straight lines of the design are matched in practicality by rust-proof bodywork.

5

6 This model has a solid roof, but soft-top versions are available, with a canvas hood which can be unfastened to allow bulky loads to be fitted in easily.

The Defender is a lot more than just a farm truck. It has proved ideal for exploration, off-road events and rallies, and military use.

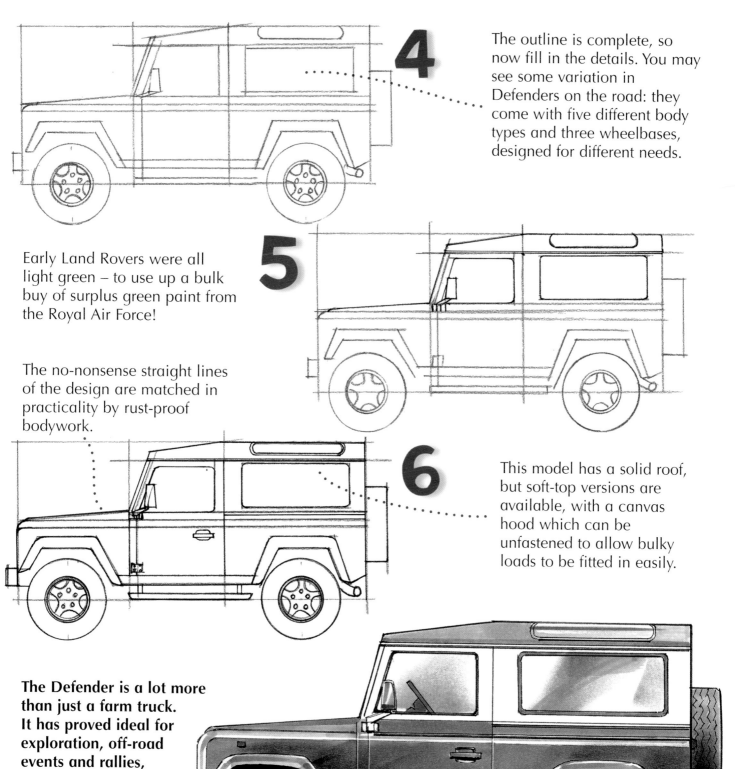

Fork Lift Truck

This is a handy little workhorse used to transport heavy loads short distances on site. It can carry bricks on a building site, or move pallets from a delivery lorry into a warehouse. It is small enough to carry its load into a building and deliver it directly to the storage bays.

1

These three simple shapes form the main part of this little vehicle.

This upright piece stops the load tipping backwards on to the driver.

2

The engine is positioned at the rear, so the body sticks out behind.

Add arms and legs, curve the shoulders, and suddenly we have quite a convincing driver. The shape in front of him houses the steering column, with the steering wheel under his hands.

3

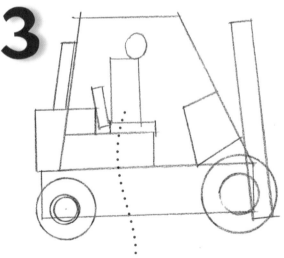

Draw in a simple seat and start on the driver. An oblong and a circle don't look much like a human being – yet. But soon they will!

This long tube is the exhaust pipe, placed here to direct fumes away from the driver.

4

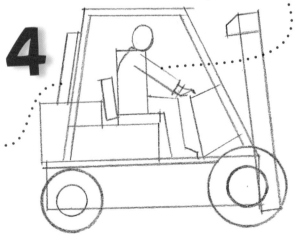

5

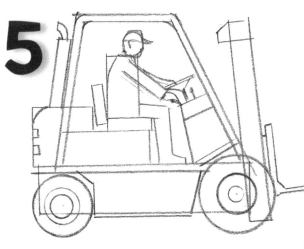

Now add the important bit: the lifting arms. They are quite thin so that the driver can slide them underneath a load. But they are also strong enough to support heavy weights.

Now you can start inking in your final lines. The shapes are very regular so make sure your angles are right.

The driver's seat fits neatly on top of the engine casing. This is a very basic vehicle, covering only short distances, so it does not need a luxury interior.

6

7

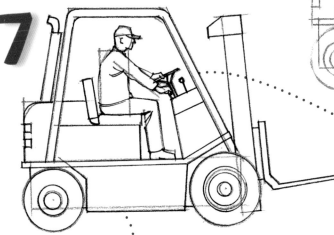

Finish inking in your outlines. Because the sides are open, to give the driver a good all-round view, you can see right inside the cab and draw more detail inside than you can for other vehicles.

The base is low to the ground, to cut down any risk of the truck tipping over. Since it is not used on rough ground, it does not need high ground clearance.

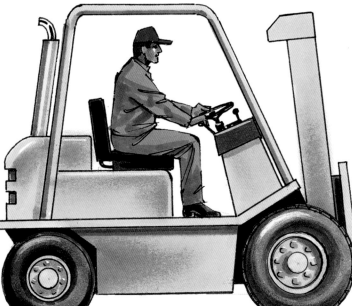

If big trucks are the workhorses of industry, this is the donkey – small, but strong and very useful. Factories and warehouses depend on it to move heavy loads about.

Tractor

Tractors were invented in the late 19th century to do the work of farm-horses, pulling ploughs and other farm machinery.

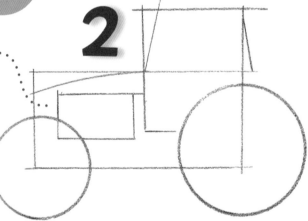

1

The tractor's shape is simple – two box shapes plus wheels.

2

Shape the bonnet with a curving line. It slopes downward so that it does not block the driver's view.

Now add a slant to the front and back of the cab. Early tractors had no cab, just an open seat at the back where the driver was exposed to all weathers.

The back wheels are big, to get a good grip on muddy ground. Draw in the curved mudguard that protects the back of the cab from mud splashes.

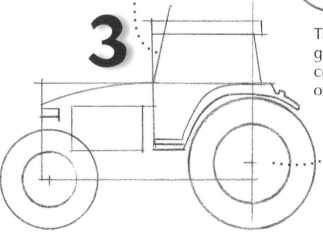

3

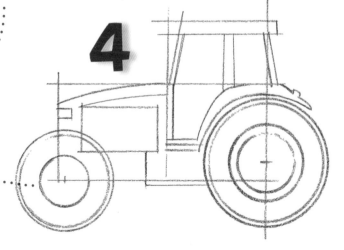

4

The front wheels are smaller, to make steering easier. Some tractors have caterpillar tracks instead of wheels, to cope with extra-rough ground.

Start putting in details like the steering wheel and the grille on the side of the engine cover.

5

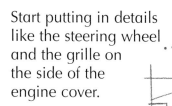

Draw in the deep tread patterns on the tyres, which help to give a grip on muddy ground. The tyres themselves are extra thick, to help stop the tractor from tipping over on sloping ground.

The exhaust pipe is at the front, directing the fumes away from the driver and from anyone behind the tractor.

6

Large windows to the side and rear allow the driver to see exactly what his equipment is doing. The glass may be tinted to protect him from glare.

7

The height of the axles means that the driver needs a set of steps to climb up to his seat.

Tractors can pull, push or lift heavy loads. In fact, modern tractors are so powerful they are often designed to push one piece of equipment while pulling another at the same time.

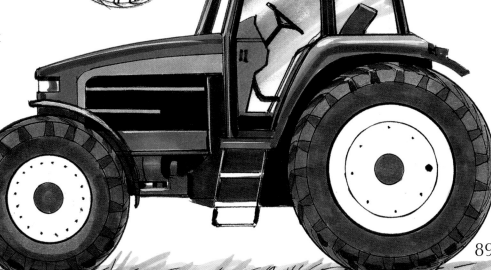

Jaguar XJS

Most cars are designed in a practical way, for reliability, space, comfort and fuel economy. Sports cars like this Jaguar are designed for enjoyment. They put speed, power and good looks first. The XJS first appeared in 1975. It had a big V12 engine and could reach 245km/h.

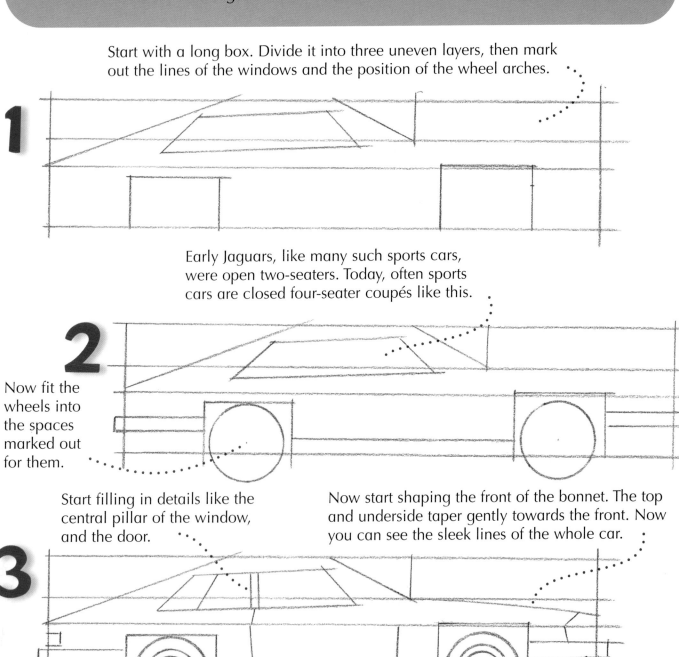

Start with a long box. Divide it into three uneven layers, then mark out the lines of the windows and the position of the wheel arches.

1

Early Jaguars, like many such sports cars, were open two-seaters. Today, often sports cars are closed four-seater coupés like this.

2

Now fit the wheels into the spaces marked out for them.

Start filling in details like the central pillar of the window, and the door.

Now start shaping the front of the bonnet. The top and underside taper gently towards the front. Now you can see the sleek lines of the whole car.

3

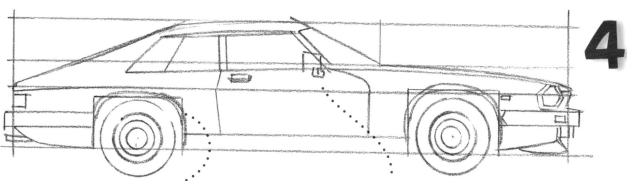

4

Draw in the wheel arches, which flare out slightly from the body.

Now you can add the smaller details – the door handle, wing mirror, and head- and tail lights. Note the unusual shape of the headlights.

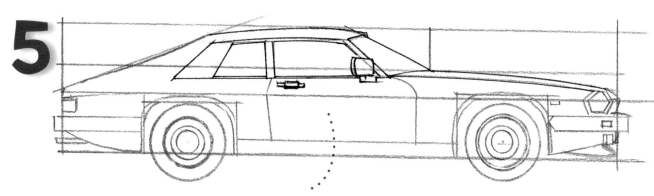

5

This is a luxury car, with a smooth, powerful engine and electronic seats. It is just as finely finished inside, with hand-sewn leather seats.

6

For safety reasons, Jaguars no longer bear the famous 'big cat' mascot on the bonnet, which might cause injuries in an accident.

The powerful engine means this car can reach a speed of 160km/h in just 16 seconds.

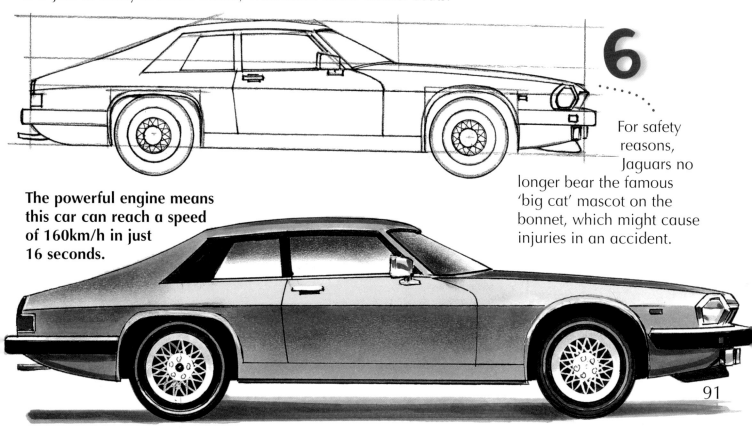

91

American Truck

Huge articulated trucks travel America's highways. These 'big rigs' are part of the American legend and, along with their drivers, are the heroes of many road movies.

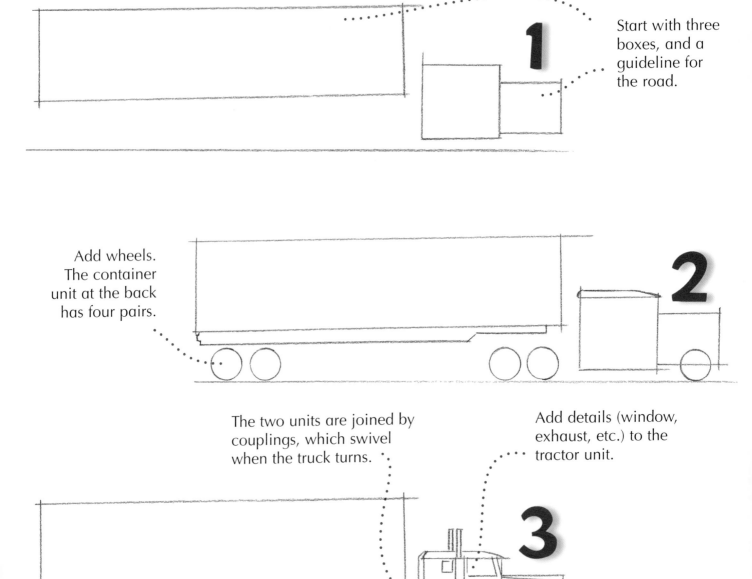

1 Start with three boxes, and a guideline for the road.

2 Add wheels. The container unit at the back has four pairs.

3 The two units are joined by couplings, which swivel when the truck turns.

Add details (window, exhaust, etc.) to the tractor unit.

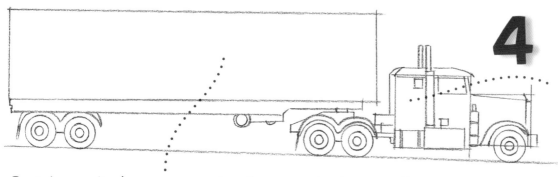

4

A separate sleeping cabin is set behind the driver's cab.

Container units, known as semi-trailers, vary in shape. Different kinds are designed to carry liquids, cars, refrigerated goods, etc.

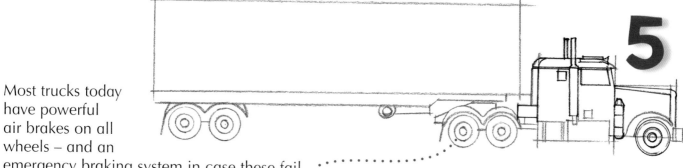

5

Most trucks today have powerful air brakes on all wheels – and an emergency braking system in case these fail. Brakes are vital with such heavy vehicles.

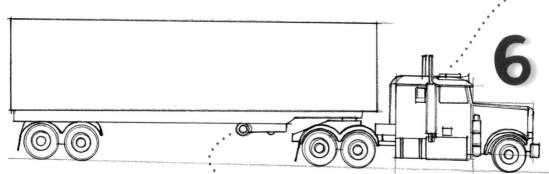

6

Radio antennae allow long-distance drivers to report to base or keep in touch with each other on the road.

Fold-away parking wheels are lowered to support the trailer when it is uncoupled from the tractor unit.

Tractor-and-trailer outfits like this date back to the mid-1900s. But there have been many improvements since then!

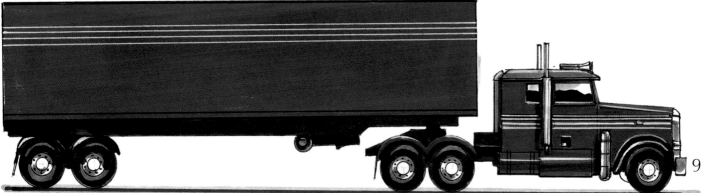

Trucks and Cars

Dumper Truck

The dumper works at building sites, mines and quarries. It carries heavy loads of rock, earth and rubble. When it is time to unload, the body of the truck tips backwards to dump this material wherever it is wanted.

1

This truck is quite a simple shape. Start off with these two rectangles and a triangle joining them.

2

Now add the cab and shape the front of the vehicle.

The enormous wheels stand higher than a man, and take up half the height of the truck.

3

The tipper is a giant, shallow, open-topped box. It is tipped up by two hydraulic rams, which the driver can only operate when the engine is stopped.

4

These huge wheels are designed to support heavy weights, and to travel over very rough ground. The tyres have deep treads to help get a grip on soft sand or sticky mud.

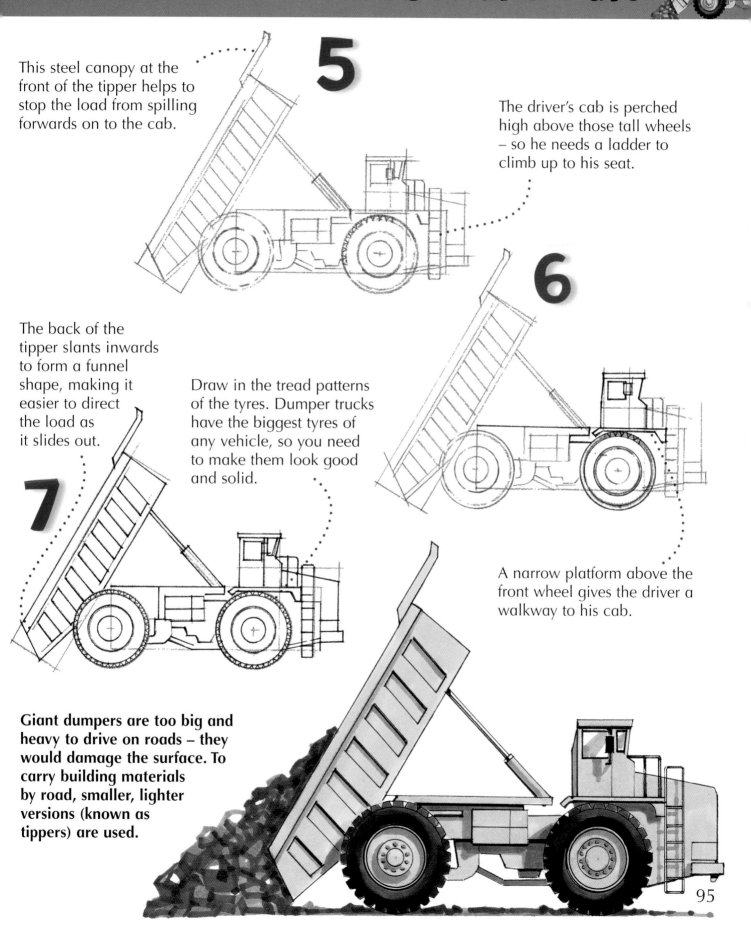

5

This steel canopy at the front of the tipper helps to stop the load from spilling forwards on to the cab.

The driver's cab is perched high above those tall wheels – so he needs a ladder to climb up to his seat.

6

The back of the tipper slants inwards to form a funnel shape, making it easier to direct the load as it slides out.

Draw in the tread patterns of the tyres. Dumper trucks have the biggest tyres of any vehicle, so you need to make them look good and solid.

7

A narrow platform above the front wheel gives the driver a walkway to his cab.

Giant dumpers are too big and heavy to drive on roads – they would damage the surface. To carry building materials by road, smaller, lighter versions (known as tippers) are used.

95

Tiger

The tiger is a large and powerful predator which usually hunts by stealth at night. It feeds mainly on wild oxen and buffalo which it kills with a bite to the back of the neck or the throat. Tigers are found in south and south-east Asia.

Start with these three simple shapes. Pay attention to their sizes and the space between them.

1

Add the flowing shape of the body, the curved tail and the outstretched foreleg.

2

Start to draw in the rear legs.

Add this shape for the tiger's snout.

3

The tail trails out behind the tiger.

This leg is centred under the shoulder. It is about as long as the body is deep.

The front leg is strong and powerful at the shoulder, which is represented by the centre circle.

4

All of the tiger's weight is on one foreleg. Draw the two back legs in this way. They appear smaller as they are further away from us.

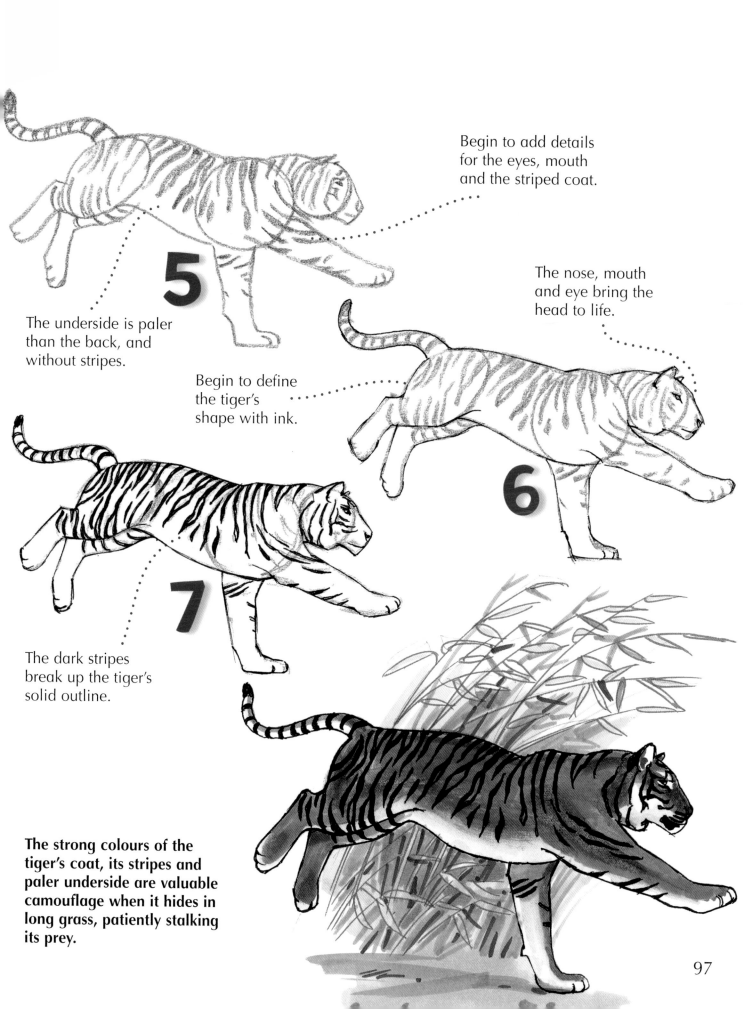

Begin to add details
for the eyes, mouth
and the striped coat.

5

The underside is paler
than the back, and
without stripes.

Begin to define
the tiger's
shape with ink.

The nose, mouth
and eye bring the
head to life.

6

7

The dark stripes
break up the tiger's
solid outline.

The strong colours of the
tiger's coat, its stripes and
paler underside are valuable
camouflage when it hides in
long grass, patiently stalking
its prey.

White Rhino

The rhino is a vegetarian – but it is also one of Africa's most dangerous animals. It is built like a tank, and armed with sharp horns. A charging rhino can knock an elephant down! The White Rhino is less aggressive than its cousin, the Black Rhino, and is normally gentle unless disturbed.

1

Start with an egg shape for the body, and add a thick, slanted column for the head.

2

Two ovals mark out the sites of the horns. Both African rhinos, White and Black, have two horns: Indian Rhinos have only one.

Overlay the 'egg' with a curve to shape the small hump of fat behind the heavy shoulders.

3

These ovals form the top sections of the massive legs.

Complete the horns – which are made of hairy fibres packed tightly together.

4

Now complete the legs with columns, growing wider at the base for the large feet.

The long ears can turn to face the direction of any sound.

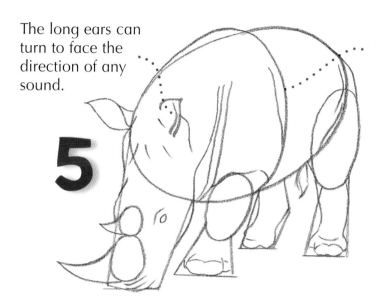

5

Draw the folds in the heavy skin. A rhino's skin is like armour-plating, about 2.5cm thick, so without any folds it wouldn't be able to move!

This is a massive animal, so every part of your drawing needs to be solid and strong.

6

The wide, square mouth is shaped to graze on short grass.

Keep the eye small. Rhinos are short-sighted, relying largely on the senses of hearing and smell.

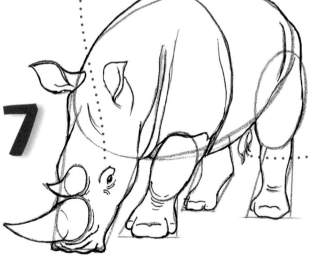

7

The tail ends in a tassel, like an old-fashioned bell rope.

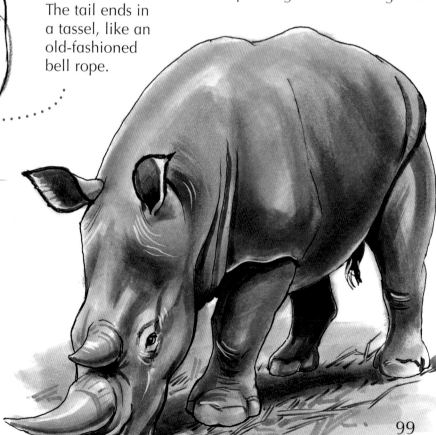

The first thing you notice about the White Rhino is that it isn't white! Like its cousin the Black Rhino, it is grey. The name 'white' probably comes from 'wide', referring to the broad mouth.

Scarlet Macaw

Macaws are the biggest and brightest-coloured members of the parrot family. They live in the tropical rainforests of Central and South America. They are superb fliers, and equally good at climbing through the trees where they live.

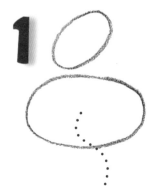

1 Start with these two egg shapes, for the head and the top of the body.

2 This shape forms the wing, folded to cover most of the body.

A macaw is perfectly adapted for life among the trees. Its feet are as good as hands for gripping branches. So is its beak – which, at mealtimes, doubles up as the perfect nutcracker.

3 Now add a long pillar, the same length as the head, body and wing combined. It may not look much like a tail yet, but it will!

Join the head to the body with a strong, supple neck.

4 Add a short, strong leg. Macaws don't hop, like many birds, but walk – with a waddling stride because their legs are so short.

Draw the tip of the second wing, peeping out from under the first.

5

The eyes are set on the side of the head, giving all-round vision.

The huge, hooked upper beak curves downwards to fit over the smaller lower beak. This tool can hack through the hardest seed-cases.

6

The feet have two toes pointing forwards, and two backwards, for a firm grip.

7

Draw the feathers overlapping each other neatly in a regular pattern.

A macaw's bright feathers are not just for decoration! In the wild, splashes of brilliant colour actually disappear among leaves and flowers. They help to break up the bird's outline, making it harder for hawks to target their prey.

Birds have several thousand feathers, but you only need to draw in the main ones of the wings and tail.

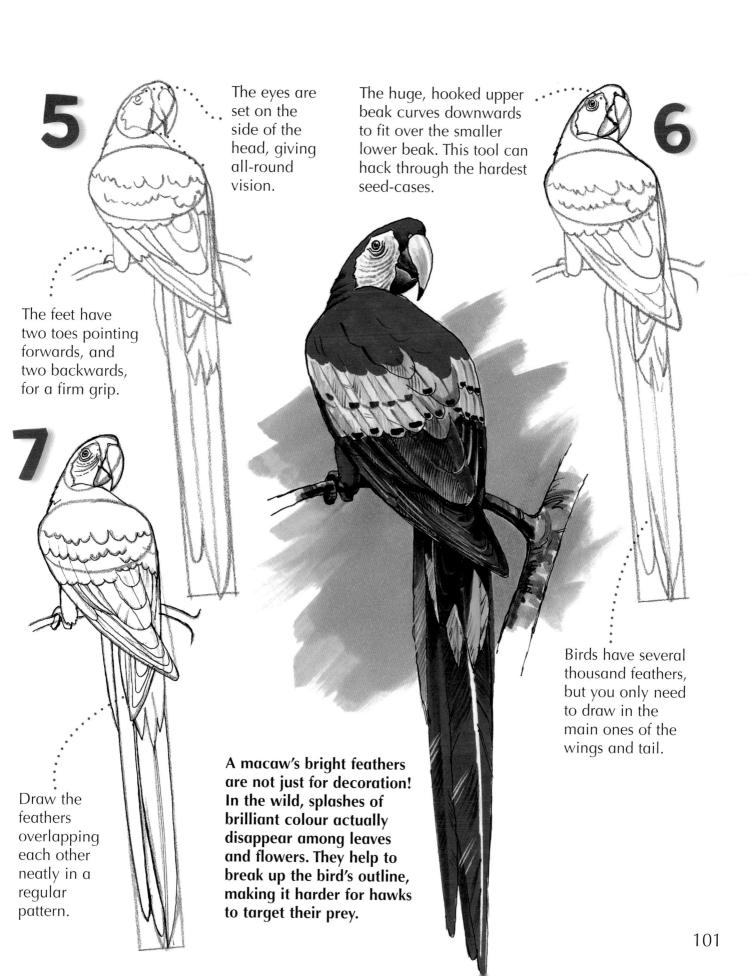

Crocodile

Crocodiles belong to an ancient family, dating back to the time of the dinosaurs. They live mostly in tropical rivers and lakes and are beautifully adapted to a life in the water, although they also like to bask in the sun on shore.

1

Start with these two simple egg-like shapes for the head and body.

Now add the long, thick tail. This is a useful weapon to stun prey, as well as a swimming aid.

2

Lengthen the head with a long snout, making the head and snout together the same length as the body.

This oval forms the top section of the front leg. It is set upright at the shoulder.

Draw an oval, slanted at an angle, for the upper hindleg.

3

Two more shapes form the hindleg and foot.

Now sketch in the foreleg. The legs are short and quite weak. They are used to crawl on land, and are folded close to the body when the crocodile swims.

4

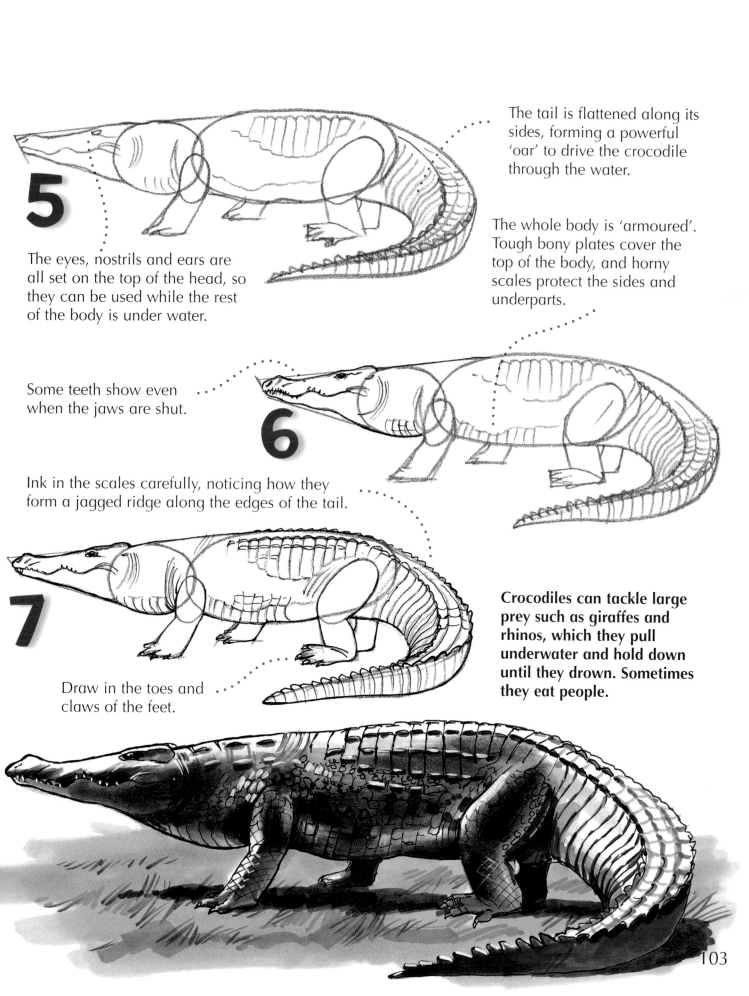

5

The eyes, nostrils and ears are all set on the top of the head, so they can be used while the rest of the body is under water.

The tail is flattened along its sides, forming a powerful 'oar' to drive the crocodile through the water.

The whole body is 'armoured'. Tough bony plates cover the top of the body, and horny scales protect the sides and underparts.

Some teeth show even when the jaws are shut.

6

Ink in the scales carefully, noticing how they form a jagged ridge along the edges of the tail.

7

Draw in the toes and claws of the feet.

Crocodiles can tackle large prey such as giraffes and rhinos, which they pull underwater and hold down until they drown. Sometimes they eat people.

103

Three-toed Sloth

The Three-toed Sloth, from South America, spends most of its life in the trees, where it feeds on leaves. Its legs are designed for hanging from branches, not for walking. On the ground, it is probably the slowest mammal in the world, taking a whole minute to crawl just two metres.

1

Draw these two ovals for the head and body, keeping a good space between them.

2

Join up these two shapes with gently curving lines to form a strong neck, as thick as the small round head. This lets the sloth turn its head almost all the way round.

This circle marks the top of the hindleg.

Sketch in a branch for your sloth to hold on to.

3

Now draw the other arm, stretched out to hold the branch. A sloth's arms are unusually long, and very strong.

Draw this solid, block-like shape for the thick foreleg.

4

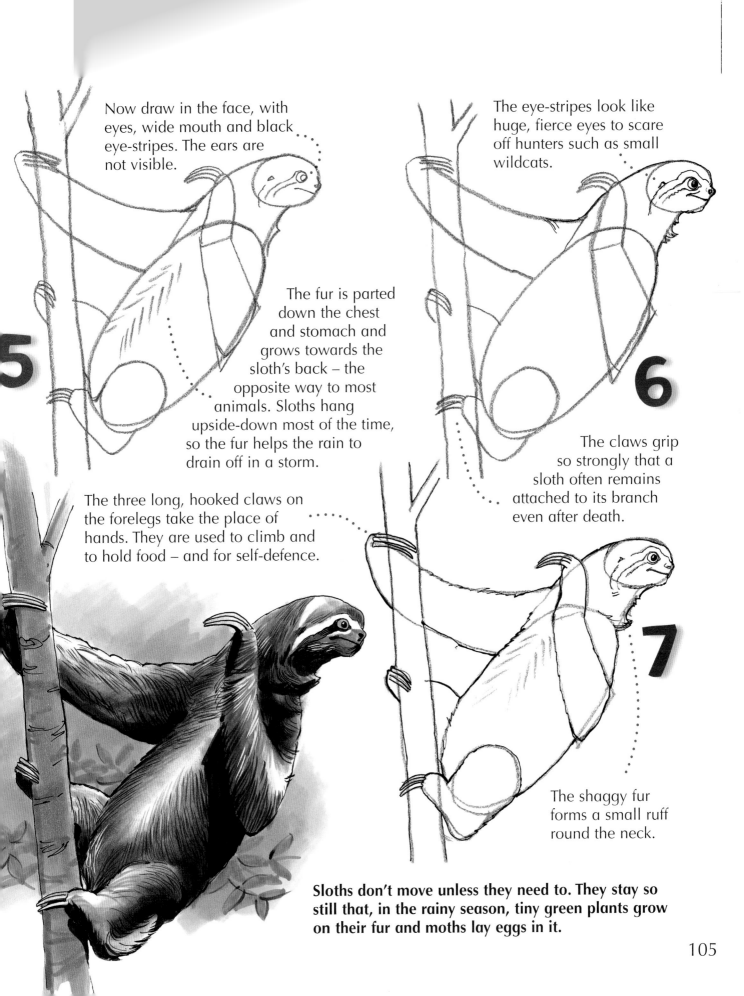

Now draw in the face, with eyes, wide mouth and black eye-stripes. The ears are not visible.

5

The fur is parted down the chest and stomach and grows towards the sloth's back – the opposite way to most animals. Sloths hang upside-down most of the time, so the fur helps the rain to drain off in a storm.

The three long, hooked claws on the forelegs take the place of hands. They are used to climb and to hold food – and for self-defence.

The eye-stripes look like huge, fierce eyes to scare off hunters such as small wildcats.

6

The claws grip so strongly that a sloth often remains attached to its branch even after death.

7

The shaggy fur forms a small ruff round the neck.

Sloths don't move unless they need to. They stay so still that, in the rainy season, tiny green plants grow on their fur and moths lay eggs in it.

105

Gorilla

Gorillas are the biggest and heaviest of the apes. In the forests of tropical Africa, they live in family groups headed by big males, who develop silver backs with age. These gentle giants feed on leaves and shoots, but are too heavy to climb trees.

1 Start with a big oval for the head, and add a second, smaller oval beside it.

2 Now draw a third oval. Most of this drawing is made up of these shapes. This helps to give the impression of great masses of muscle.

3

Another oval, as big as the head, forms the muscular hindquarters.

Add a fourth oval, a little way below your first group. This will become an arm.

Now you can start joining up your pattern of ovals, keeping your lines smooth.

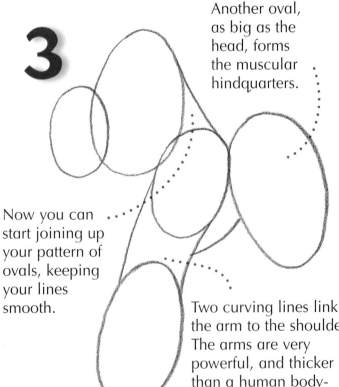

Two curving lines link the arm to the shoulder. The arms are very powerful, and thicker than a human body-builder's.

When you add the other, massive foreleg, suddenly the gorilla starts to take shape.

4

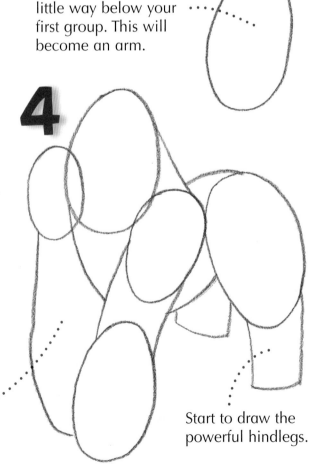

Start to draw the powerful hindlegs.

Now sketch in the face. Start in the centre, with the flattened nose, to help you to space the features. Note that the huge domed forehead takes up nearly half the space.

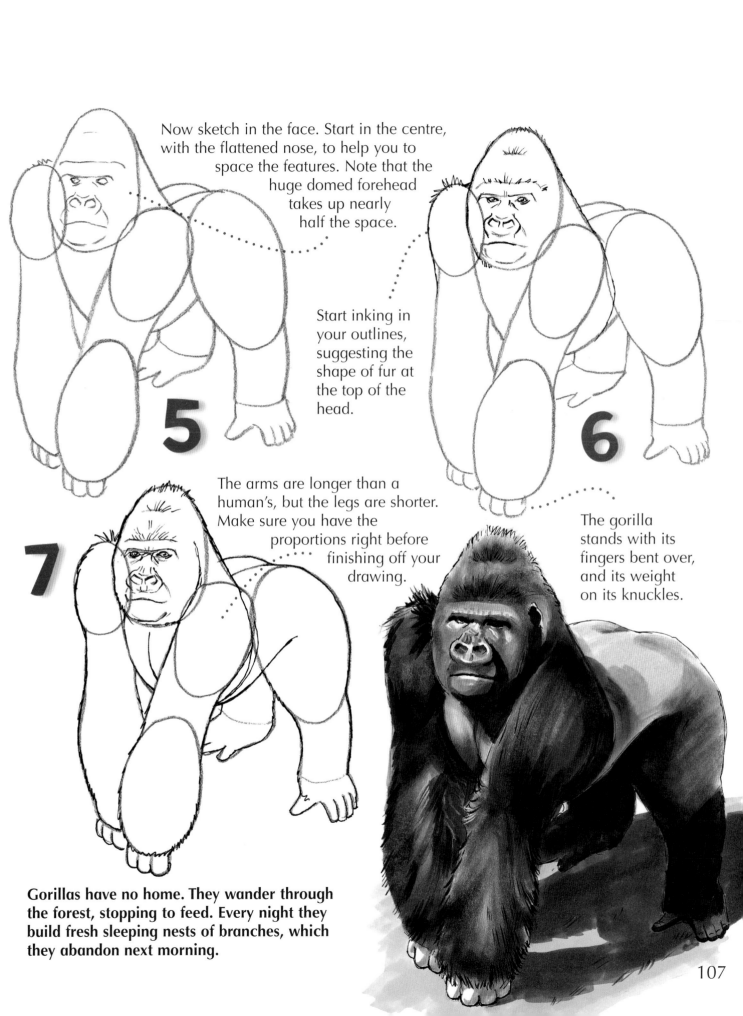

5

Start inking in your outlines, suggesting the shape of fur at the top of the head.

6

7

The arms are longer than a human's, but the legs are shorter. Make sure you have the proportions right before finishing off your drawing.

The gorilla stands with its fingers bent over, and its weight on its knuckles.

Gorillas have no home. They wander through the forest, stopping to feed. Every night they build fresh sleeping nests of branches, which they abandon next morning.

Ostrich

The world's biggest bird, the Ostrich, cannot fly at all. But it is a champion runner – faster than a racehorse. It lives on the open plains of Africa, where it keeps company with herds of grazing animals. It feeds mainly on plants, but it will eat almost anything.

1 Start with these two ovals – not the head and body, as you might think, but the body and tail.

2 A much smaller circle forms the head. Check the distance from the body, leaving room for the long neck.

This oval forms the massive thigh, whose huge muscles power the Ostrich's long strides.

A narrower triangle forms guidelines for the front leg. The legs are flung wide apart as the bird takes enormous strides.

3 A long, snaky neck connects the head to the body. It is strong and muscular, allowing the head to dart out and snatch food with surprising speed.

This triangle forms the guidelines for a leg. Check your angles carefully.

Use your triangle guidelines to fill in the outlines of the strong legs, which end in large feet.

4

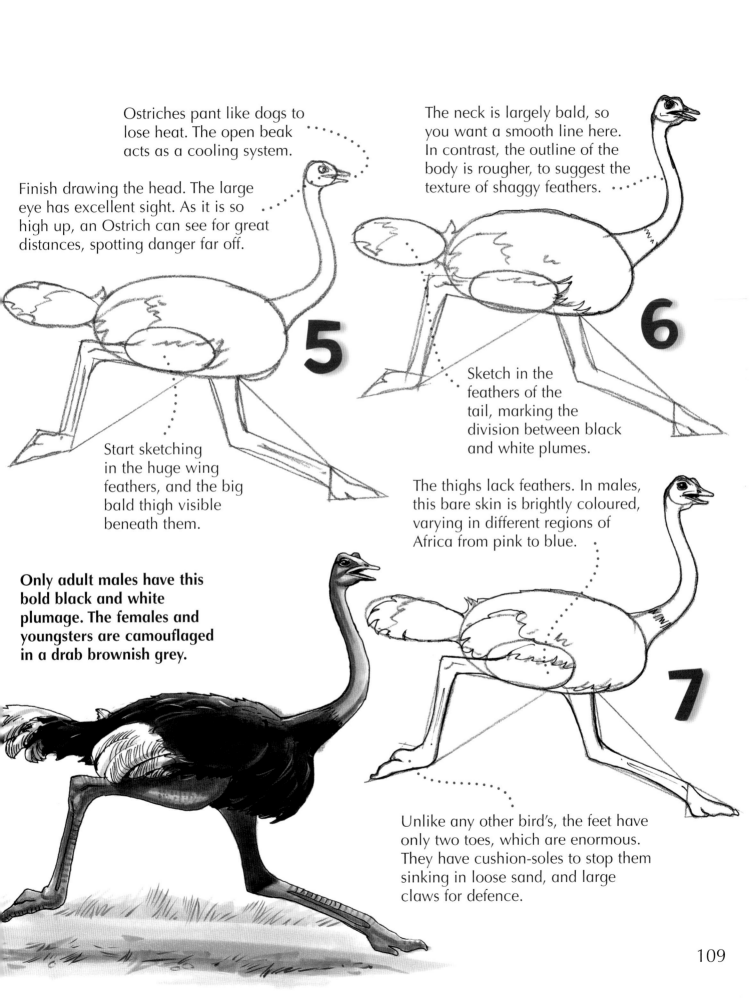

Ostriches pant like dogs to lose heat. The open beak acts as a cooling system.

Finish drawing the head. The large eye has excellent sight. As it is so high up, an Ostrich can see for great distances, spotting danger far off.

The neck is largely bald, so you want a smooth line here. In contrast, the outline of the body is rougher, to suggest the texture of shaggy feathers.

5

Start sketching in the huge wing feathers, and the big bald thigh visible beneath them.

6

Sketch in the feathers of the tail, marking the division between black and white plumes.

The thighs lack feathers. In males, this bare skin is brightly coloured, varying in different regions of Africa from pink to blue.

Only adult males have this bold black and white plumage. The females and youngsters are camouflaged in a drab brownish grey.

7

Unlike any other bird's, the feet have only two toes, which are enormous. They have cushion-soles to stop them sinking in loose sand, and large claws for defence.

109

Meerkat

This little mongoose is found in the grasslands and deserts of southern Africa. It lives in large family groups, which work together to keep family members fed and safe. Males take turns at sentry duty. Standing upright on a tree or rock, they watch for danger.

1

Copy this shape carefully. It forms guidelines for the upright body, all four legs and even the branch on which the Meerkat sentry perches.

This shape – like an egg flattened at the top – forms the long, narrow head with its pointed snout.

2

Now add a neck, and draw a long sausage-shape for the body. Make sure this runs down the outline at the back, but leave a gap at the front and a larger one at the base.

3

Draw the first foreleg, hanging down. It is shaped very much like a human arm, with dangling hands.

This small shape will form the top of a hindleg. The legs are strong enough for the Meerkat to stand up erect for long periods.

Now follow the front edge of your guideline to mark out the far shoulder and second foreleg.

4

Two bold curving lines form the second hind leg. Finish it off with a long foot.

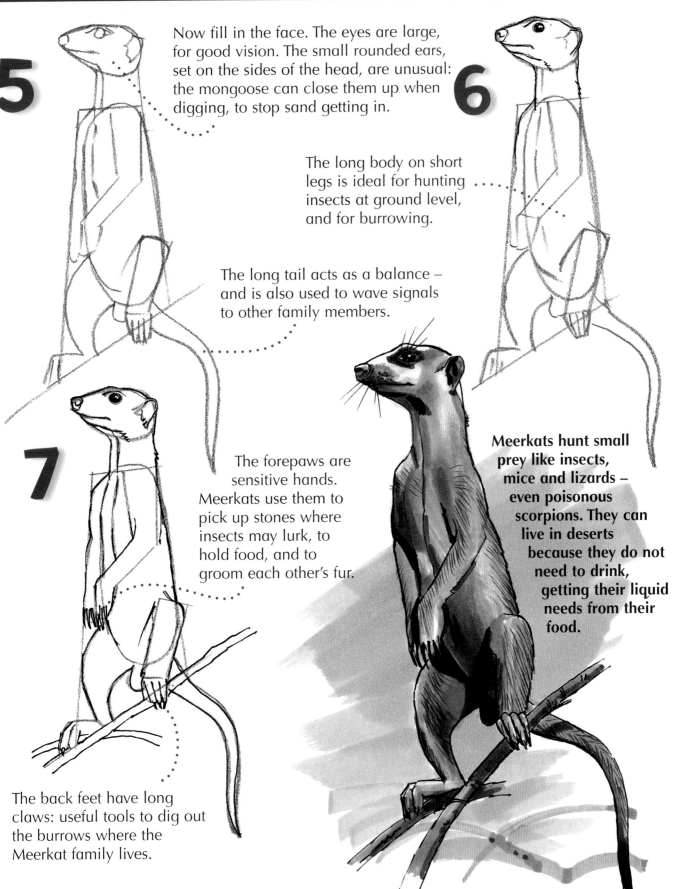

5

Now fill in the face. The eyes are large, for good vision. The small rounded ears, set on the sides of the head, are unusual: the mongoose can close them up when digging, to stop sand getting in.

6

The long body on short legs is ideal for hunting insects at ground level, and for burrowing.

The long tail acts as a balance – and is also used to wave signals to other family members.

7

The forepaws are sensitive hands. Meerkats use them to pick up stones where insects may lurk, to hold food, and to groom each other's fur.

Meerkats hunt small prey like insects, mice and lizards – even poisonous scorpions. They can live in deserts because they do not need to drink, getting their liquid needs from their food.

The back feet have long claws: useful tools to dig out the burrows where the Meerkat family lives.

Lion

This big, handsome cat is nicknamed 'King of Beasts' because he looks so noble. But really he is a lazy creature who lets his female lionesses do the hunting. Lions are the only cats to live in large family groups, called prides. They are found only in Africa, and in the Gir Forest of India.

1 A huge egg-shape forms the head and mane. Add a smaller, long oval for the hindquarters, and link up your two shapes.

2 Now draw the smaller shape of the face within the mane. Below, add a curve for the shaggy chest.

3 This big block forms both the powerful forelegs.

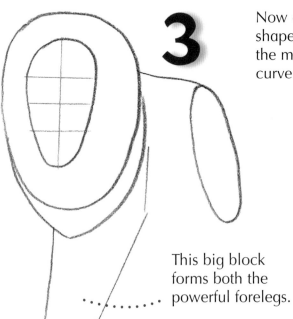

Divide the face into eight sections. This will help you position the eyes, nose and mouth.

4 Now complete the legs. This forepaw is raised and bent backwards as the lion steps forward on the other paw. The hindlegs are braced well apart to carry the lion's weight.

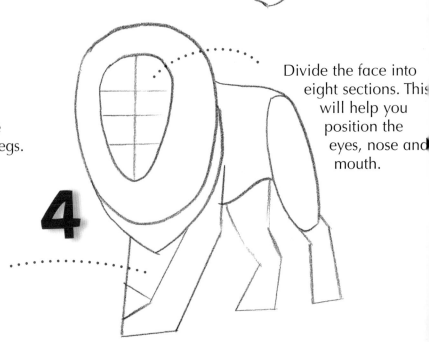

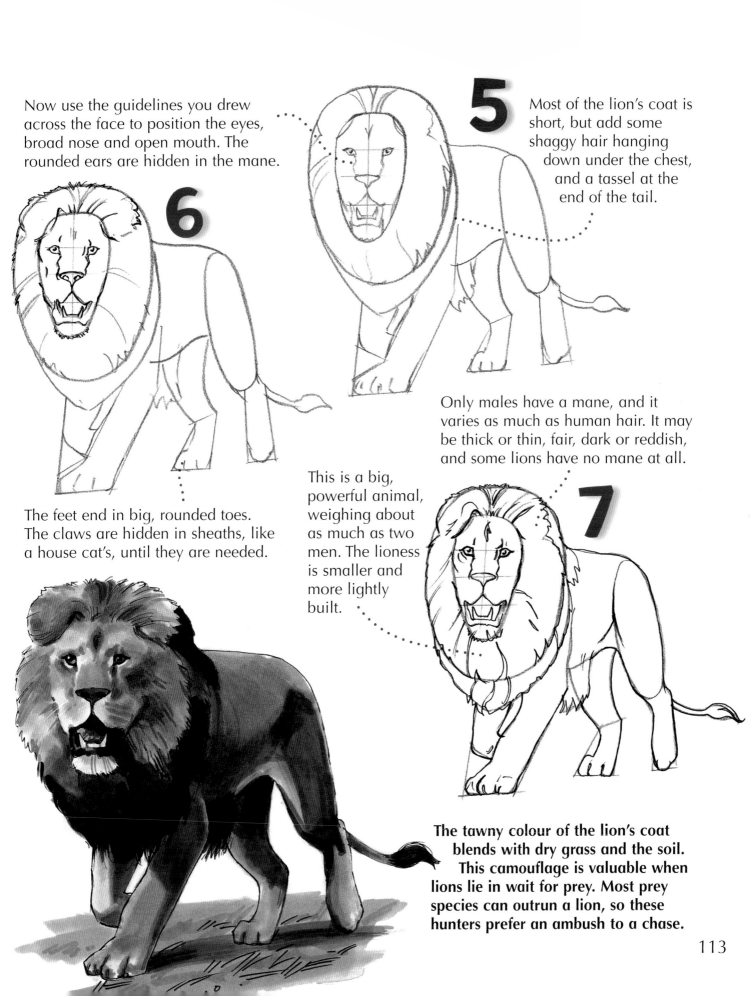

Now use the guidelines you drew across the face to position the eyes, broad nose and open mouth. The rounded ears are hidden in the mane.

5 Most of the lion's coat is short, but add some shaggy hair hanging down under the chest, and a tassel at the end of the tail.

6

The feet end in big, rounded toes. The claws are hidden in sheaths, like a house cat's, until they are needed.

Only males have a mane, and it varies as much as human hair. It may be thick or thin, fair, dark or reddish, and some lions have no mane at all.

This is a big, powerful animal, weighing about as much as two men. The lioness is smaller and more lightly built.

7

The tawny colour of the lion's coat blends with dry grass and the soil. This camouflage is valuable when lions lie in wait for prey. Most prey species can outrun a lion, so these hunters prefer an ambush to a chase.

Giraffe

The Giraffe is the tallest living animal. In the African grasslands, it can feed on the scattered trees which other animals cannot reach.

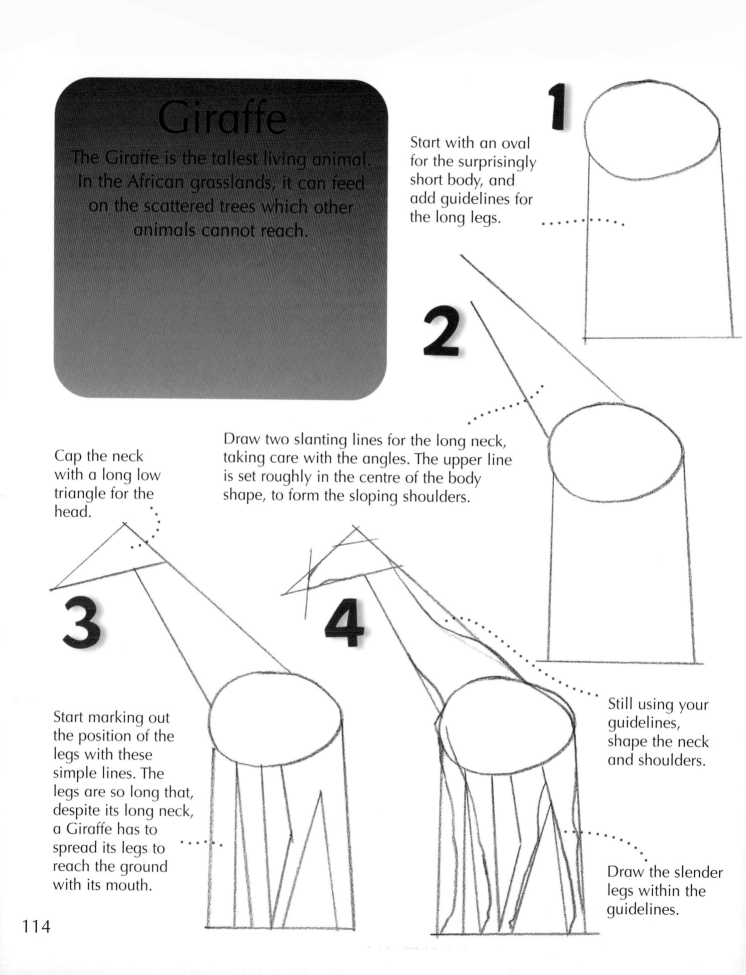

1 Start with an oval for the surprisingly short body, and add guidelines for the long legs.

2 Draw two slanting lines for the long neck, taking care with the angles. The upper line is set roughly in the centre of the body shape, to form the sloping shoulders.

3 Cap the neck with a long low triangle for the head.

Start marking out the position of the legs with these simple lines. The legs are so long that, despite its long neck, a Giraffe has to spread its legs to reach the ground with its mouth.

4 Still using your guidelines, shape the neck and shoulders.

Draw the slender legs within the guidelines.

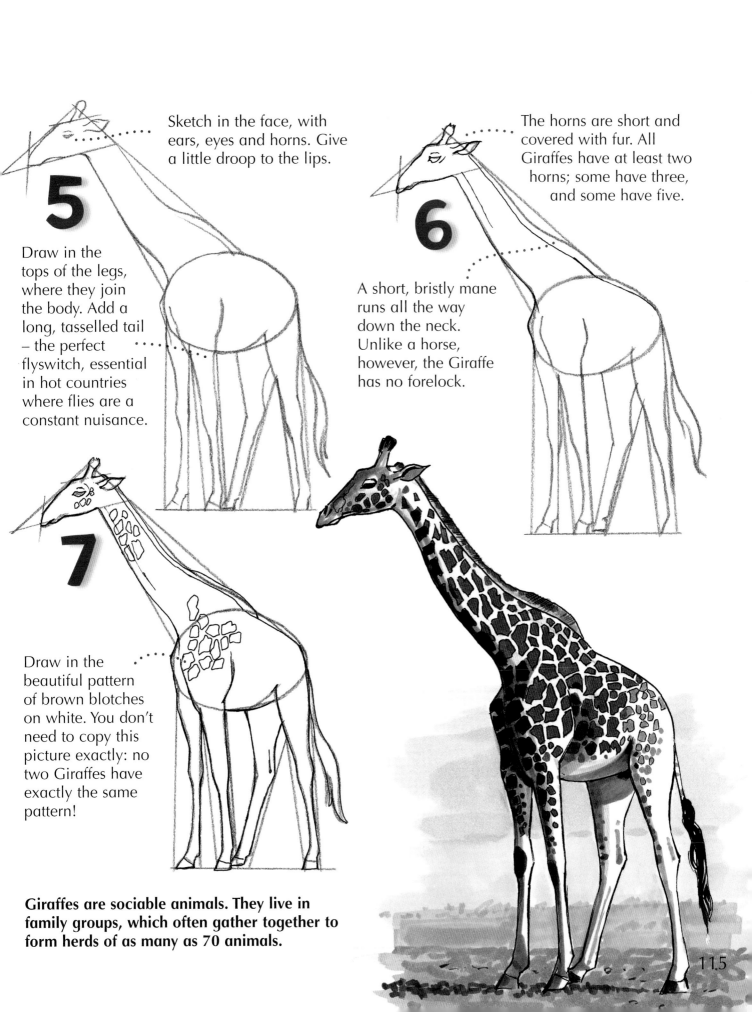

5 Sketch in the face, with ears, eyes and horns. Give a little droop to the lips.

Draw in the tops of the legs, where they join the body. Add a long, tasselled tail – the perfect flyswitch, essential in hot countries where flies are a constant nuisance.

6 The horns are short and covered with fur. All Giraffes have at least two horns; some have three, and some have five.

A short, bristly mane runs all the way down the neck. Unlike a horse, however, the Giraffe has no forelock.

7 Draw in the beautiful pattern of brown blotches on white. You don't need to copy this picture exactly: no two Giraffes have exactly the same pattern!

Giraffes are sociable animals. They live in family groups, which often gather together to form herds of as many as 70 animals.

115

South African Oryx

This large, handsome African antelope is a desert dweller. It sometimes goes without drinking, getting all the water it needs from plants. Its impressive horns can be more than a metre long, and are as straight as walking sticks. They are deadly weapons for defence, even against lions.

1

These two simple shapes form the animal's body.

2

Be careful when adding this shape for the head. Make its base line the same length as the width of the circle, so it sticks out well beyond the body.

3

This shape forms guidelines for the legs. Line it up with the nose, well in front of the body.

Mark in a line for the underside of the neck, taking care to position it correctly.

4

Draw in the long, straight, narrow horns.

Add a tall triangle – further guidelines for the legs. Check each new shape carefully as you draw it.

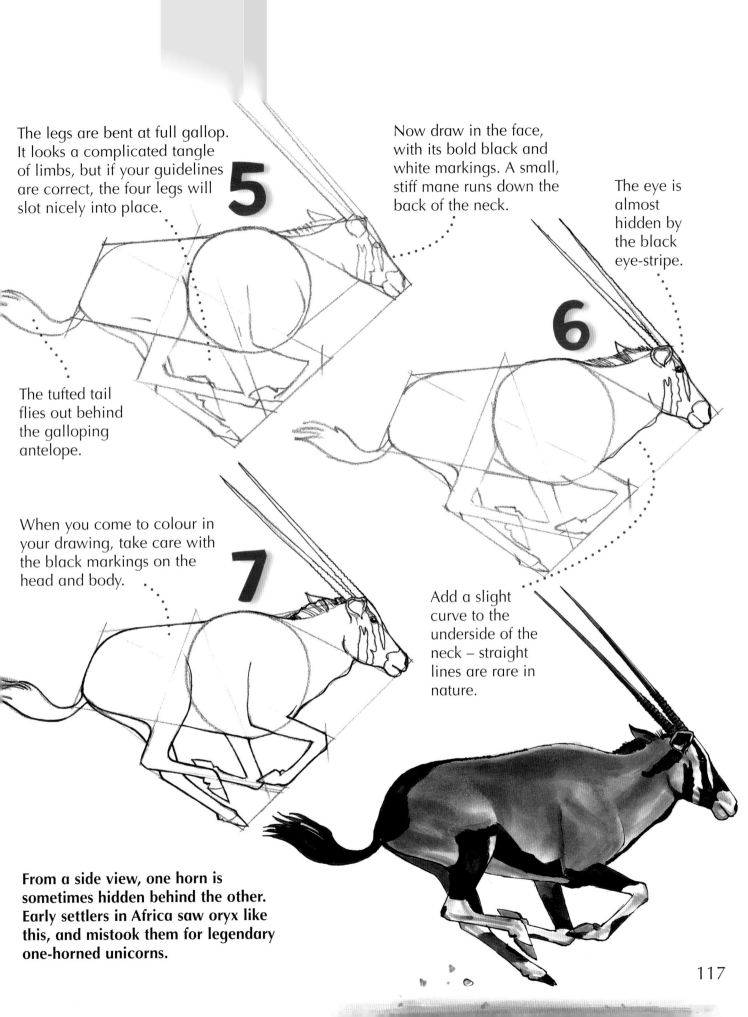

The legs are bent at full gallop. It looks a complicated tangle of limbs, but if your guidelines are correct, the four legs will slot nicely into place.

5

The tufted tail flies out behind the galloping antelope.

Now draw in the face, with its bold black and white markings. A small, stiff mane runs down the back of the neck.

The eye is almost hidden by the black eye-stripe.

6

When you come to colour in your drawing, take care with the black markings on the head and body.

7

Add a slight curve to the underside of the neck – straight lines are rare in nature.

From a side view, one horn is sometimes hidden behind the other. Early settlers in Africa saw oryx like this, and mistook them for legendary one-horned unicorns.

Marabou Stork

This huge African stork has the largest wingspan of any land bird. Clumsy on the ground, it is a master of the air, soaring to great heights to look for food. It hunts all kinds of small animals, and also feeds on carrion.

1

Start with a large, leaf-like shape for the body and a small circle for the head.

2

Now add the long heavy beak, shaped like a short sword. This is a stabbing weapon, used to kill small prey such as birds, mice and frogs.

These two lines form guidelines for the long, slender legs. Take care to position them exactly.

3

Add a curve behind the neck, to give a hunched outline. The long neck is tucked into the body.

Working within your guidelines, draw in the three parts of a leg. Make the upper two sections the same length, and the third (forming the foot) a little shorter.

4

Draw some wavy lines to mark rows of feathers down the long, broad wings which cover most of the body.

One more line within the framework of the legs gives you the rear leg, which is raised.

118

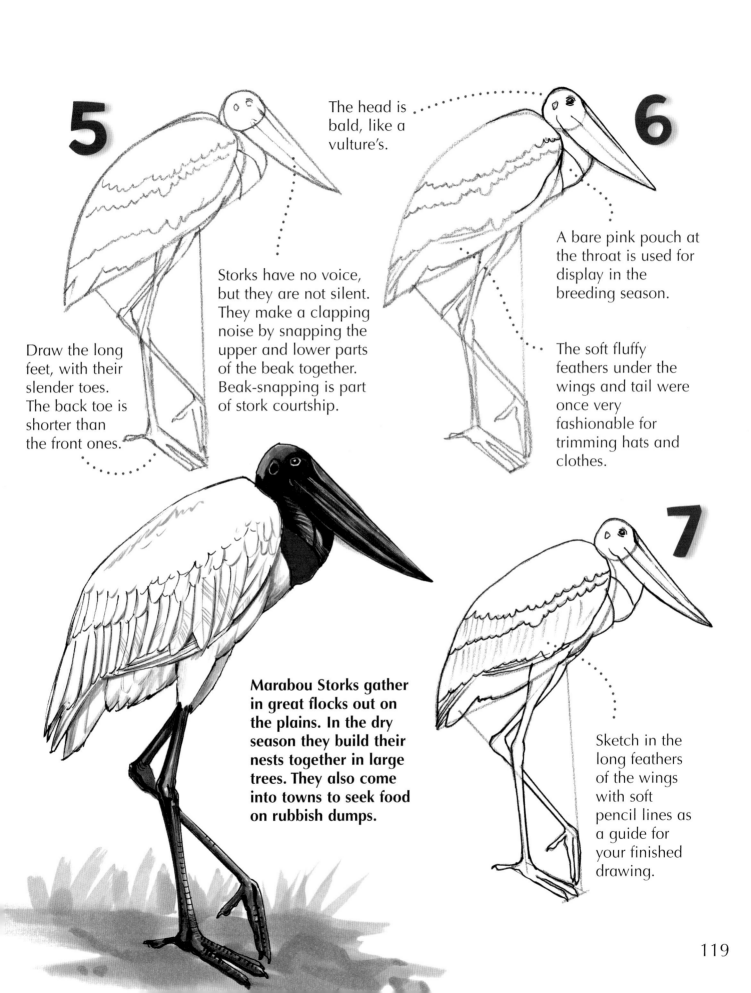

5

The head is bald, like a vulture's.

Draw the long feet, with their slender toes. The back toe is shorter than the front ones.

Storks have no voice, but they are not silent. They make a clapping noise by snapping the upper and lower parts of the beak together. Beak-snapping is part of stork courtship.

6

A bare pink pouch at the throat is used for display in the breeding season.

The soft fluffy feathers under the wings and tail were once very fashionable for trimming hats and clothes.

7

Marabou Storks gather in great flocks out on the plains. In the dry season they build their nests together in large trees. They also come into towns to seek food on rubbish dumps.

Sketch in the long feathers of the wings with soft pencil lines as a guide for your finished drawing.

Elephant

The African Elephant is the largest living land mammal. It can weigh as much as seven cars. Even a baby elephant weighs as much as a fully grown man. Asian Elephants are smaller than their African cousins, though they are still huge animals.

1

Draw this four-sided shape for the head, with triangles on either side for ears. Huge ears show that this is an African Elephant – Asian Elephants have smaller ears.

Add another uneven four-sided shape below. This does not form part of your finished drawing, but acts as a guideline for the position of the tusks.

2

Draw this heavy column below the head. The front legs will fit into this shape.

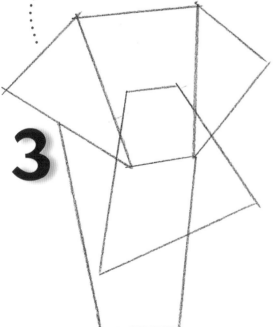

3

Now you can start shaping your elephant, adding the massive legs, the long trunk and curving the body behind the head.

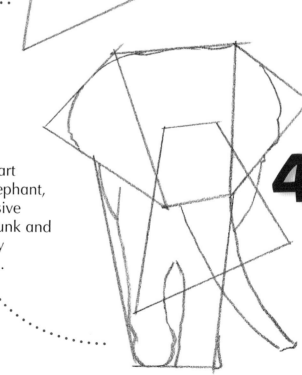

4

5

Use your guidelines to position the large tusks.

Huge ears also act as radiators to help cool the elephant down.

6

An African Elephant's trunk is made up of a series of rings, like a vacuum-cleaner hose. Sketch these in with little curving lines. Asian Elephants have smooth tube-like trunks.

7

The legs are huge, weight-bearing pillars, with padded feet that can walk without making a sound.

An elephant's trunk is a 'hand'; strong enough to lift up a lion, and sensitive enough to pick up a peanut. It is also used to suck up water, which it sprays down its throat – and as a trumpet to sound the alarm.

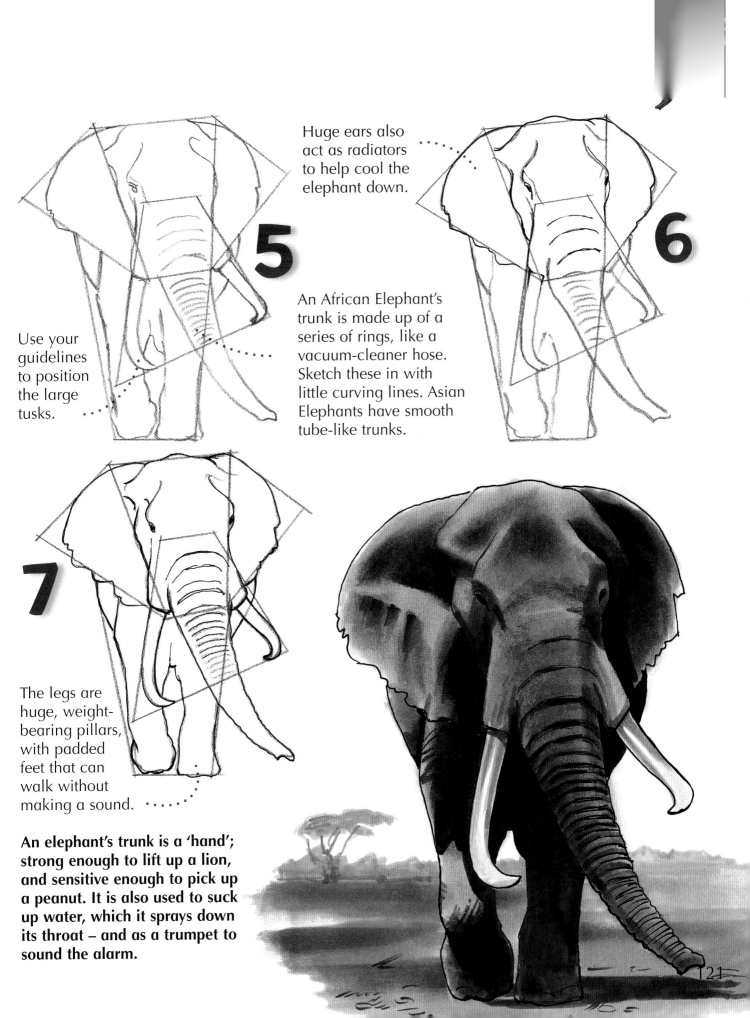

Hippo

Its name means 'river horse', but the hippo's nearest relatives are the pig family. It is superbly adapted to a river life. Clumsy on land, that huge body is made for underwater swimming, floating lightly on the surface or walking submerged along the riverbed.

Start with these two circles – head and body. The base of the smaller circle is slightly above that of the larger, its top well below the big one.

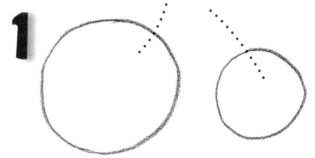

Join up the head and body with a curved line for the heavy shoulder. Hippos' bodies are nicely rounded, with no angles, to help it glide through the water.

Now add a fat half-moon on the end for the hindquarters, lengthening the whole body.

Add a huge, broad muzzle, as long as the legs.

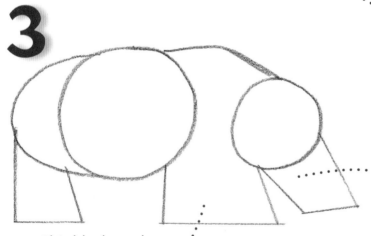

This block marks the position of both front legs.

Now draw in the short, column-like legs with their broad feet. They are set far apart, to help them support all that weight.

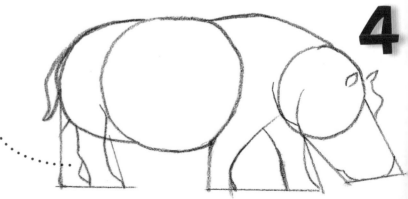

5 Draw in the face, with small ears and eyes and enormous jaws. Hippos are vegetarians, but those jaws are very effective for fighting other males and for self-defence.

Draw little domes around the eyes. The eyes are raised so that they are above water when the rest of the body is submerged.

6

Each foot ends in four well-developed toes, supporting the weight between them.

The hippo's body is protected by tough skin nearly 5cm thick.

7

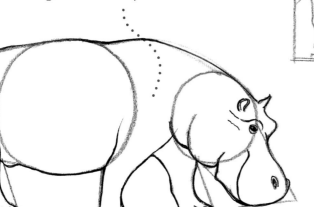

The hippo's jaws can open in an enormous gape, exposing the huge teeth. In defence of their young, hippos have been known to bite small boats in half!

Hippos spend most of the day relaxing in the water. At night they come out to feed, taking well-trodden tracks from the river to their grazing place. The male will attack any trespassers on these private paths.

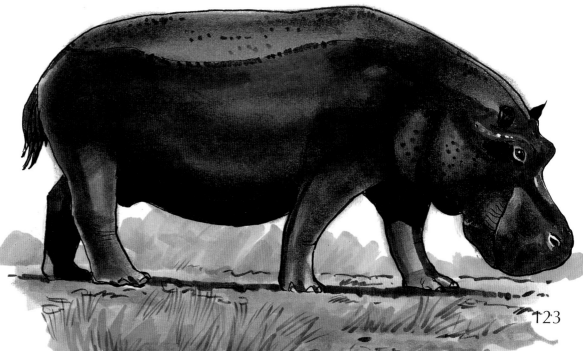

123

Grizzly Bear

This huge North American bear is bigger than European brown bears. Its name comes from the 'grizzled' or greyish hairs that overlay its brown coat.

1

Start with a 'snowman' shape – a circle perched on a fat oval. Bears have massive bodies, covered with a thick layer of fat under the heavy fur.

2

Now add two uneven sections at the bottom, which will become the legs and feet.

Add small rounded ears, and draw in a long snout. Curve the sides of the head outwards to form a thick ruff of fur.

3

4

Now draw in a pair of 'arms', or forelegs. At this stage your drawing will look more like a teddy bear than a Grizzly!

5

Start developing the face, shaping the nose and mouth. Add a curve above the eyes to make them look more deep-set.

6

Now you can start sketching in the shaggy fur of the head and neck.

The huge claws, more than 5cm long, are used to dig for roots and burrowing animals like mice and squirrels.

Ink in your outlines, developing the shagginess of the dense coat.

7

This is a truly powerful animal. It may look clumsy, but it is a master climber and swimmer – and can run as fast as a horse.

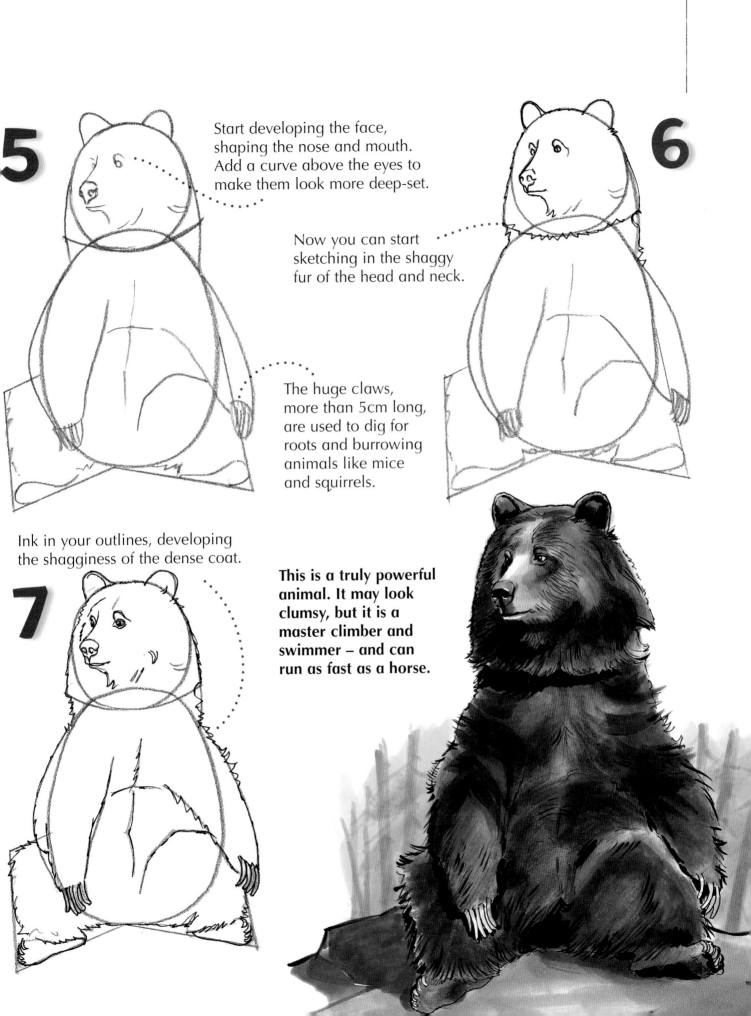

Orang-utan

Found only on the south-east Asian islands of Borneo and Sumatra, this giant ape lives in the trees. It feeds on leaves, fruit and flowers, and spends most of its life high above the ground. The world's largest tree-living mammal, it has long, strong arms to pull it through the branches.

1 Start with these two shapes, like short eggs, for the head and body.

This shape will form the rounded muzzle.

2

Build this shape with four lines joined to the base of your big oval. It will form the folded limbs.

Divide the face down the centre as a guideline to help you position the eyes and nose.

3

Draw the raised arm and hand in three sections. Orangs have unusually long arms, to help them climb.

Add a four-sided shape for one bent back leg, just overlapping the other 'leg' shape.

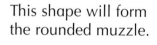

4

5 Draw a hand like your own – only bigger and much more powerful.

6 Sketch in the coarse, shaggy coat which hangs in 'sleeves' from the arms. Orang-utans have the longest hair of any ape.

The short, bandy legs are used for walking – but, with double-jointed hips, are even more useful as a second pair of 'arms', complete with finger-like toes.

Now draw in the details of the face, with its broad nose and deep-set eyes.

7 Strengthen the outlines ready for colouring.

At night, orangs build nests in the forks of trees, bending branches to make a secure platform.

'Orang-utan' is a Malay word meaning 'man of the forest'. Apes and humans belong to the same family, and some scientists believe the Orang is our nearest relative.

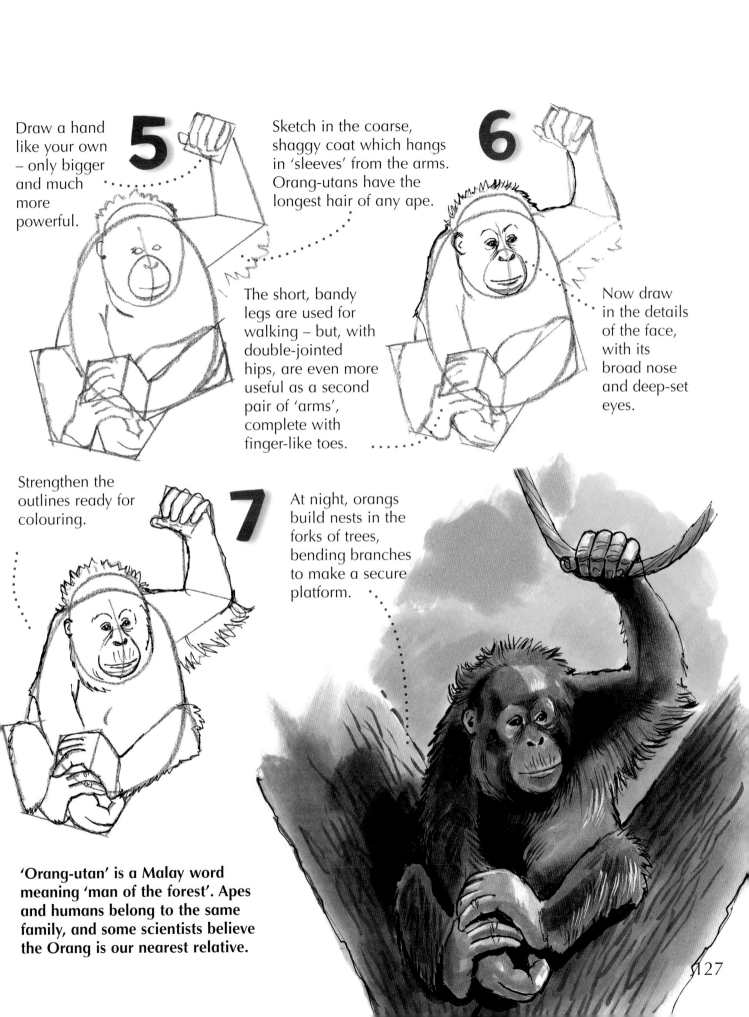

Boxer

The sport of boxing dates back to Ancient Greek and Roman times. But the rules and padded gloves used today were introduced in the 19th century. Boxers aim to score points by landing punches with the knuckle part of the glove. They may win a bout on points or by knocking out their opponent.

1 Start with an egg shape for the head. Overlapping it, draw this four-sided shape, wider at the top.

2 Draw a long, slanting line from the point of the shoulder as a guideline for one leg.

Add another slanting line running down from the waist, forming a shape like a skirt. This marks out the second leg.

This triangle defines the right arm.

3 A long narrow triangle on the side extends the leg further.

The left arm is outstretched, in line with the shoulder.

Add these two lines, roughly blocking in the position of the legs. They are braced wide apart for balance.

4 Large circles at the end of the arms form the padded boxing gloves.

5

Now draw the legs, using the guidelines created earlier. Boxers need strong legs to keep on the move.

Draw the face. The head is tucked in, so as not to offer the chin as a target for the opponent.

6

The left arm is thrust out in a left jab.

Mark in the boots, which come well up the calf of the leg to provide support.

7

The right arm is held close to the body ready to strike. Draw slightly bulging curves at the shoulder and down the arms to give the shape of strong muscles.

The weight is taken on the left leg. The right foot is just lifting off the ground.

Boxers don't have to be big men: the different weight classes range from tiny flyweight to mighty heavyweight. But they do have to be very fit. Quick reactions are as important as a powerful punch.

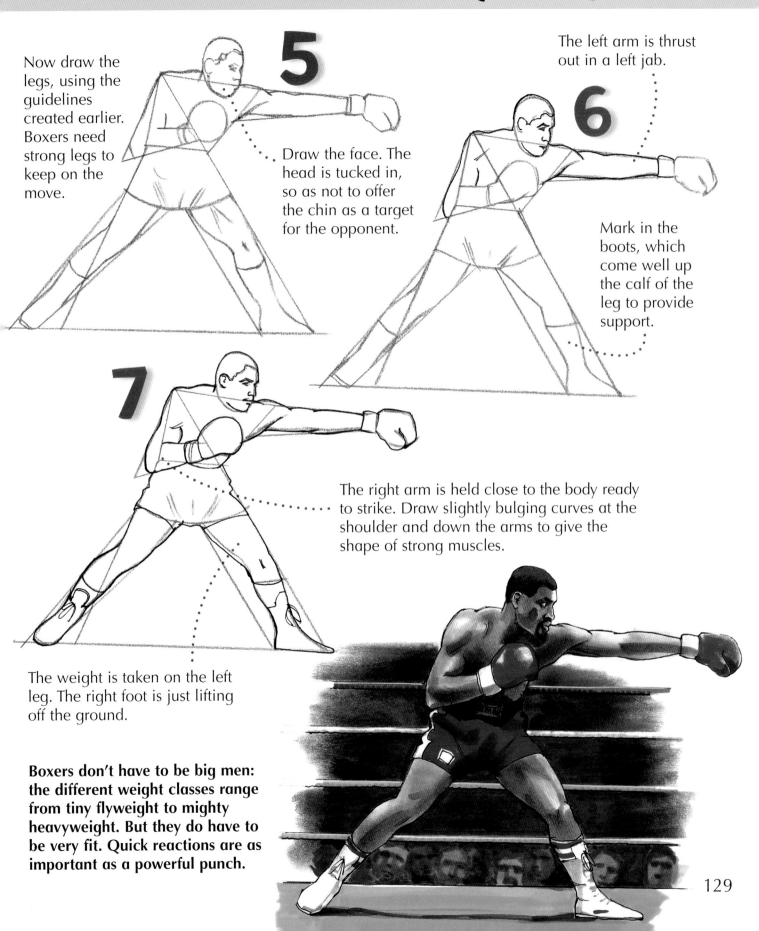

Cowboy

From about 1870 onwards, cattle raising was big business in the Wild West of America – and it all depended on cowboys. They tended the herds, and drove them long distances to markets. Western films make their lives look glamorous, but they worked hard in tough conditions.

1 Start with an egg shape for the head.

Add these two simple shapes for the upper part of the body.

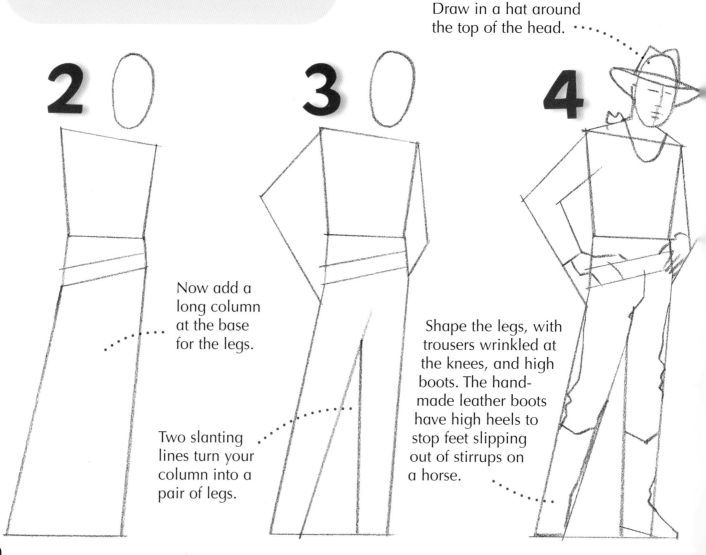

2 Now add a long column at the base for the legs.

Two slanting lines turn your column into a pair of legs.

3

4 Draw in a hat around the top of the head.

Shape the legs, with trousers wrinkled at the knees, and high boots. The hand-made leather boots have high heels to stop feet slipping out of stirrups on a horse.

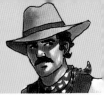

5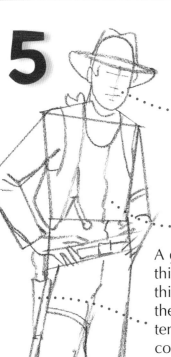

A line sketched down the centre of the face will help you position eyes, nose and mouth.

Now draw in his clothes – jeans, shirt and a short waistcoat, or 'vest'.

A gun was protection from thieves and rustlers (cattle thieves). But long months on the trail made for short tempers, and gunfights were common.

6

The high, broad-rimmed hat keeps the head cool and shades the eyes from the Sun.

The gunbelt is worn low on the hips, at a slant. The six-shooter gun is carried in a leather holster.

7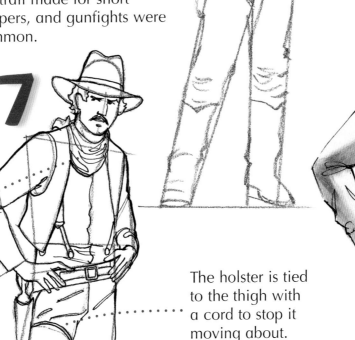

A bandanna (cotton neckcloth) protects his neck from the Sun. On cattle drives, it serves as a mask against the choking dust kicked up by the animals' feet.

The holster is tied to the thigh with a cord to stop it moving about.

There are still cowboys today – but they tend their cattle from pick-up trucks and helicopters as well as from horses as in days gone by.

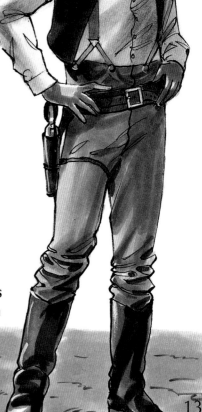

Astronaut

Out in space, an astronaut depends on his spacesuit for his life. It keeps his body at normal pressure and provides air for him to breathe.

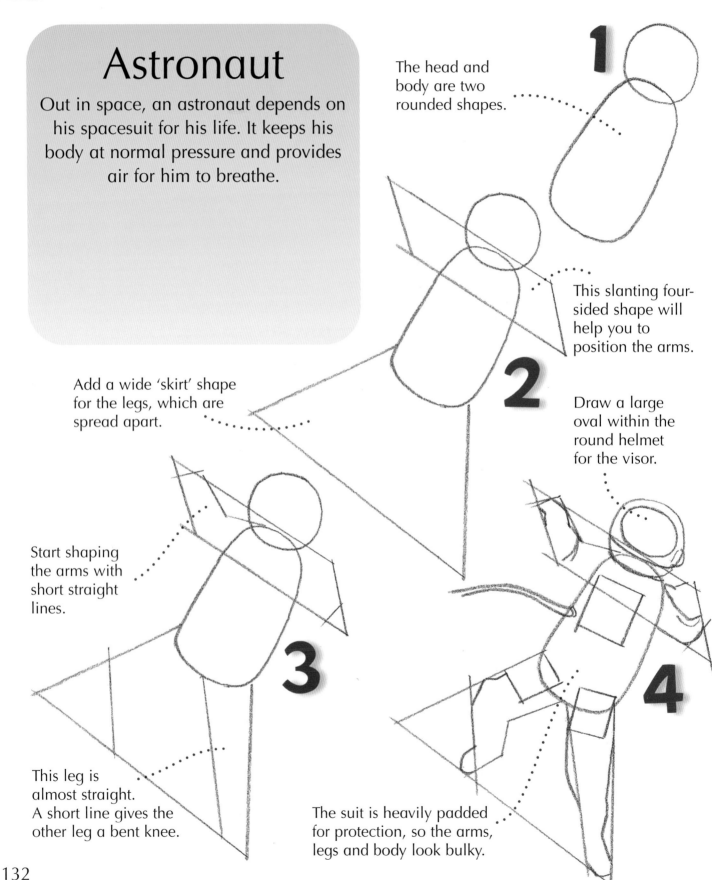

1 The head and body are two rounded shapes.

2 This slanting four-sided shape will help you to position the arms.

Draw a large oval within the round helmet for the visor.

Add a wide 'skirt' shape for the legs, which are spread apart.

3 Start shaping the arms with short straight lines.

This leg is almost straight. A short line gives the other leg a bent knee.

4 The suit is heavily padded for protection, so the arms, legs and body look bulky.

His hands look big and square in their thick gloves.

5

The control unit for his oxygen supply is strapped to his chest.

6

Outside the spacecraft, an outer garment goes on top of the spacesuit for extra protection from specks of space 'dust'.

Pockets have lift-up flaps for easy access.

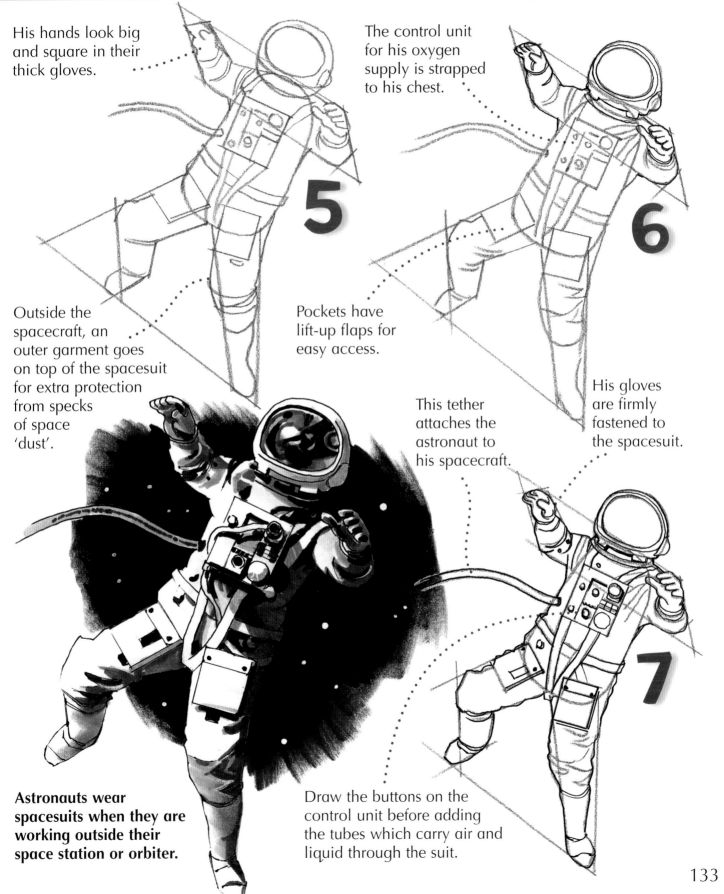

This tether attaches the astronaut to his spacecraft.

His gloves are firmly fastened to the spacesuit.

7

Astronauts wear spacesuits when they are working outside their space station or orbiter.

Draw the buttons on the control unit before adding the tubes which carry air and liquid through the suit.

Busy People

Japanese Girl

This Japanese girl is wearing her traditional costume, a loose, long-sleeved gown called a kimono. This graceful garment is worn by both men and women. The wide sash at the waist, called an obi, is also traditional.

1

Start with an egg shape for the head, on a thick, slanting stem – not a lopsided neck, but part of the shoulder!

Add a long column, wider at the bottom, for the floor-length kimono.

Draw a large oval behind her head, reaching down to her waist, for her parasol, or sunshade.

2

These two blocks form one of the wide sleeves.

This chunky shape behind her arm is part of the sash, tied in a bulky bow behind her back.

3

Draw a 'halo' around her head. This forms the outline of her hair.

4

At the end of the sleeve, draw this small shape for her hand.

Change the straight line at the bottom of the robe into a wavy edge. This helps to suggest the way the material hangs in folds.

5

6 Draw in the slender ribs of her delicate paper parasol.

Her kimono hangs in soft folds, shown by pencil lines. Be sure to match these up with the curves of the hem.

A folded fan is held in her right hand, ready for graceful use.

7

Ink in the parasol struts lightly. When you colour in your drawing, you may want to add painted leaves or flowers on the open sunshade.

The obi (sash) is often beautifully embroidered.

Nowadays, more and more Japanese wear Western-style clothing rather than beautiful kimonos like this.

She wears a simple sandal, and a divided sock which separates the big toe from the other toes.

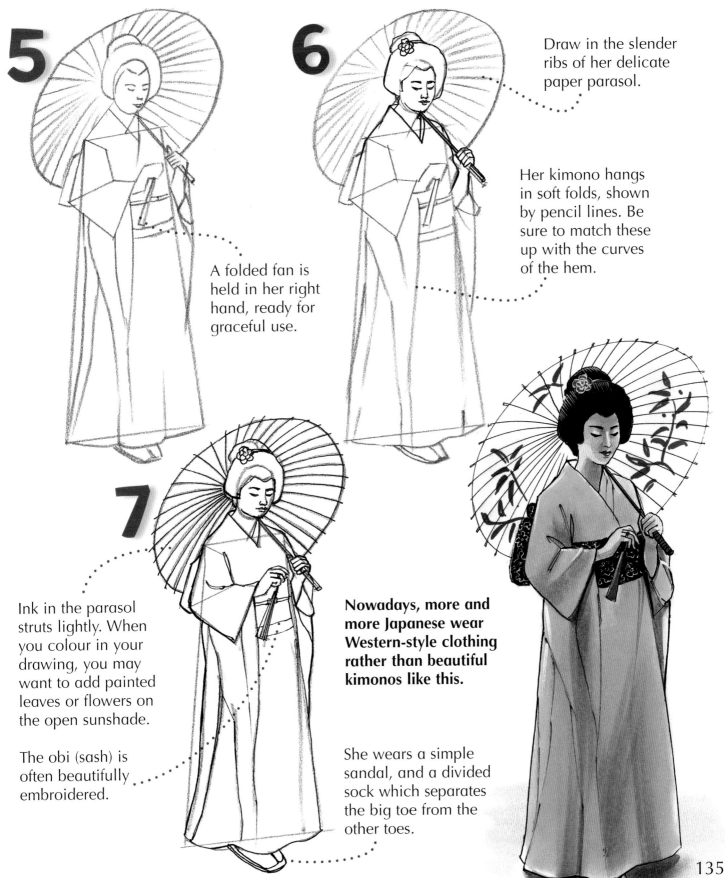

Firefighter

The first organized team of firefighters was formed by the Ancient Romans. Regular fire brigades were not formed until the 18th century. Today they use modern equipment, but theirs is still a very dangerous job.

1

Start with the usual egg shape for the head.

Take care with your angles here! The base of this shape slants more steeply than the top line.

2

Draw the shape of the helmet around his head, and mark out the positions of eyes, nose and mouth.

His bent left arm stretches nearly all the way across the original shape.

This is the nozzle of the hose.

3

Four short, straight lines will form a bent leg.

Unlike most garden hosepipes the firehose is flat, like a ribbon, until water flows through it.

4

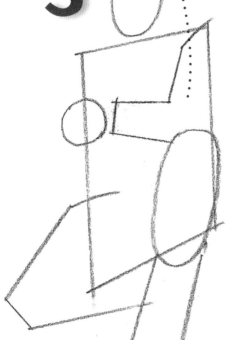

5 Draw in his protective jacket, with its turned-up collar.

This 'splash suit' is the outfit worn for most fires. It is made of heat-resistant materials developed for spaceflight.

6 The hard helmet protects the firefighter's head from falling debris.

The long jacket and high-waisted trousers keep him dry as well as protecting him from searing heat.

Heavy boots are essential.

7 Water is pumped down the hose with such force that it may take several firefighters to control the nozzle.

For dangerous situations like aircraft fuel fires, a fire-resistant suit is worn over the splash suit. Firefighters also have chemical protection suits for fires involving poisonous chemicals.

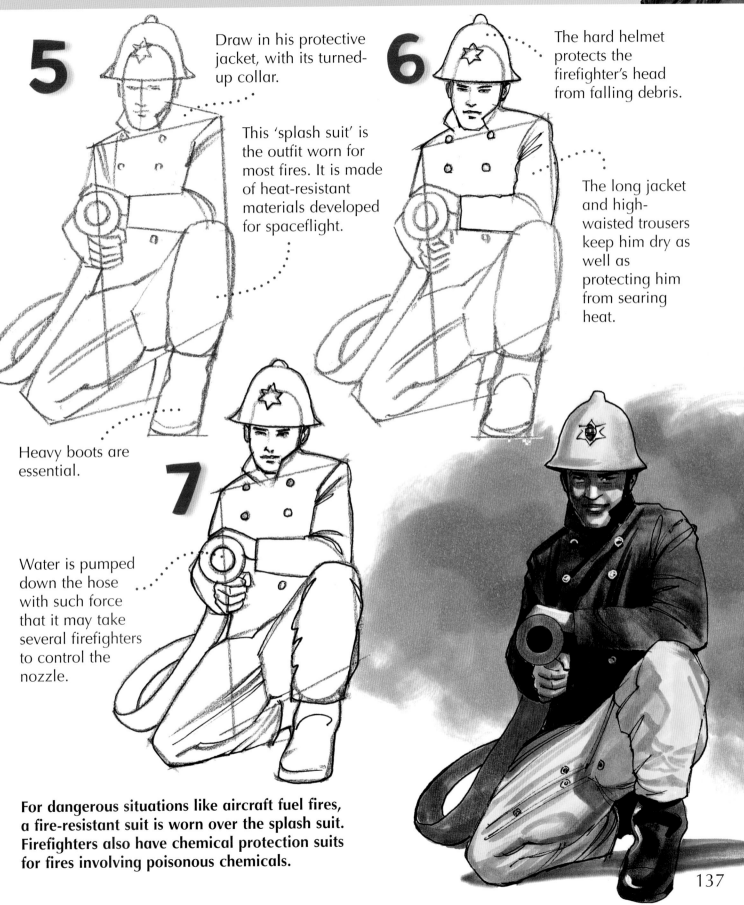

Tennis Player

The game of tennis was developed in 15th century France when it was played indoors. The outdoors version, lawn tennis, became popular in the 19th century, when the modern rules were drawn up.

1

Start with this tall cone, slanting more steeply on the left side. This slant gives you the leaning-forward stance of a body in motion.

Draw a slanting line across the inside of your cone to mark out the position of the body.

Add the arm, and hands gripping the racquet with its oval head and tapered handle.

2

Now add an oval for the head, below the tip of the cone and overlapping it at the back.

This slanting line will help you to position the raised foot.

3

Start shaping the shoulders and upper body.

Draw in the hem of the short tennis skirt. White socks, shirt and shorts or tennis skirt are the standard tennis outfit.

4

Draw in the legs. One foot is in the air, the other raised on its toes ready to dart forward.

5

Draw in the face and hair.

A baseball cap shades the player's eyes from the Sun.

Early racquet frames were made of wood, often ash. Nowadays modern materials like fibreglass or carbon graphite are used.

Tennis shoes support the ankles and cushion the soles of the feet.

6

Start to ink in your outlines carefully.

7

Draw the racquet strings with fine, criss-crossed lines.

The most famous tennis championships in the world are the All-England Championships held at Wimbledon. They were first played there in 1877.

139

Inline Skater

Ice-skates were known in ancient times. Roller-skates arrived in the 18th century, fitted with wheels to glide over the ground instead of blades for skating on ice. They soon became popular worldwide. Inline skates were a 1980s development, faster and easier to turn.

1

Position the head on one side of this four-sided shape.

2

Three lines form a tapering base, setting up guidelines for the wide-spread legs.

3

A line from the head marks out the skater's back. Add two slanting lines within the base for the legs.

Draw in the foot on its skate. The curves on the bottom are the wheels of the skate itself.

4

Draw the outlines of an arm within your first shape. The hand is protected by padded gloves, so make it large.

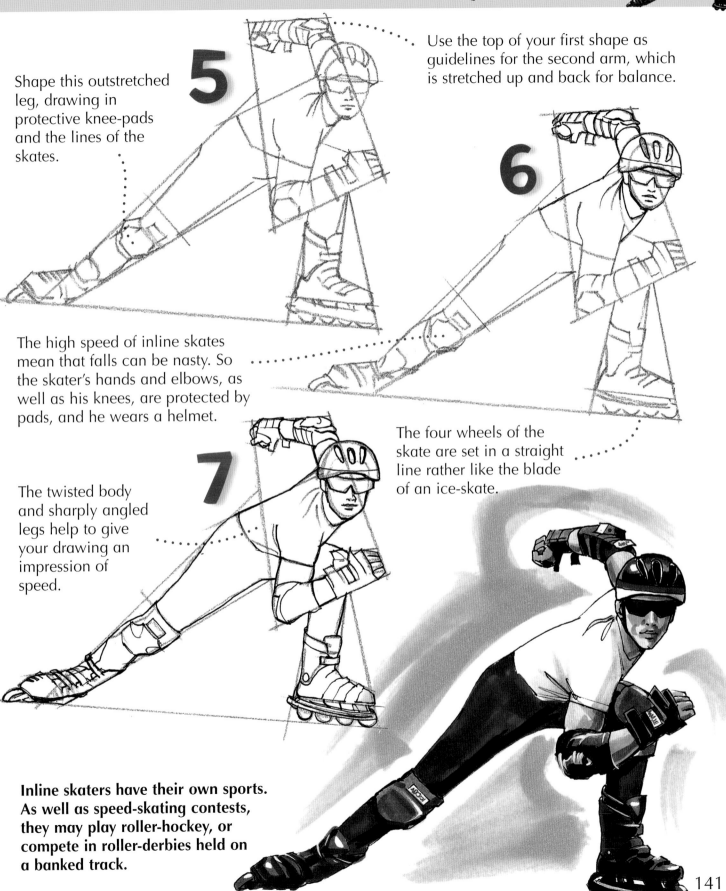

5 Shape this outstretched leg, drawing in protective knee-pads and the lines of the skates.

Use the top of your first shape as guidelines for the second arm, which is stretched up and back for balance.

6

The high speed of inline skates mean that falls can be nasty. So the skater's hands and elbows, as well as his knees, are protected by pads, and he wears a helmet.

The four wheels of the skate are set in a straight line rather like the blade of an ice-skate.

7 The twisted body and sharply angled legs help to give your drawing an impression of speed.

Inline skaters have their own sports. As well as speed-skating contests, they may play roller-hockey, or compete in roller-derbies held on a banked track.

141

Ballet Dancer

Ballet dancing may express a mood, or it may tell a story, like a play using dance instead of words. It is hard work: ballet dancers practise every day to make their bodies strong and supple.

A long, uneven triangle forms the arms and shoulders.

A much larger triangle forms guidelines for the legs.

1

Sketch the rough shape of legs within the triangle. This leg looks wider because it is seen from the side.

2

Add a 'boat' shape for the stiff tutu skirt, which stands straight out from the waist.

Add hair, neatly piled on top of the head.

Now sketch in the arms, one outstretched, one bent.

3

Finish off this leg with its foot, balanced on the very tips of the toes.

4

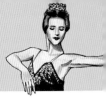

5

Use a wiggly line to draw the frilled edges of the short stiff skirt.

6

The flowing line of the arm ends in a relaxed, gently drooping hand.

This leg turns outwards at the hip joint. The foot follows the line of the leg, with the toes pointed.

This leg is straight and fully extended, with the body fully raised on the toes of this foot.

7

Nearly all ballet steps are based on just five foot positions.

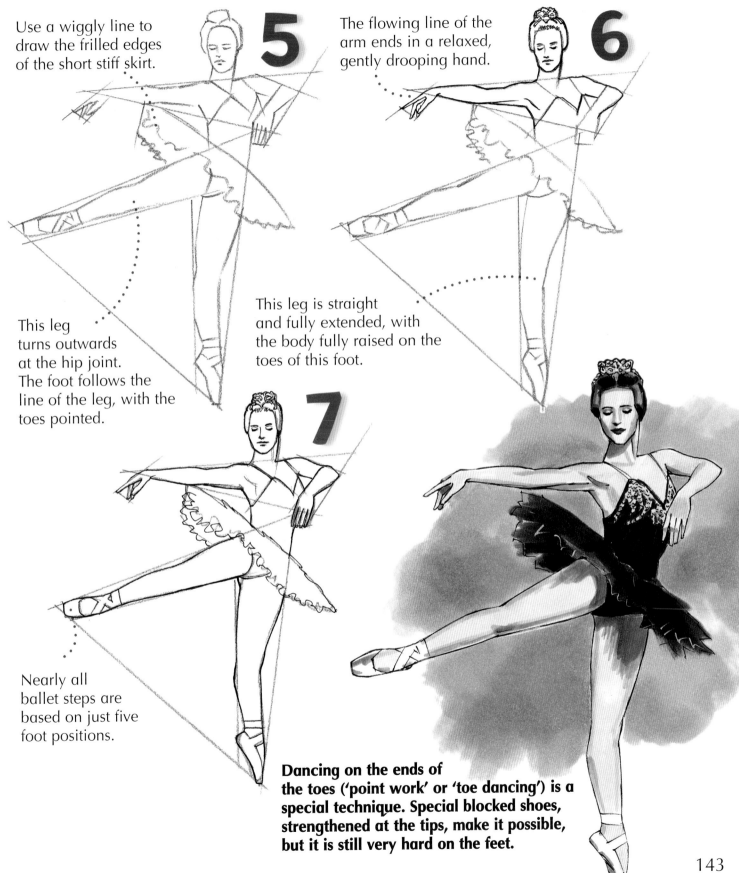

Dancing on the ends of the toes ('point work' or 'toe dancing') is a special technique. Special blocked shoes, strengthened at the tips, make it possible, but it is still very hard on the feet.

143

Martial arts Expert

Martial arts are Eastern fighting skills, such as judo, karate and tae kwon do. They are intended for self-defence, not attack, and are often linked with religion. They are now also popular in the West, chiefly as sports.

1 The oval for the head is slightly tilted.

This long triangle forms the upper body and arms.

2 A second, slightly larger triangle forms the legs, spread in a flying leap.

Start breaking up your first triangle, using straight lines, to establish the shapes of the two arms, one outstretched, the other tucked close to the body.

3

The right arm curves up towards the neck, its closed hand overlapping the area of the cheek.

4

Use straight lines to block in the shape of this extended leg and foot.

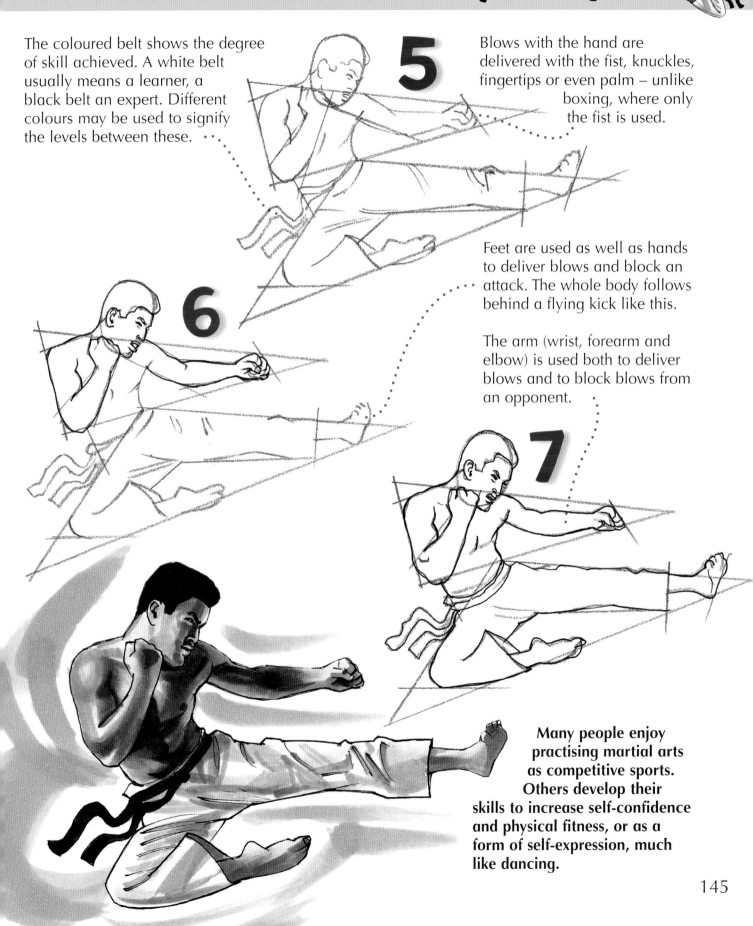

The coloured belt shows the degree of skill achieved. A white belt usually means a learner, a black belt an expert. Different colours may be used to signify the levels between these.

5

Blows with the hand are delivered with the fist, knuckles, fingertips or even palm – unlike boxing, where only the fist is used.

6

Feet are used as well as hands to deliver blows and block an attack. The whole body follows behind a flying kick like this.

The arm (wrist, forearm and elbow) is used both to deliver blows and to block blows from an opponent.

7

Many people enjoy practising martial arts as competitive sports. Others develop their skills to increase self-confidence and physical fitness, or as a form of self-expression, much like dancing.

145

Scuba Diver

Scuba divers can swim underwater as freely as fish. They don't have to keep returning to the surface to breathe, nor are they linked to their boats by air hoses or lines. They carry their air under the water with them, in tanks strapped to their backs, and breathe it in through a mouthpiece.

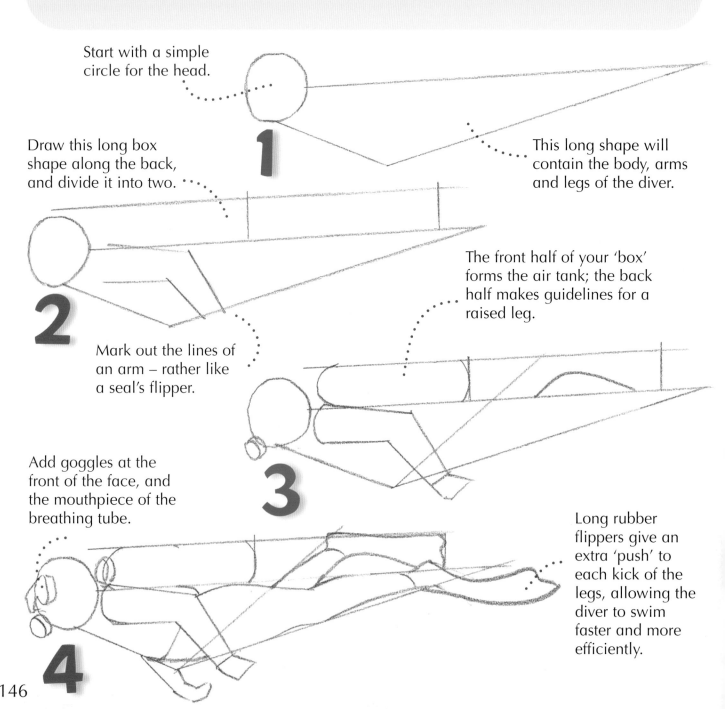

Start with a simple circle for the head.

1

This long shape will contain the body, arms and legs of the diver.

Draw this long box shape along the back, and divide it into two.

2

Mark out the lines of an arm – rather like a seal's flipper.

The front half of your 'box' forms the air tank; the back half makes guidelines for a raised leg.

3

Add goggles at the front of the face, and the mouthpiece of the breathing tube.

Long rubber flippers give an extra 'push' to each kick of the legs, allowing the diver to swim faster and more efficiently.

4

Breathing in opens a valve on the tank, which lets air flow out to the mouthpiece. The valve closes when the diver stops inhaling. A second, one-way valve lets used breath bubble out into the water.

A rubber suit helps to keep the body warm, and protects the skin from bumps and scratches from rocks and coral.

5

Ink in the details of the goggles and diving equipment.

Complete the smooth outline in ink and you are ready to colour your drawing.

6

7

Most scuba divers can swim comfortably at a depth of 40m. Deeper than this is dangerous, as the extra pressure of the water at these depths can harm the body.

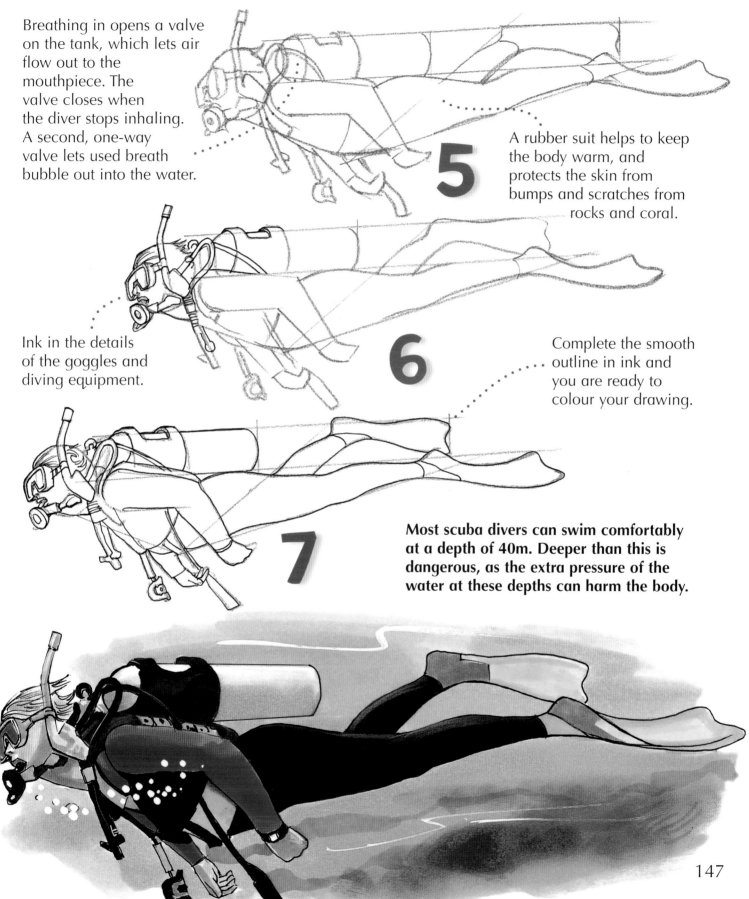

147

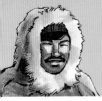

Inuit Hunter

The Inuit are people of the Arctic – the icy land around the North Pole that is one of the harshest regions of the world. For thousands of years they have lived by hunting and fishing. They make skin tents for summer use, and houses of stone or even snow blocks (igloos) for winter.

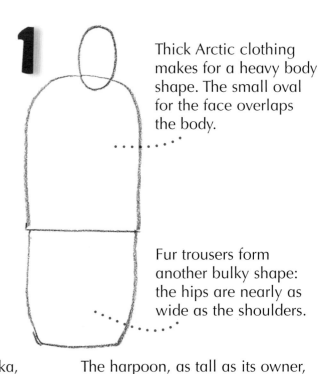

1 Thick Arctic clothing makes for a heavy body shape. The small oval for the face overlaps the body.

Fur trousers form another bulky shape: the hips are nearly as wide as the shoulders.

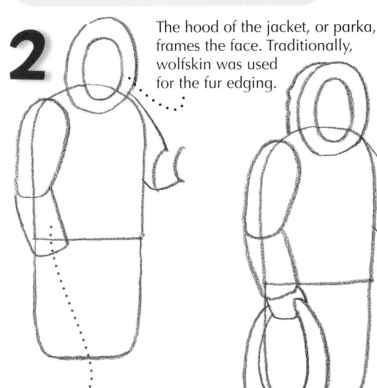

2 The hood of the jacket, or parka, frames the face. Traditionally, wolfskin was used for the fur edging.

Draw in the arms, making them short and thick because of the jacket sleeves.

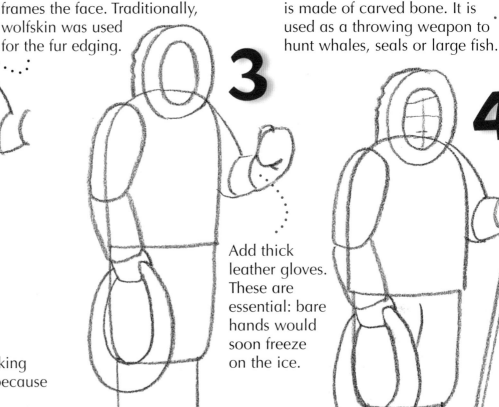

3 Add thick leather gloves. These are essential: bare hands would soon freeze on the ice.

The harpoon, as tall as its owner, is made of carved bone. It is used as a throwing weapon to hunt whales, seals or large fish.

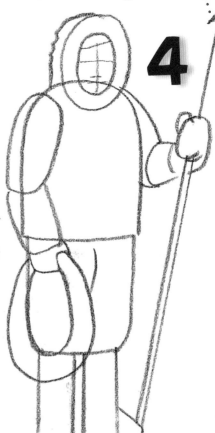

4

5

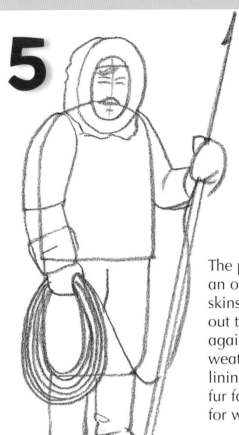

The parka has an outer layer of skins, fur side out to protect against the weather, and a lining with the fur facing inside for warmth.

6

The strong deerskin boots are called mukluks. Like all his clothes, they are sewn with animal sinews.

The harpoon is attached to a line, so that the catch is not lost in the water. This line is made of braided strips of sealskin.

7

When inking in the outline of the clothes, use short jagged lines to suggest the rough texture of fur.

The Inuit wastes nothing. A seal's skin provides material for clothes, tents, boats and ropes, its bones are carved into tools and weapons, and its fat is burned for light and heat.

Sperm Whale

This is the champion deep sea diver. It goes deeper than any other whale (at least 2000 metres) and can stay down for more than an hour before coming up for air. In the depths of the sea, squid are plentiful – and the Sperm Whale eats up to a tonne of squid a day.

1

A diamond shape forms the huge head.

The head makes up about a third of the total length.

2

Now add a smaller triangle for the tail.

3

Join the whale's head to its body with two smoothly curving lines.

4

The flippers are small and paddle-shaped. Don't forget to draw in a small eye close to the flipper.

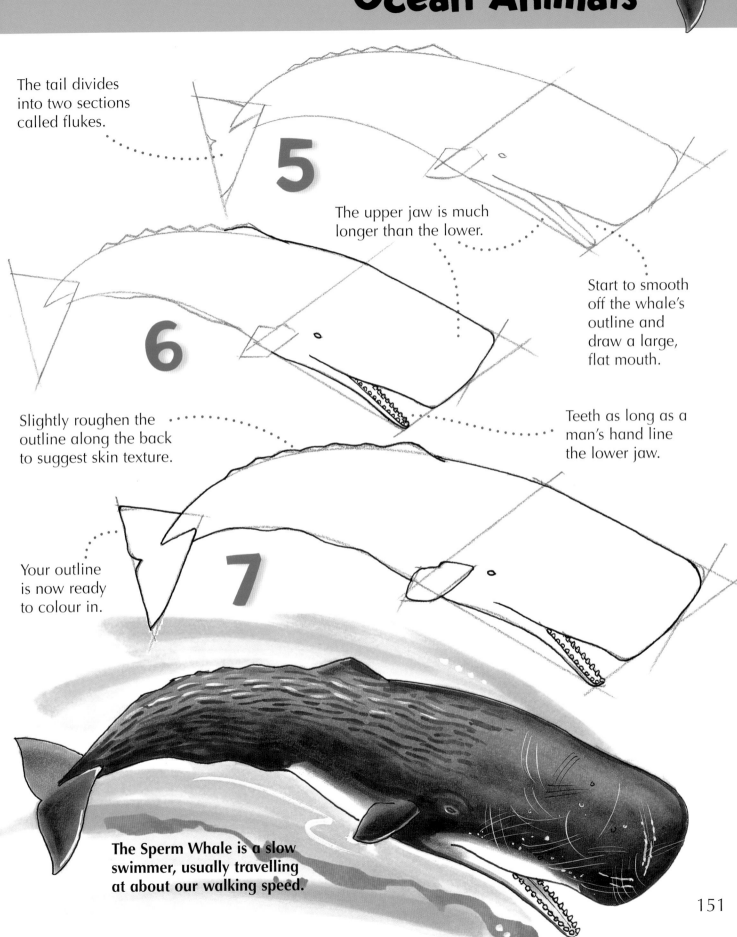

The tail divides into two sections called flukes.

5

The upper jaw is much longer than the lower.

Start to smooth off the whale's outline and draw a large, flat mouth.

6

Slightly roughen the outline along the back to suggest skin texture.

Teeth as long as a man's hand line the lower jaw.

7

Your outline is now ready to colour in.

The Sperm Whale is a slow swimmer, usually travelling at about our walking speed.

151

Dolphin

The Dolphin is the acrobat of the ocean. Some species can leap as high as 7 metres (twice the height of an elephant) out of the water – and perform somersaults in mid-air.

1

Draw two ovals for the head and body.

2

Dolphins are very intelligent – the large head houses a big brain.

A large triangle forms the tail.

3

Now join the tail to the body in a graceful curve.

Add a triangle for this fin.

4

Now start to shape the tail.

The flippers are quite short.

The long jaw is called a beak.

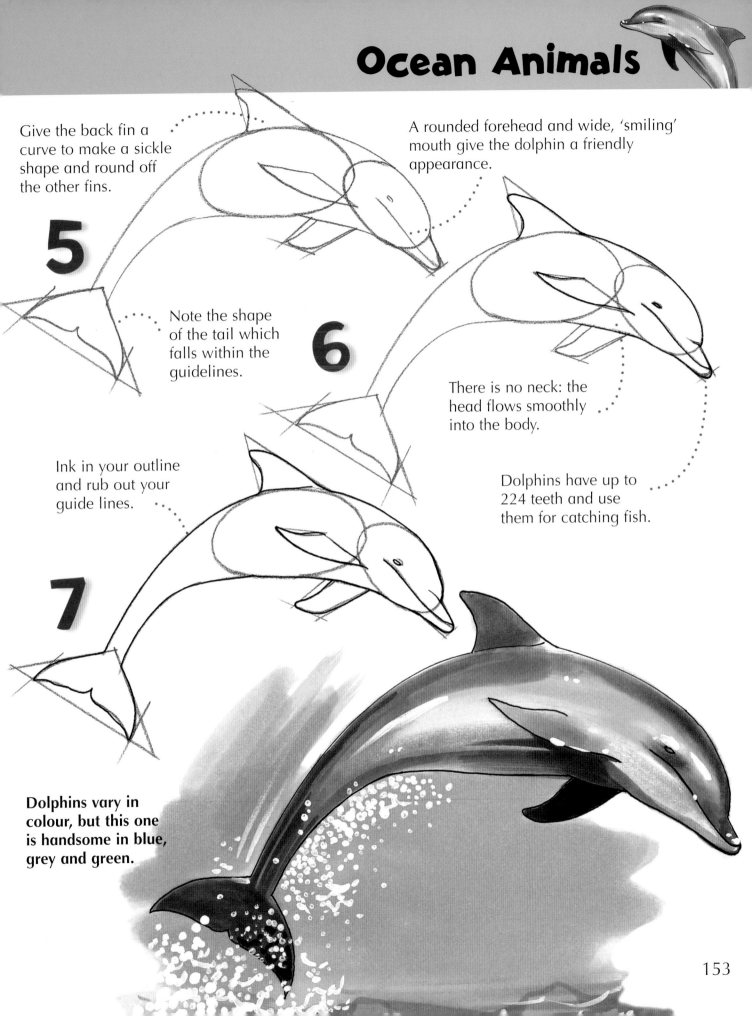

Give the back fin a curve to make a sickle shape and round off the other fins.

5

A rounded forehead and wide, 'smiling' mouth give the dolphin a friendly appearance.

Note the shape of the tail which falls within the guidelines.

6

There is no neck: the head flows smoothly into the body.

Dolphins have up to 224 teeth and use them for catching fish.

Ink in your outline and rub out your guide lines.

7

Dolphins vary in colour, but this one is handsome in blue, grey and green.

153

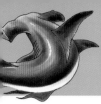

Hammerhead Shark

You only have to look at a Hammerhead to see how it got its name. The strange, flattened head extends on either side to form a shape just like a hammer.

1 Start with a lopsided crescent which will become the shark's body.

2 Add another sail-like shape to mark out the position of the tail.

Note how the curved body fits together with the tail.

3 Draw in curved lines for the strange head.

The upper part of the tail fin is much longer than the lower section.

Start to shape the tail fin.

A curved line here marks where the white of the underparts begins.

Draw triangles for the fins.

4 Draw in the 'hammer'. The round eye is placed right at the end, giving good vision to one side.

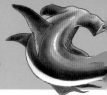

Draw in the gill slits.

Note the tiny notch in the top of the tail.

The powerful tail propels the shark through the water.

5

Shape the fins within the guide triangles. The back fin is very high and curved.

6

The other eye is hidden on the far side of the head.

7

The drawing is complete and ready for you to colour.

Hammerheads eat fish and other sea life, but are mostly harmless to humans.

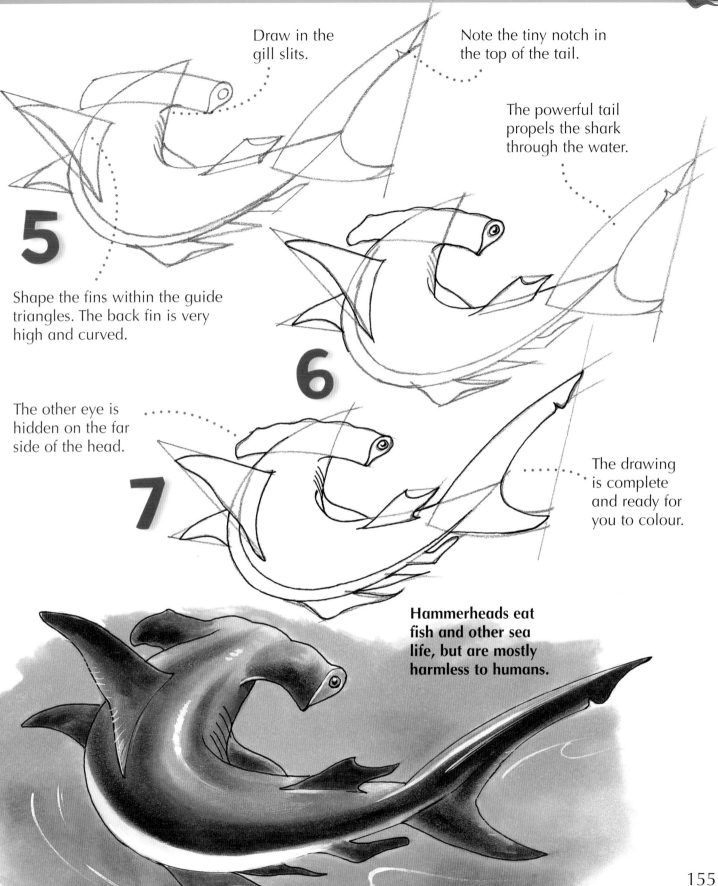

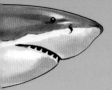

Ocean Animals

Great White Shark

This is the biggest and most dangerous of all sharks. It hunts large prey like seals and dolphins – and sometimes attacks humans. Most people know this shark best as the giant man-eater in the film Jaws.

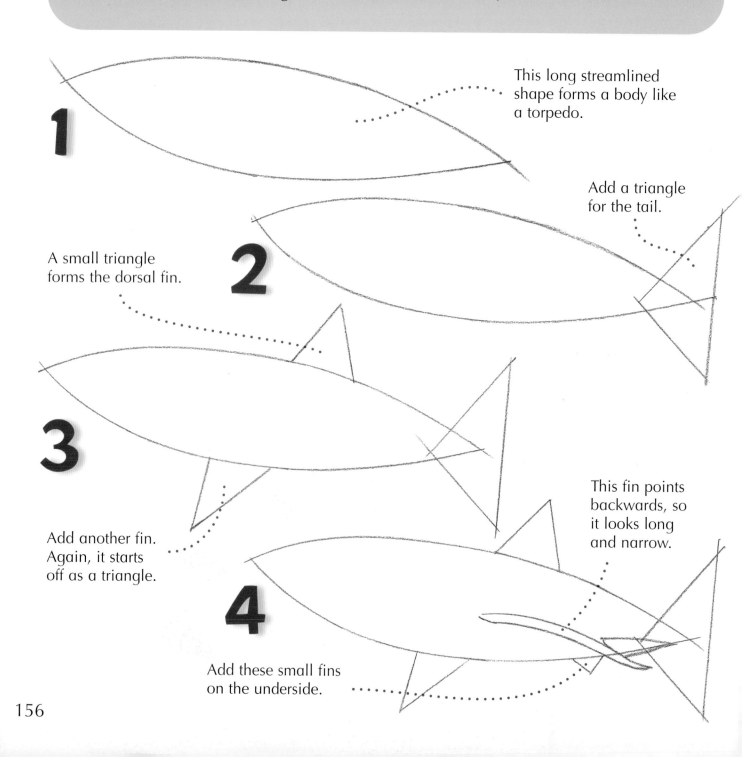

1 This long streamlined shape forms a body like a torpedo.

2 Add a triangle for the tail.

A small triangle forms the dorsal fin.

3 Add another fin. Again, it starts off as a triangle.

This fin points backwards, so it looks long and narrow.

4 Add these small fins on the underside.

156

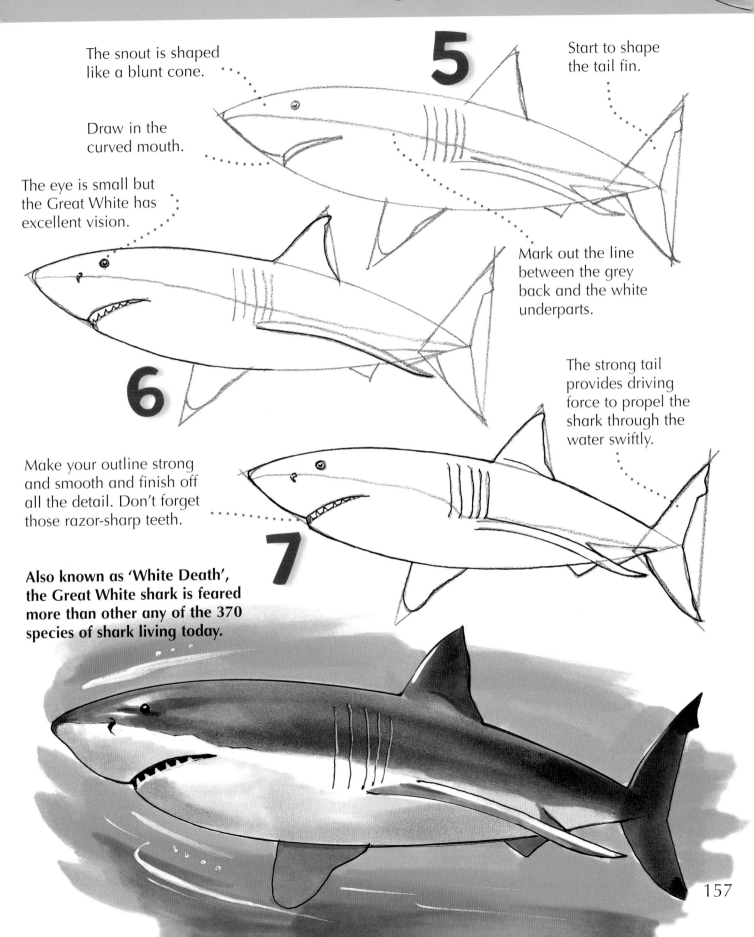

5

The snout is shaped like a blunt cone.

Draw in the curved mouth.

Start to shape the tail fin.

The eye is small but the Great White has excellent vision.

Mark out the line between the grey back and the white underparts.

6

The strong tail provides driving force to propel the shark through the water swiftly.

Make your outline strong and smooth and finish off all the detail. Don't forget those razor-sharp teeth.

7

Also known as 'White Death', the Great White shark is feared more than other any of the 370 species of shark living today.

Humpback Whale

Humpback Whales are famous for their 'songs'. They 'talk' to each other underwater in musical-sounding clicks. Despite its large size, the Humpback feeds only on tiny sea creatures. A built-in sieve at the back of its mouth allows it to filter these out from mouthfuls of sea water.

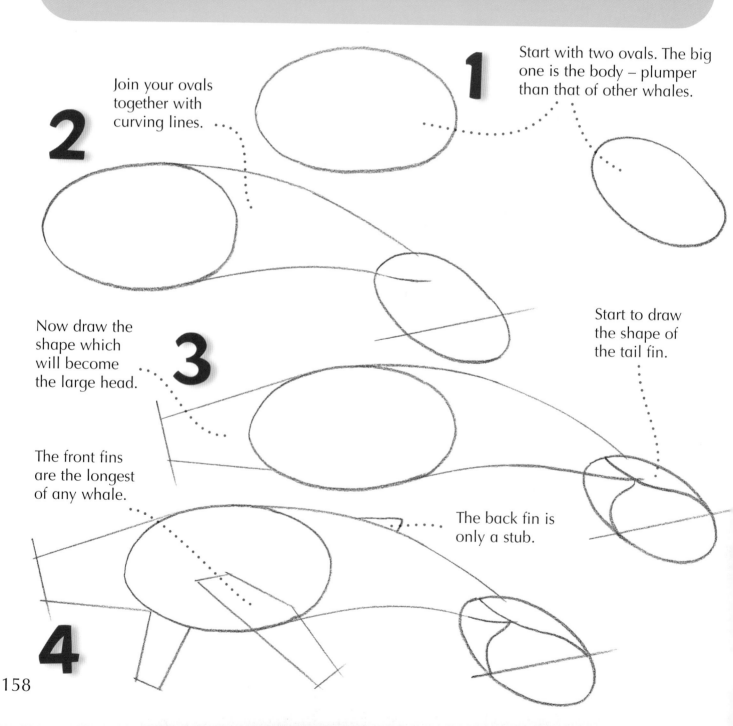

1 Start with two ovals. The big one is the body – plumper than that of other whales.

2 Join your ovals together with curving lines.

3 Now draw the shape which will become the large head.

Start to draw the shape of the tail fin.

The front fins are the longest of any whale.

The back fin is only a stub.

4

The small eye is set well back in the head.

Start to add more detail and smooth off the outline to your drawing.

5

Shape the fins, with a wavy front edge.

The tail is large – from tip to tip, larger than an elephant!

Deep grooves in the throat stretch like elastic when the whale is feeding.

6

The rounded back gives the Humpback its name.

Complete your drawing and it is ready to colour in.

7

Humpbacks live in family groups which travel together for thousands of miles across the oceans.

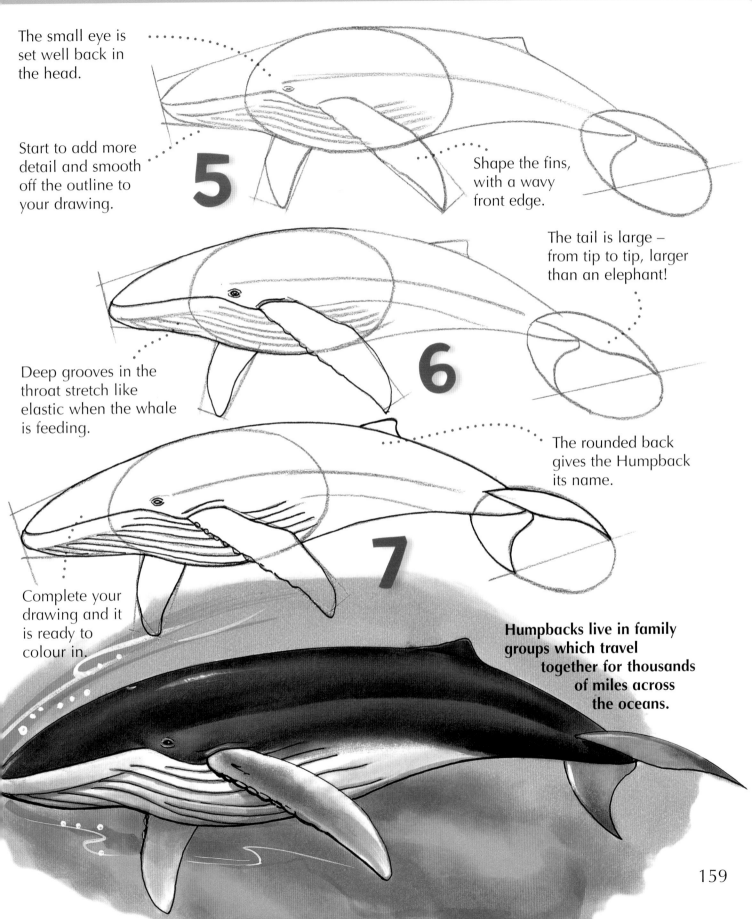

Thresher Shark

The Thresher has the longest tail of any fish – as long as its body. It uses this like a whip to stun its prey, threshing the water – hence its name. A strong swimmer, it sometimes jumps out of the water in pursuit of prey and may even catch seabirds.

1

Start with the long, narrow body.

2

This long, thin oblong will contain the extra-long tail.

3

A tall triangle forms the shape of the back fin.

The front fins are long and powerful.

4

Now the basic shape of your shark is almost complete.

Shape the tail, tapering it to a narrow pointed tip.

Add the smaller fins on the underside.

Ocean Animals

Start to smooth the shape of the fins.

The second back fin is very small indeed.

Give your shark a short cone-shaped snout and a small mouth.

The tail is used like a whip to herd fish together before stunning them.

5

Now complete your outline and draw in the details carefully.

6

Work on your outline – don't forget the gills.

7

The Thresher Shark is found only in warm and tropical seas.

The Thresher is sometimes called the Whip-tailed Shark – you can see why!

Fin Whale

This is the second-largest living whale. But, like the Humpback, the Fin Whale feeds on tiny sea creatures which it sieves out of the water. It also hunts small fish, like herrings, which it herds together like a sheepdog before gulping them down.

1

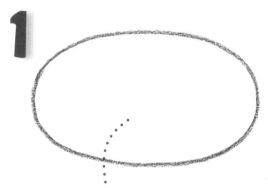

Start with this oval for the head. It has to be big to house several hundred fibrous plates which act as food sieves.

This oval shape will become the tail.

Add a long snout.

Join the head to the tail with curved lines. The body is quite slender compared to the head.

2

Now draw the open jaws.

The long, curved back gives the Fin Whale its nickname of 'Razorback'.

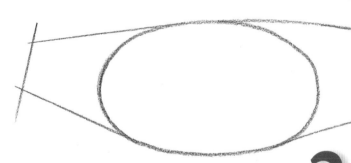

3

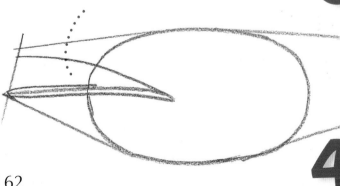

Mark a line where the tail fins will end.

4

5

Folds down the throat let it stretch like elastic to take in huge mouthfuls of water.

The narrow flippers are only an eighth of the body length.

Shape the tail fin with curved lines.

6

Inside the mouth are about 300 rows of 'sieves' (baleen plates) to filter microscopic food out of the water.

The eye is small and close to the mouth.

Add more detail to your drawing, giving your whale a smooth, streamlined body.

7

Complete your drawing by inking in the outline. Rub out any guide lines and your whale is ready to colour.

Fin Whales like company. They live in groups which may contain as many as 200 whales.

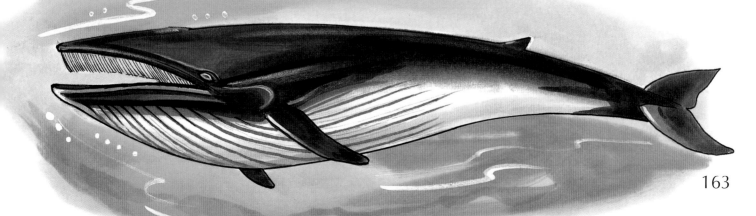

163

Basking Shark

This is a giant, beaten for size only by the Whale Shark, but it is one shark you don't have to fear. It has tiny teeth, and feeds on microscopic sea creatures. It gets its name because it likes to bask in the sun near the surface of the water.

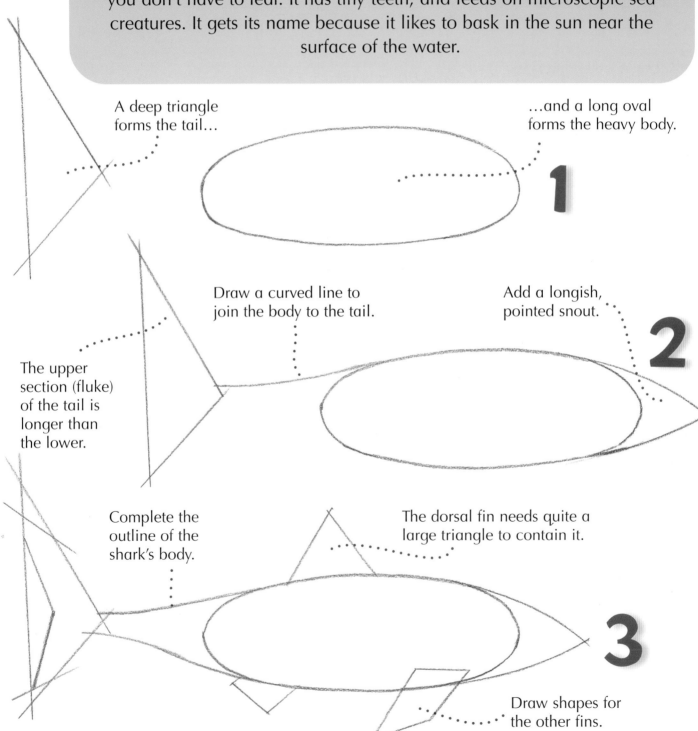

A deep triangle forms the tail...

...and a long oval forms the heavy body.

1

Draw a curved line to join the body to the tail.

Add a longish, pointed snout.

2

The upper section (fluke) of the tail is longer than the lower.

Complete the outline of the shark's body.

The dorsal fin needs quite a large triangle to contain it.

3

Draw shapes for the other fins.

Shape the strong tail, adding a small notch near the tip.

The enormous gill slits extend almost all around the head.

4

Curve the back edge of the dorsal fin like this.

The front fin ends in a blunt point.

5

The small eye is placed quite low on the head.

6

The body is shaped like a huge spindle.

Basking Sharks have sometimes been washed up, dead, on a beach – and been mistaken for sea monsters!

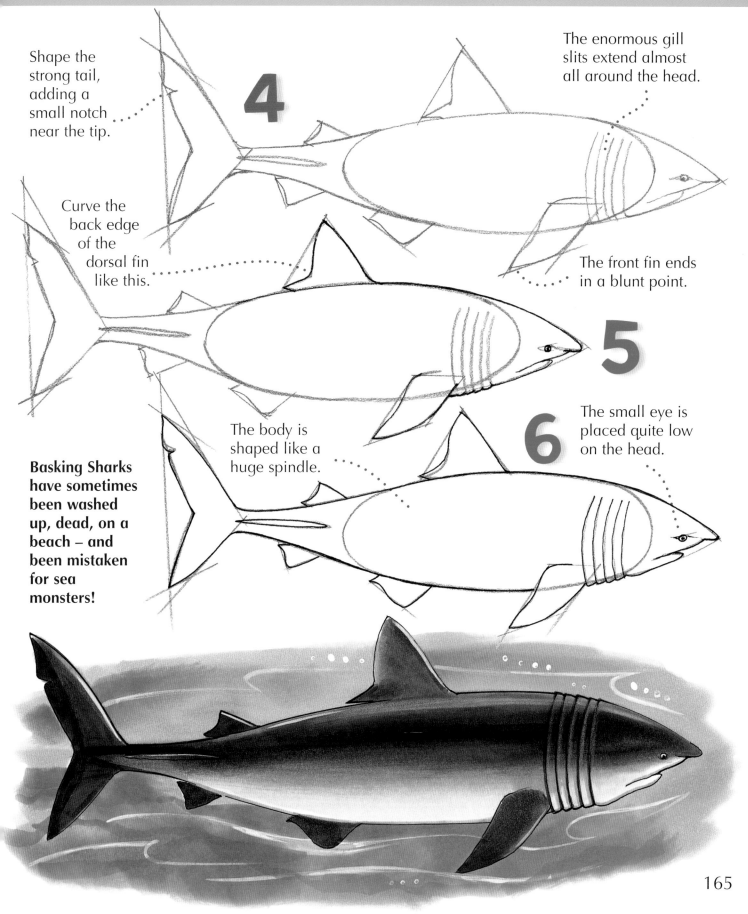

Killer Whale

The black and white Killer Whale is not actually a whale at all, but a member of the dolphin family. Large groups of Killers hunt in fierce packs to attack seals, porpoises and even whales. But tame Killers have shown themselves to be as intelligent and friendly as more popular dolphins.

1

Start with a large oval for the body.

A smaller, tilted oval marks out the tail.

2

Add a large, boxy shape for the head.

Cut off the corners of the head shape, but leave it blunt.

Now attach the tail to the body with a curving line.

3

The back fin is the tallest of any sea mammal – it stands as high as a man.

Add a graceful curve to form the underside of the Killer and draw a line to mark where the tail will end.

4

Draw an oval to form this flipper.

5

Put in a white oval above the eye, like a giant eyebrow.

Only males have this strikingly tall back fin: a female's fin is shorter and curvier.

Start to draw the flat, curved tail.

The front fins are large and rounded.

6

The blunt head lacks the beak of a Dolphin.

In top gear, Killers are probably the fastest swimmers in the sea.

7

Black and white markings make this species instantly recognizable.

Ink in your outline.

This handsome and ferocious hunter can swallow a big seal whole.

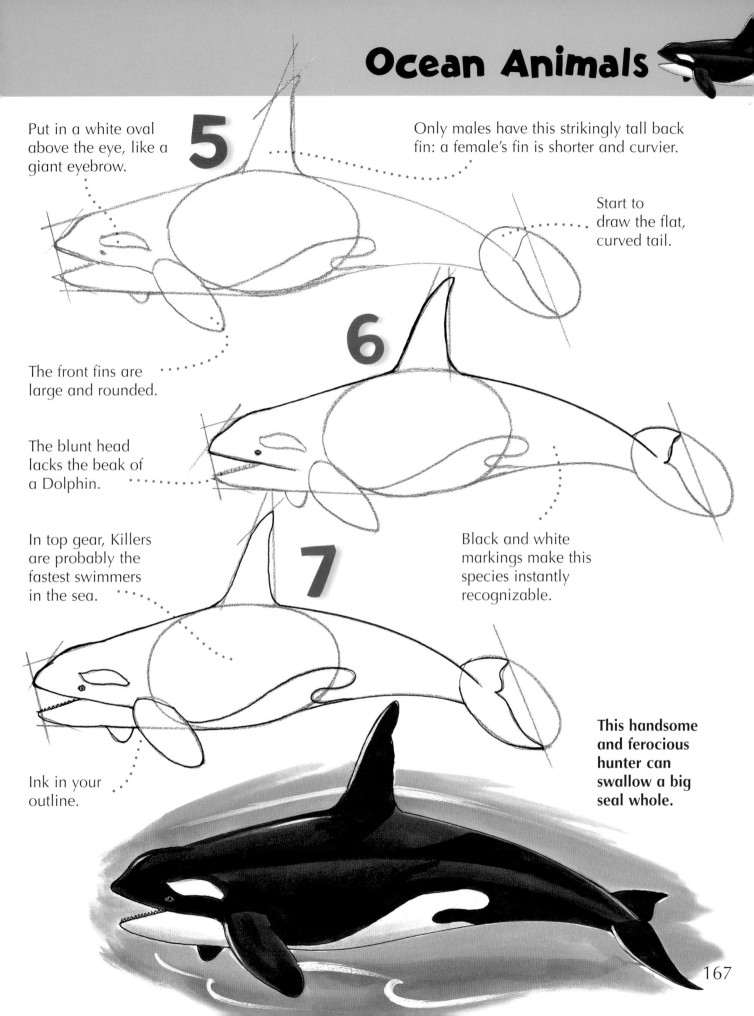

167

River Dolphin

River Dolphins live in the rivers of Asia and South America. Unable to hunt by sight in these muddy waters, they have developed radar, like bats. They 'see' underwater objects by aiming high-pitched clicking sounds at them and detecting the echoes as they bounce back.

1

Start with this oval for the body.

2

A circle for the head overlaps with your first shape.

River Dolphins are quite compact in shape.

3

The long slender beak is about the same length as the head circle.

Draw this sail shape for the tail.

4

Now join the tail to the body with curved lines.

Add broad flippers.

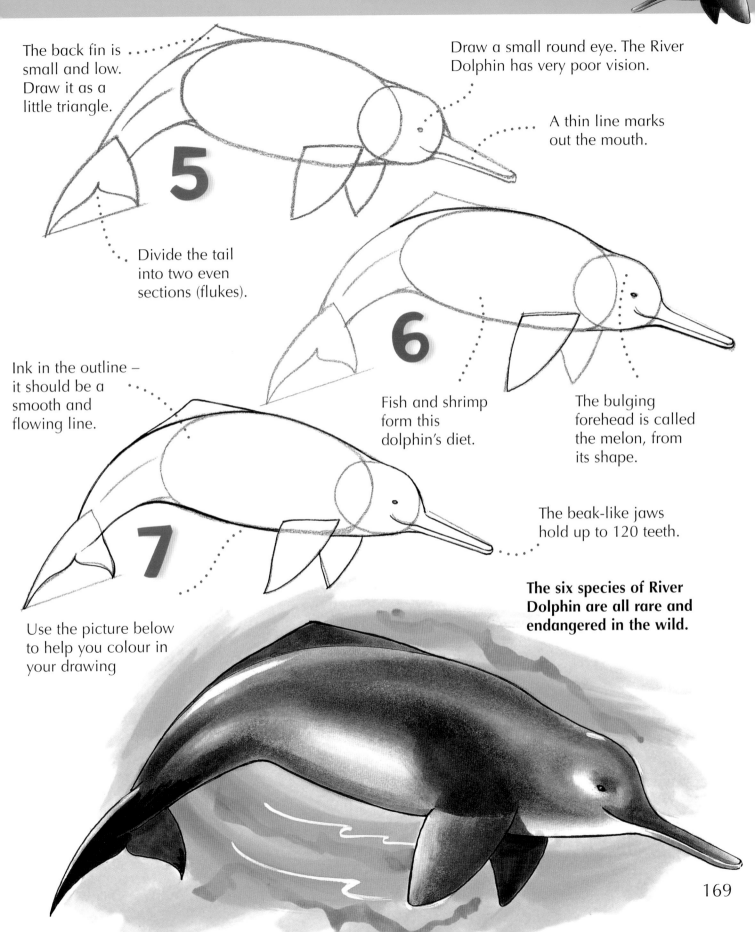

The back fin is small and low. Draw it as a little triangle.

5

Draw a small round eye. The River Dolphin has very poor vision.

A thin line marks out the mouth.

Divide the tail into two even sections (flukes).

6

Fish and shrimp form this dolphin's diet.

The bulging forehead is called the melon, from its shape.

Ink in the outline – it should be a smooth and flowing line.

7

The beak-like jaws hold up to 120 teeth.

The six species of River Dolphin are all rare and endangered in the wild.

Use the picture below to help you colour in your drawing

169

Bottlenose Whale

There are many kinds of Beaked Whales, with long, beak-like snouts. As its name suggests, the Bottlenose has the most oddly shaped beak of all. Its whole head is unusual, with a huge bulging forehead which makes the long beak beneath it look just like the neck of a bottle.

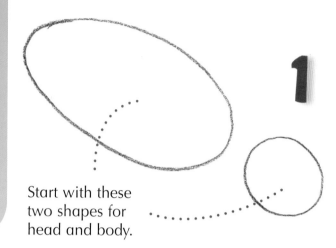

1

Start with these two shapes for head and body.

2

This triangle forms the tail.

Join the tail to the body with curved lines.

The small triangular rear fin is set well back.

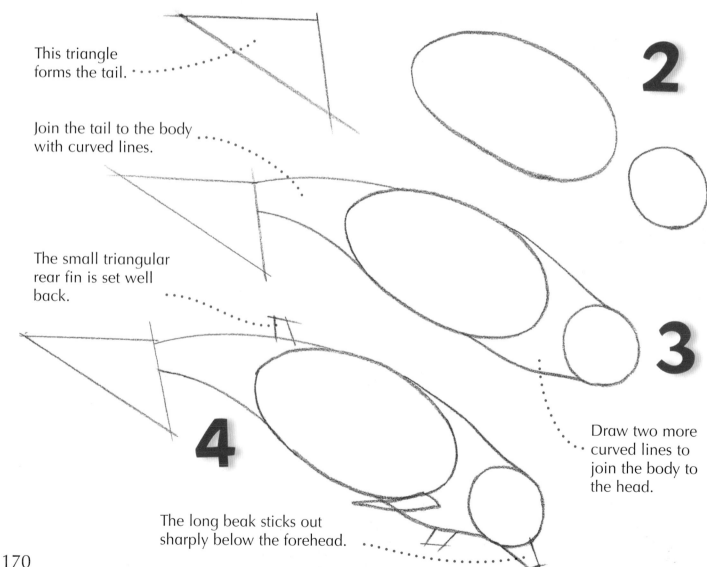

3

Draw two more curved lines to join the body to the head.

4

The long beak sticks out sharply below the forehead.

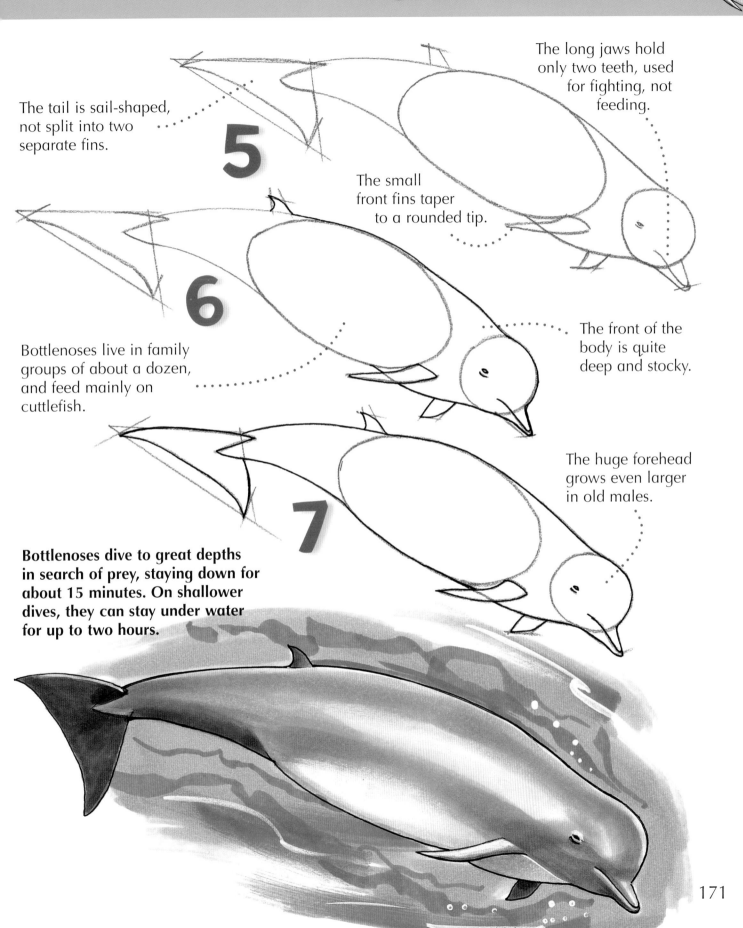

The tail is sail-shaped, not split into two separate fins.

The long jaws hold only two teeth, used for fighting, not feeding.

The small front fins taper to a rounded tip.

Bottlenoses live in family groups of about a dozen, and feed mainly on cuttlefish.

The front of the body is quite deep and stocky.

Bottlenoses dive to great depths in search of prey, staying down for about 15 minutes. On shallower dives, they can stay under water for up to two hours.

The huge forehead grows even larger in old males.

171

Harrier

This fighter plane is a jump jet – an aircraft which can take off straight upwards, and land by coming straight down. It is designed for use on aircraft carriers, or anywhere there is limited space for a runway.

1 The whole drawing sits on this central line. Take care how you space your sections along it.

This triangle forms the wings.

2 Build up the shape of the plane with straight lines. A smaller triangle at the rear forms the tail.

Now add a gentle curve on either side of the fuselage in front of the wings. This shapes the inlets that direct air to the engine.

3

Draw in the cockpit, and complete the nose of the plane.

4

Shape the tail of the plane. From above, you can only see the upper edge of the upright tail fin.

172

The cockpit contains an ejector seat, so the pilot can escape quickly if the plane is in trouble.

5

The Harrier's missiles and bombs and extra fuel tanks are carried under the wings.

The cockpit houses all the dials and controls that help the pilot to fly.

7

Draw in camouflage markings, which make the plane harder for enemy planes to spot. Add roundels on the wings.

6

This is the radar warning receiver, to spot enemy aircraft coming up behind.

The Harrier is a Vertical Take-Off and Landing (VTOL) fighter. It works because the engine nozzles can swivel to point downwards when it is time to take off or land.

Flying Machines

Avro Tutor

This little biplane was used in the 1930s to train military pilots. A basic trainer for absolute beginners, it flies very slowly and is therefore easy to land. It has two seats, one for the learner pilot and one for his instructor. Pilots learned the basic skills on this before moving on to faster aircraft.

1

These three shapes form the body (fuselage) of the plane and its upright tail fin.

2

Now add the flat tailplane, with its squared-off ends, under the upright fin.

These two small circles form the wheels.

3

Add four short straight lines for the wheel struts. The wheels do not fold away, but hang down when the aircraft is in flight.

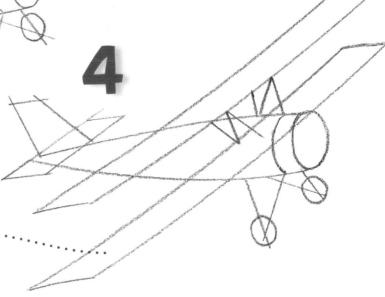

4

Draw the two pairs of wings, of the same size, one above the other.

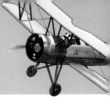

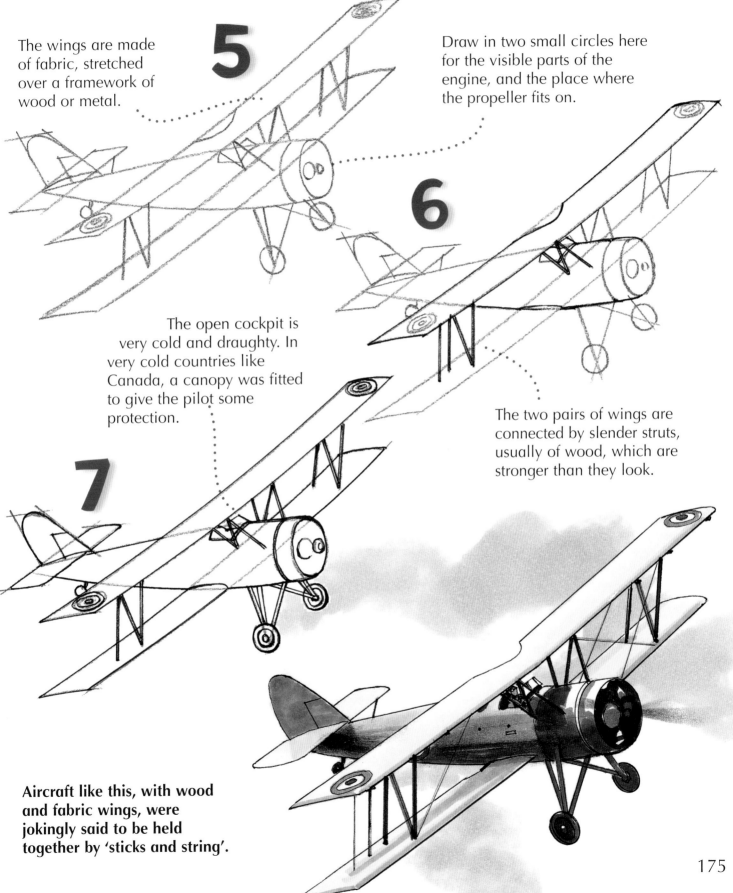

5

The wings are made of fabric, stretched over a framework of wood or metal.

Draw in two small circles here for the visible parts of the engine, and the place where the propeller fits on.

6

The open cockpit is very cold and draughty. In very cold countries like Canada, a canopy was fitted to give the pilot some protection.

7

The two pairs of wings are connected by slender struts, usually of wood, which are stronger than they look.

Aircraft like this, with wood and fabric wings, were jokingly said to be held together by 'sticks and string'.

175

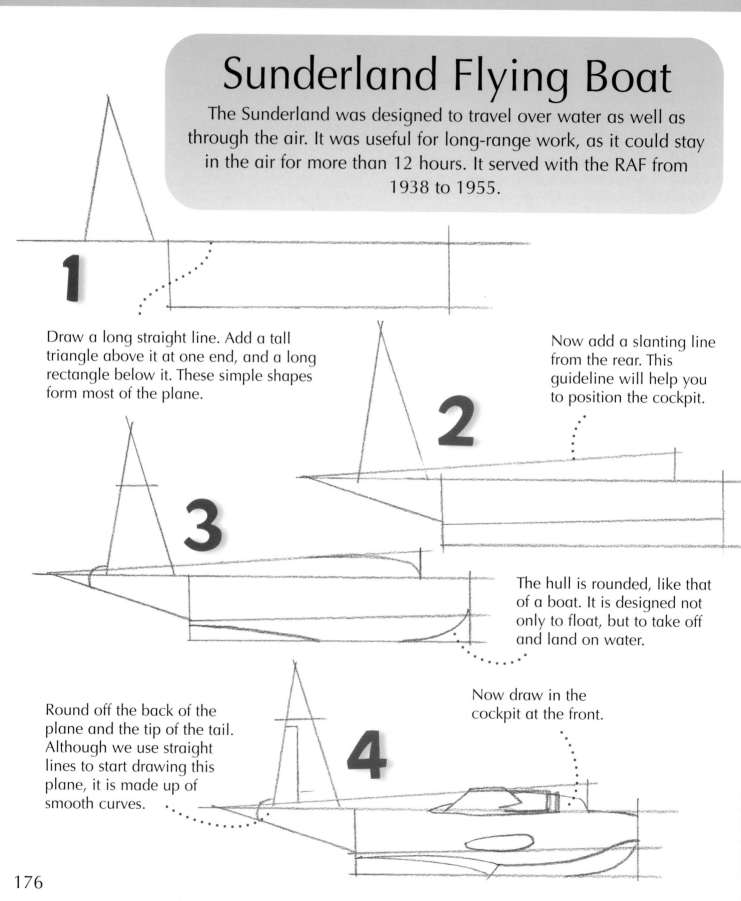

Sunderland Flying Boat

The Sunderland was designed to travel over water as well as through the air. It was useful for long-range work, as it could stay in the air for more than 12 hours. It served with the RAF from 1938 to 1955.

1 Draw a long straight line. Add a tall triangle above it at one end, and a long rectangle below it. These simple shapes form most of the plane.

2 Now add a slanting line from the rear. This guideline will help you to position the cockpit.

3 Round off the back of the plane and the tip of the tail. Although we use straight lines to start drawing this plane, it is made up of smooth curves.

The hull is rounded, like that of a boat. It is designed not only to float, but to take off and land on water.

4 Now draw in the cockpit at the front.

176

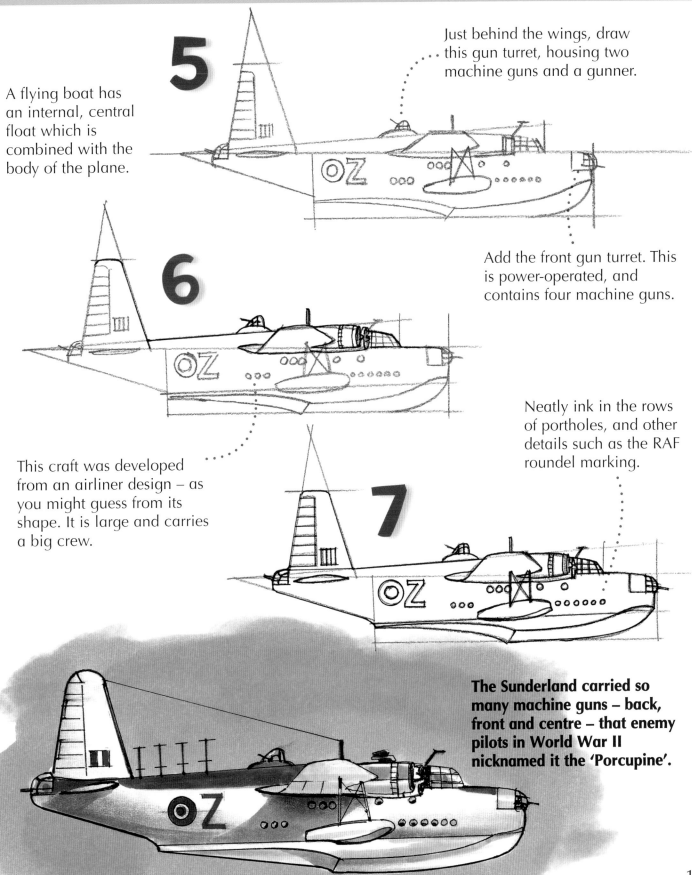

5

A flying boat has an internal, central float which is combined with the body of the plane.

Just behind the wings, draw this gun turret, housing two machine guns and a gunner.

Add the front gun turret. This is power-operated, and contains four machine guns.

6

This craft was developed from an airliner design – as you might guess from its shape. It is large and carries a big crew.

Neatly ink in the rows of portholes, and other details such as the RAF roundel marking.

7

The Sunderland carried so many machine guns – back, front and centre – that enemy pilots in World War II nicknamed it the 'Porcupine'.

177

Flying Machines

Hot-air Balloon

This is the oldest form of flying machine, invented in France in 1783. It is also the simplest, using the natural law that hot air is lighter than cold air and therefore rises. It has no steering mechanism, but goes where the wind takes it.

1

Start with this simple oval shape, and draw a straight line down the centre.

Two more lines complete the shape of the airtight canopy which holds the hot air. At the base, sketch in the basket where the crew are stationed.

2

3

These curved lines help to show the rounded shape of the balloon.

Add a gentle curve to the outside lines, too.

4

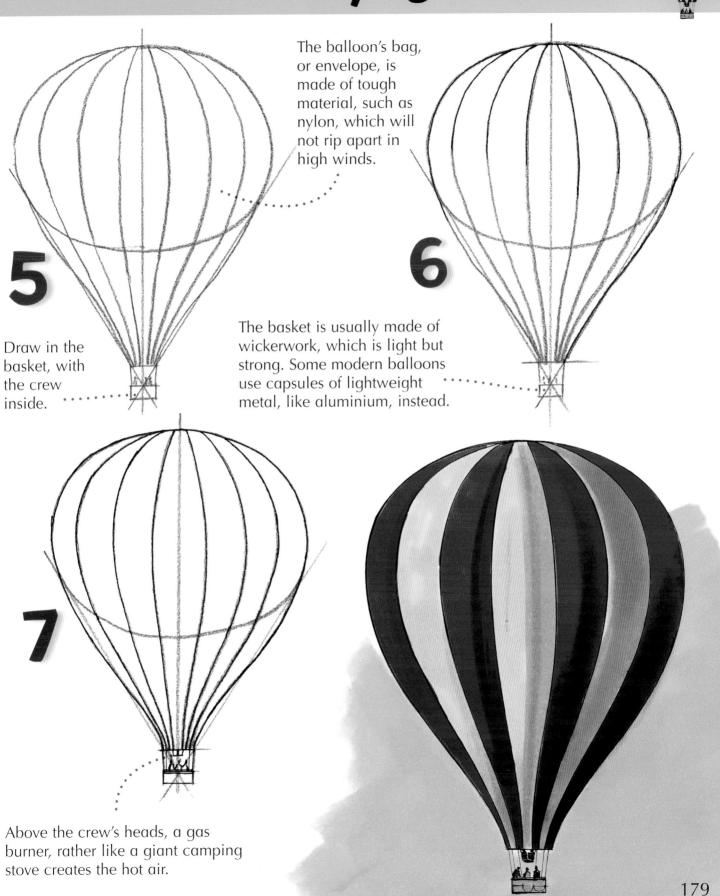

5

Draw in the basket, with the crew inside.

The balloon's bag, or envelope, is made of tough material, such as nylon, which will not rip apart in high winds.

6

The basket is usually made of wickerwork, which is light but strong. Some modern balloons use capsules of lightweight metal, like aluminium, instead.

7

Above the crew's heads, a gas burner, rather like a giant camping stove creates the hot air.

179

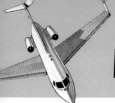

Gulfstream

This American twin-jet plane can carry up to 19 passengers in comfort. It is also used for special duties from anti-submarine warfare to sea and fishery patrols.

1

Start with this rectangular shape across a central line.

2

Draw two long triangles from the central line, for the wings. Add a flat triangle at the top for the tailplane.

Now trim off the top of the tailplane with two more slanted lines, making it narrower.

3

Trim off the ends of the tail and the wings with short slanting lines.

About halfway down the block in front of the wings, begin to shape the pointed nose of the plane with smooth curves.

4

The two jet engines are mounted towards the rear of the plane, behind the wings.

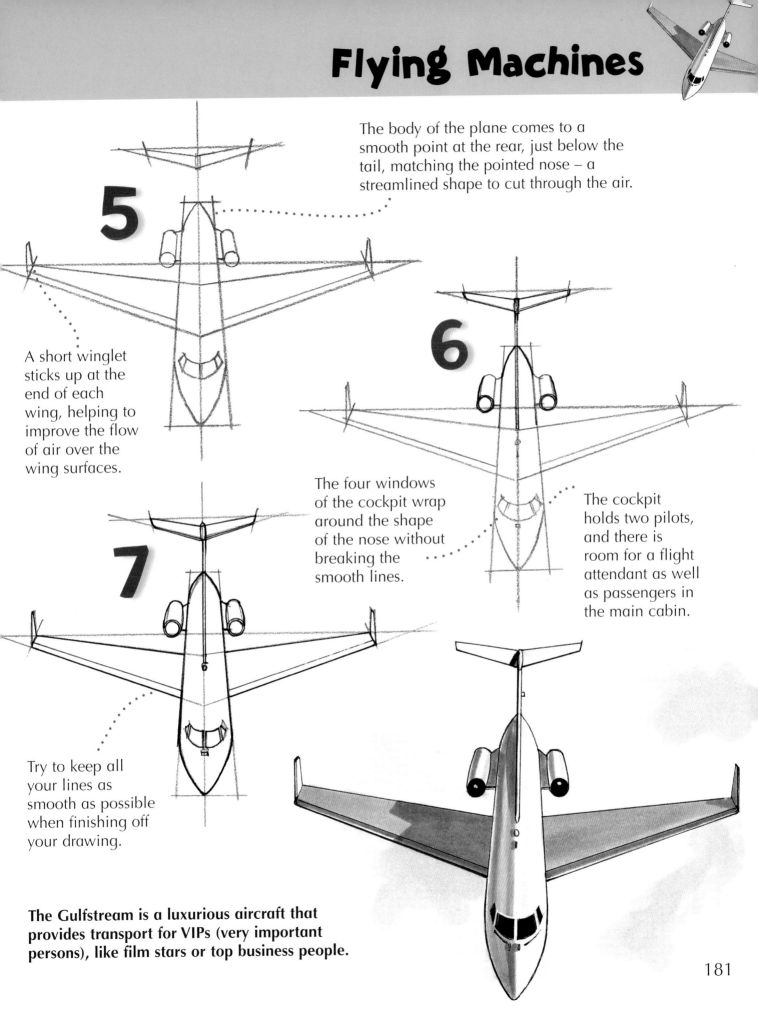

5

The body of the plane comes to a smooth point at the rear, just below the tail, matching the pointed nose – a streamlined shape to cut through the air.

A short winglet sticks up at the end of each wing, helping to improve the flow of air over the wing surfaces.

6

The four windows of the cockpit wrap around the shape of the nose without breaking the smooth lines.

The cockpit holds two pilots, and there is room for a flight attendant as well as passengers in the main cabin.

7

Try to keep all your lines as smooth as possible when finishing off your drawing.

The Gulfstream is a luxurious aircraft that provides transport for VIPs (very important persons), like film stars or top business people.

F-14 Tomcat

This fighter plane was specially designed to fly from aircraft carriers. Its task is to attack other fighter planes, and also to take on enemy bombers.

1

Start with a central line and two triangles for the wings – a shape rather like a paper aeroplane.

2

Movable 'swing wings' fitted with powerful flaps and slats can fold back in flight to make the plane perform better. They swing right back for high-speed flight.

Now start dividing up this shape with short straight lines.

3

Draw the radar 'stinger' as a small oblong. Called a stinger because it is set at the tail like a wasp's sting, it warns of missiles or enemy aircraft coming up from behind.

4

These intakes funnel air to the twin engines (not seen at this angle), which run down the side of the fuselage.

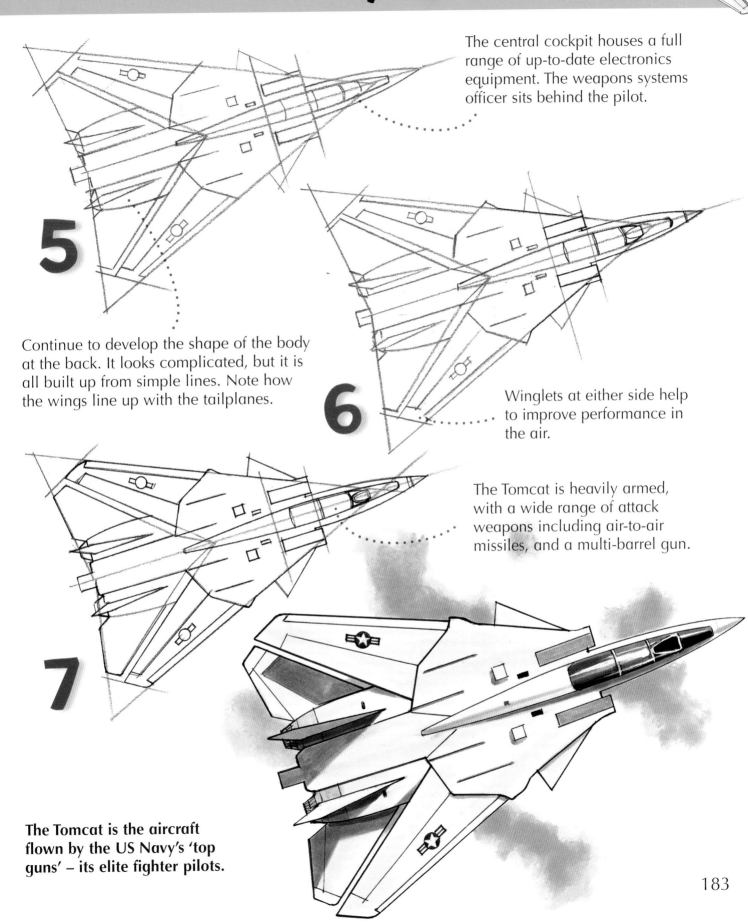

5

The central cockpit houses a full range of up-to-date electronics equipment. The weapons systems officer sits behind the pilot.

Continue to develop the shape of the body at the back. It looks complicated, but it is all built up from simple lines. Note how the wings line up with the tailplanes.

6

Winglets at either side help to improve performance in the air.

The Tomcat is heavily armed, with a wide range of attack weapons including air-to-air missiles, and a multi-barrel gun.

7

The Tomcat is the aircraft flown by the US Navy's 'top guns' – its elite fighter pilots.

183

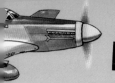

Flying Machines

Mustang

One of fastest aircraft of World War II, this fighter plane was so highly thought of that it was nicknamed the 'Cadillac of the Air' after the famous car. It first flew in 1940. Designed in America, it was used to escort bombers from Britain on their long-range missions over Germany.

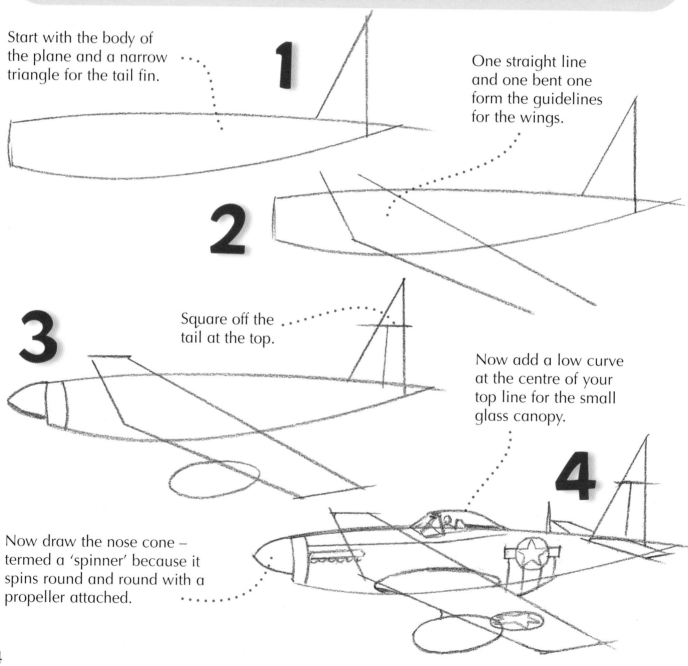

Start with the body of the plane and a narrow triangle for the tail fin.

1

One straight line and one bent one form the guidelines for the wings.

2

3

Square off the tail at the top.

Now add a low curve at the centre of your top line for the small glass canopy.

4

Now draw the nose cone – termed a 'spinner' because it spins round and round with a propeller attached.

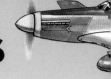

Flying Machines

5

The Mustang has square-ended wings, matching the squared-off tail.

The cocktail has a 'bubble' canopy to give the pilot good all-round vision.

The exhaust pipes from the aircraft's engine stick out at the side.

Drop tanks under the wings hold extra fuel, allowing the Mustang to fly further. It was the only fighter that could escort bombers all the way from Britain to Germany.

6

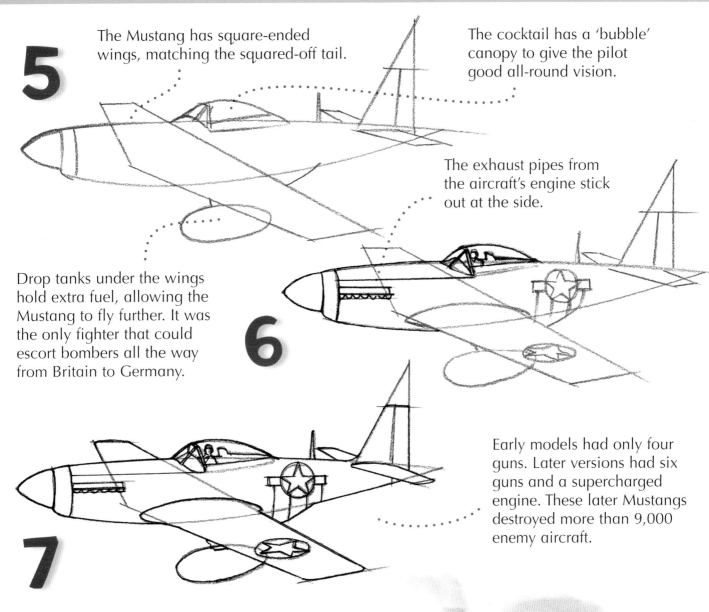

7

Early models had only four guns. Later versions had six guns and a supercharged engine. These later Mustangs destroyed more than 9,000 enemy aircraft.

The Mustang came in different variants as fighter, photo reconnaissance plane or dive bomber.

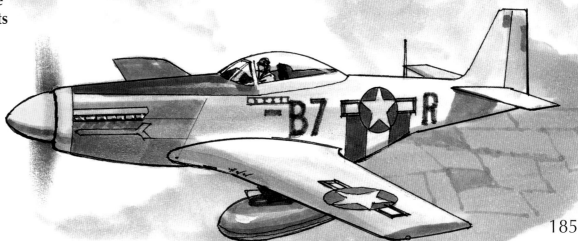

185

Space Shuttle

First launched in 1981, the Space Shuttle is designed to travel repeatedly into space and back again – unlike earlier space rockets, which could be used only once.

1

A simple line and triangle form the basis of the Shuttle's three main sections: orbiter, rocket boosters and external tank.

2

This column will form the external tank. It holds fuel for the launch and climb, and drops off before the Shuttle goes into orbit.

These two lines will help you position the nose cones of the rocket boosters.

3

Shape the wings of the orbiter. These aid its return to Earth: it takes off like a rocket, but glides back like a plane.

4

Draw the slim rocket boosters on either side. Sketch in the main engines at the tail of the orbiter.

186

5

Shape the orbiter's nose cone. It protects the Shuttle against heat of 1,260°C on re-entry into the earth's atmosphere.

6

The flight deck houses the crew – pilot, co-pilot and several mission specialists.

The Shuttle is only launched from Kennedy Space Center in Florida, USA.

7

The cargo bay carries the payload – laboratories, telescopes and satellites etc.

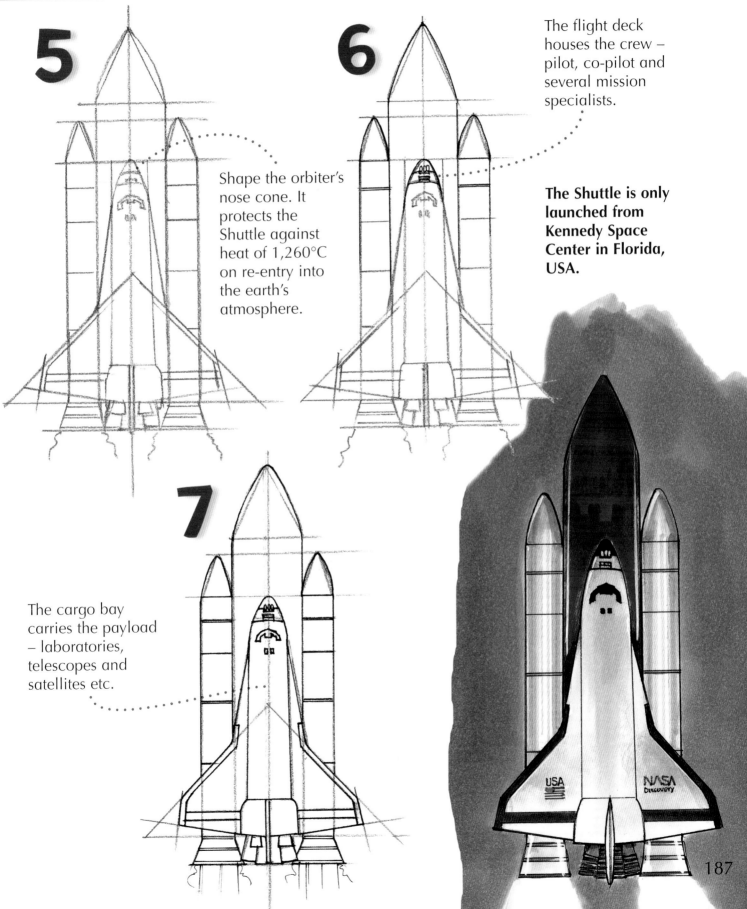

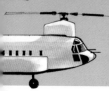
Chinook Helicopter

In service since 1962, the Chinook is the standard medium transport helicopter of the US Army. It can carry up to 44 soldiers. It can also be used to transport cargo, which may be carried inside or slung underneath, with the helicopter acting as a flying crane.

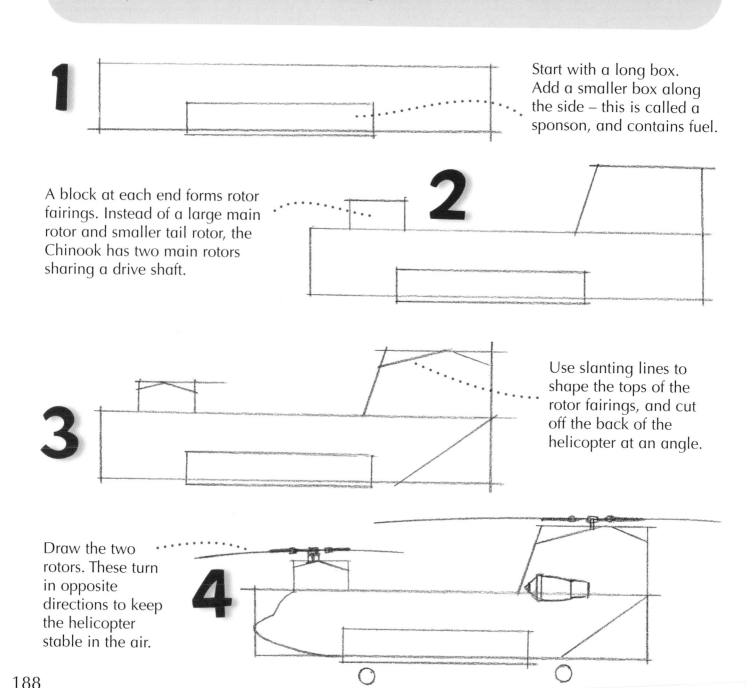

1 Start with a long box. Add a smaller box along the side – this is called a sponson, and contains fuel.

2 A block at each end forms rotor fairings. Instead of a large main rotor and smaller tail rotor, the Chinook has two main rotors sharing a drive shaft.

3 Use slanting lines to shape the tops of the rotor fairings, and cut off the back of the helicopter at an angle.

4 Draw the two rotors. These turn in opposite directions to keep the helicopter stable in the air.

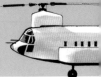

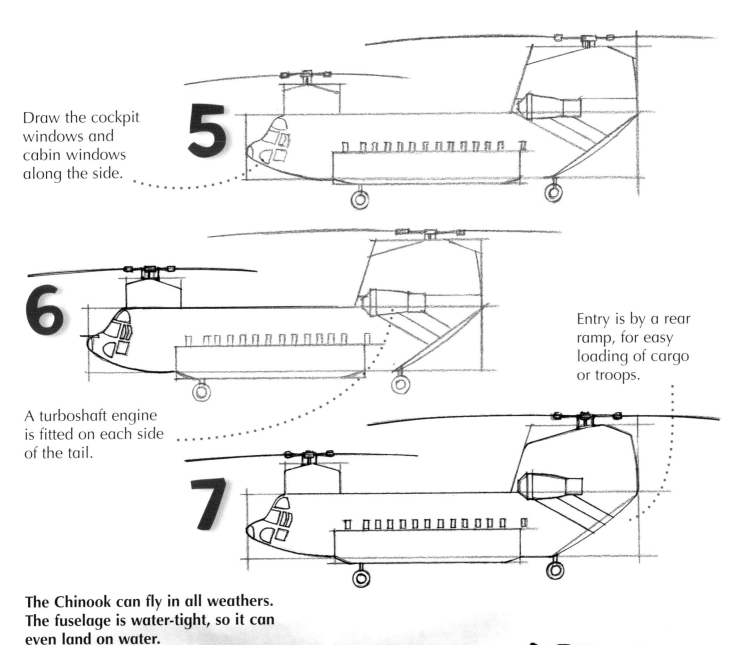

Draw the cockpit windows and cabin windows along the side.

5

6

Entry is by a rear ramp, for easy loading of cargo or troops.

A turboshaft engine is fitted on each side of the tail.

7

The Chinook can fly in all weathers. The fuselage is water-tight, so it can even land on water.

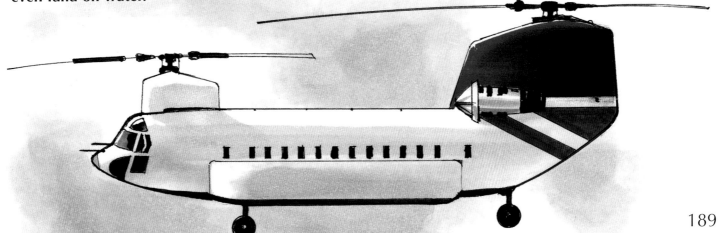

189

Microlight

This tiny aircraft is basically a hang glider with an engine. To support the motor, the structure has become a bit more complicated and the wing span has increased. The pilot has a seat instead of hanging from a harness.

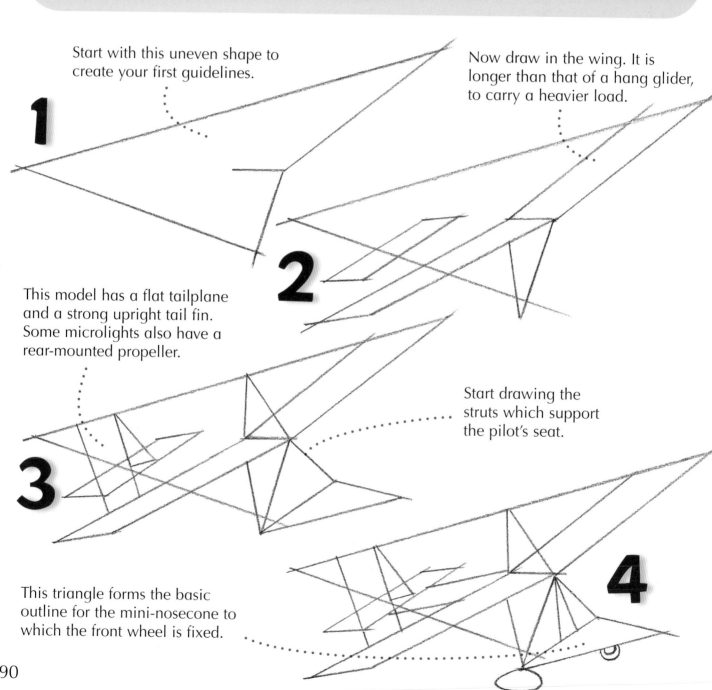

Start with this uneven shape to create your first guidelines.

1

Now draw in the wing. It is longer than that of a hang glider, to carry a heavier load.

2

This model has a flat tailplane and a strong upright tail fin. Some microlights also have a rear-mounted propeller.

3

Start drawing the struts which support the pilot's seat.

This triangle forms the basic outline for the mini-nosecone to which the front wheel is fixed.

4

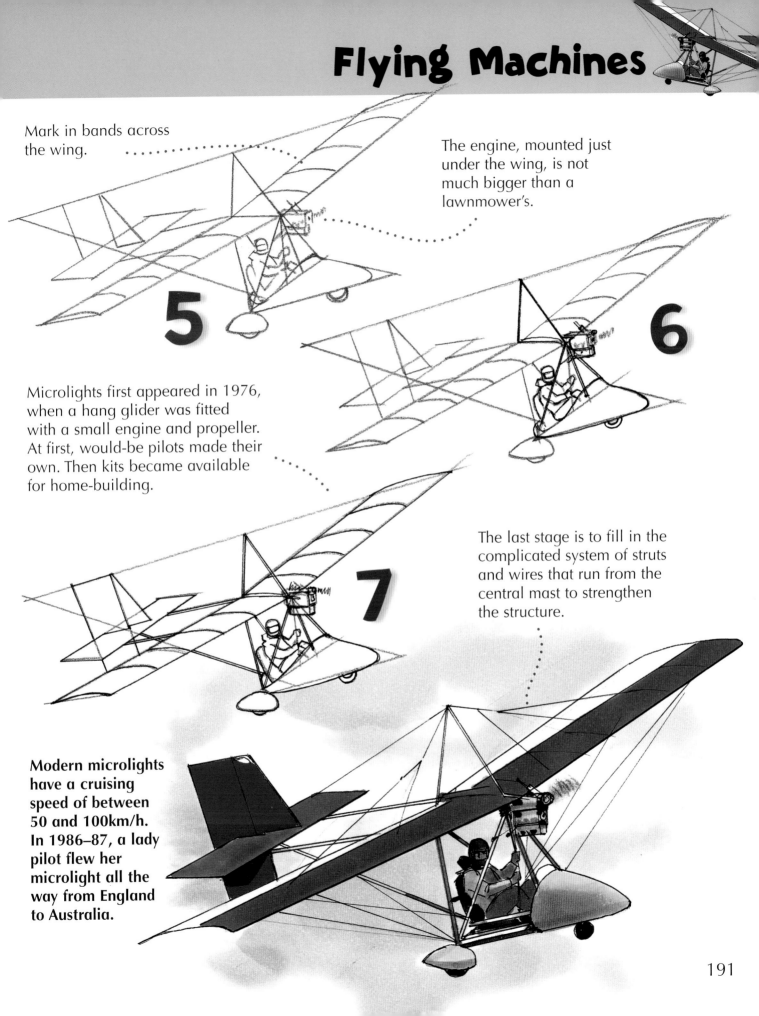

Flying Machines

Mark in bands across the wing.

The engine, mounted just under the wing, is not much bigger than a lawnmower's.

5

6

Microlights first appeared in 1976, when a hang glider was fitted with a small engine and propeller. At first, would-be pilots made their own. Then kits became available for home-building.

The last stage is to fill in the complicated system of struts and wires that run from the central mast to strengthen the structure.

7

Modern microlights have a cruising speed of between 50 and 100km/h. In 1986–87, a lady pilot flew her microlight all the way from England to Australia.

191

Flying Machines

Spitfire

The most famous fighter plane of all time, the Spitfire first flew in 1936. Its nimble handling made it popular with RAF pilots as they took on enemy aircraft during World War II.

1 Start with this boat-like shape, crossed by two slanting lines.

2 Draw the wings as a long leaf-shape, set at an angle to the body.

3 Now add the short, pointed propeller spinner.

4

Add a little bump under the body, just in front of the wings. This is the air intake to cool the supercharged Rolls Royce Merlin engine.

The single-seater cockpit has a clear, 'tear-drop' canopy to give the pilot a good all-round view.

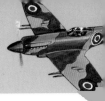

5

The Spitfire was light, fast and easy to fly; it made an ideal fighter.

Round off the edges of the wings. Machine guns and ammunition are mounted inside the wings.

6

Draw short lines under the wings for the guns. The outer, shorter guns are machine guns; the slightly longer inner ones are cannon firing more powerful shells.

7

Draw in the camouflage pattern and the RAF roundels.

In service from 1939, the Spitfire served all through World War II and for quite a long time afterwards. Between 1939 and 1947, more than 20,000 Spitfires were built for the RAF.

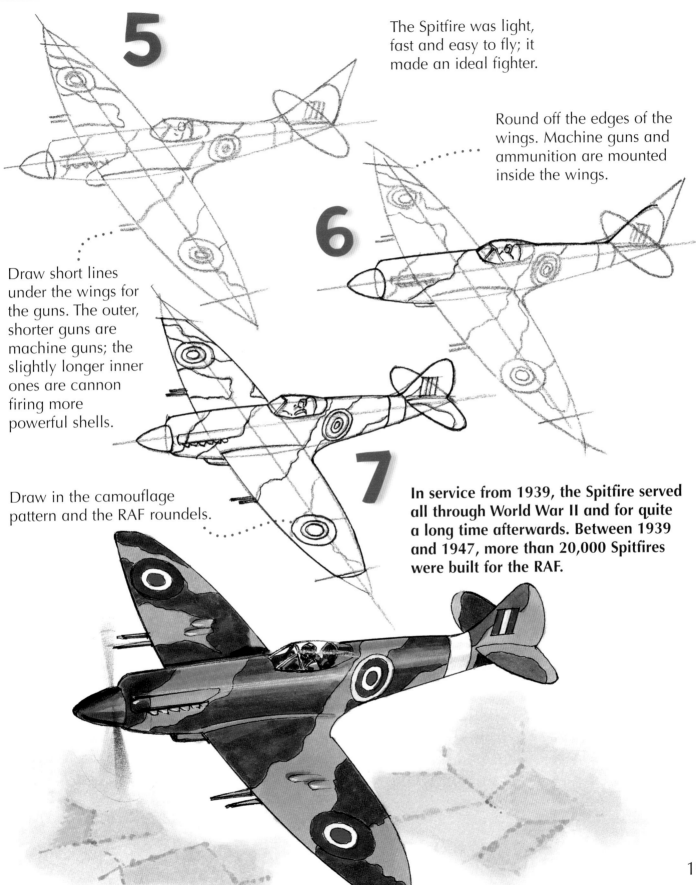

193

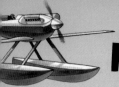

Supermarine Seaplane

The Supermarine is a seaplane, with floats instead of wheels so that it can land on or take off from water. In the late 1920s, when the Supermarine was built, it was the fastest plane in the world. It was designed specially to compete in an annual race called the Schneider Trophy.

Start with this shape, blunt at one end and pointed at the other. Add a big, tall tail fin.

1

These two triangles at the base form the struts, which attach the floats (also known as pontoons) to the body.

2

3

Under your triangles, add these two long rectangle shapes, as deep as the body, to form guidelines for the floats.

Now draw in the large, canoe-shaped floats. These hold the seaplane above the water.

4

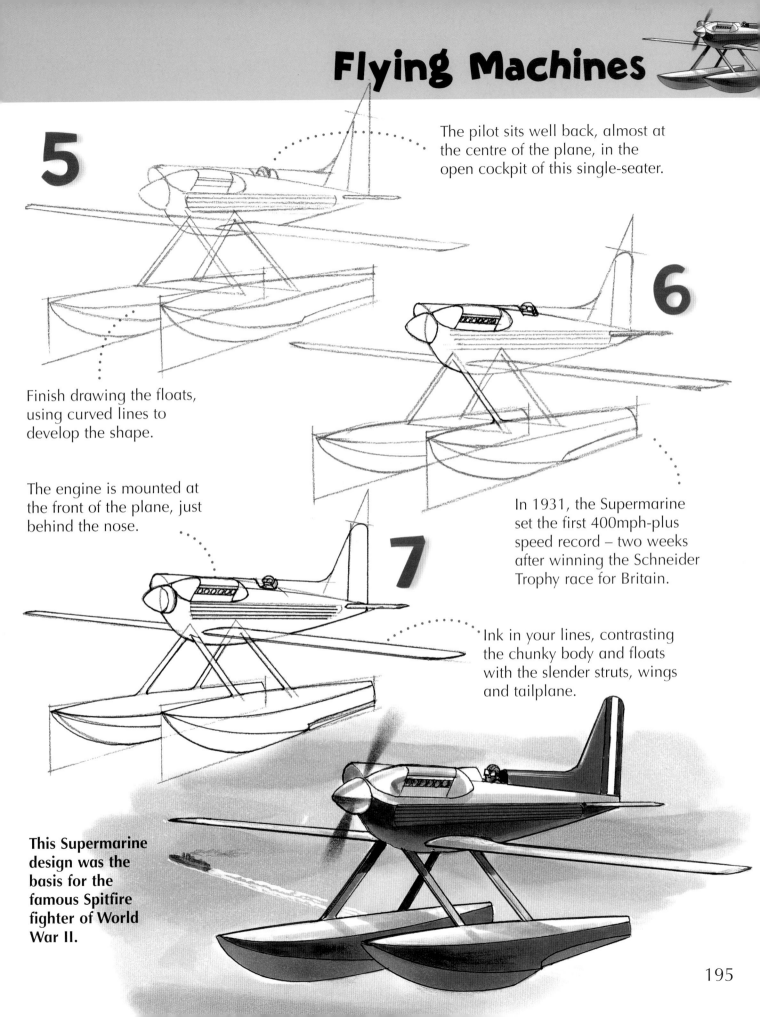

5

The pilot sits well back, almost at the centre of the plane, in the open cockpit of this single-seater.

6

Finish drawing the floats, using curved lines to develop the shape.

The engine is mounted at the front of the plane, just behind the nose.

7

In 1931, the Supermarine set the first 400mph-plus speed record – two weeks after winning the Schneider Trophy race for Britain.

Ink in your lines, contrasting the chunky body and floats with the slender struts, wings and tailplane.

This Supermarine design was the basis for the famous Spitfire fighter of World War II.

Dragonfly

Dragonflies are found all over the world – more than 2500 different kinds of them. In summer they can be seen flashing over ponds and rivers. These are their hunting grounds, where they catch smaller flying insects. Their swift, graceful flight and brilliant colours are eye-catching.

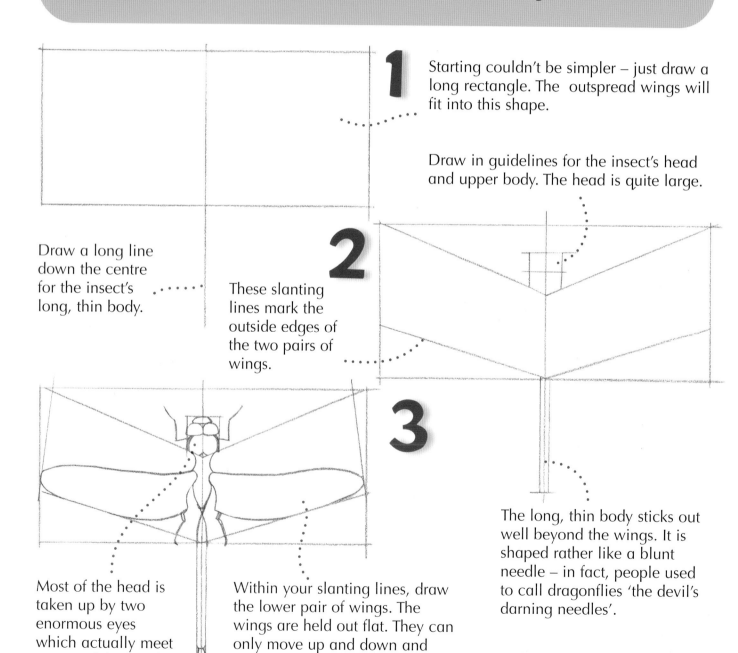

1 Starting couldn't be simpler – just draw a long rectangle. The outspread wings will fit into this shape.

Draw in guidelines for the insect's head and upper body. The head is quite large.

Draw a long line down the centre for the insect's long, thin body.

2 These slanting lines mark the outside edges of the two pairs of wings.

3

The long, thin body sticks out well beyond the wings. It is shaped rather like a blunt needle – in fact, people used to call dragonflies 'the devil's darning needles'.

Most of the head is taken up by two enormous eyes which actually meet on top of the head.

Within your slanting lines, draw the lower pair of wings. The wings are held out flat. They can only move up and down and cannot be folded back.

196

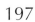

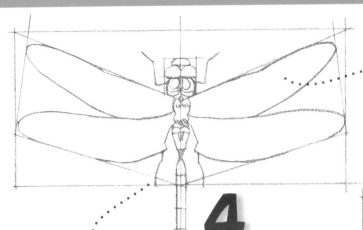

4

Add the second pair of wings. In flight, both pairs of wings beat at the same time. When the dragonfly makes a sharp turn you can actually hear the rattling sound as the front and back wings hit each other.

Finish off the head with a pair of short feelers. The head has strong biting jaws.

The short legs are hunting tools, whose main job is to grab and hold insect prey.

The body is patterned in bands. Dragonflies come in a wide range of colours, often with a metallic glint.

5

The wings are hard and glassy, patterned with many tiny veins. They are powerful enough to allow dragonflies to reach speeds of up to 30km/h.

6

The legs are spiny, not smooth, to give a good grip on insect prey. When you ink in the legs, a few short strokes of your pen will create the spiny effect.

Dragonflies are the oldest kind of insect known today. They existed some 300 million years ago. Some of these prehistoric dragonflies were giants – the biggest insects ever to live on earth! The biggest modern dragonfly lives in South America. It is the size of an adult hand.

Bush Cricket

Crickets are famous for their loud chirruping 'song'. This is made by scraping the hard edges of the front wings against each other – rather like drawing a bow across violin strings. Bush Crickets are sometimes called Long-horned Grasshoppers, from their remarkably long feelers.

1 Start with this boat shape, and mark off a line at the front for the head.

Slanting lines create the huge back legs, which stick up above the insect's back.

2 Draw in the front legs as simple lines. These legs are not just used for walking – they also contain the cricket's ears!

A slanting line across the centre of the body forms the base of the wing, which is held flat across the body.

Add two long, curving lines for the feelers. These are used to taste and to smell things.

3 The second pair of legs points backwards.

4 Now you can draw in the wings, rounding off the ends. Note that the wings stick out well beyond the end of the body.

198

5 These curving lines mark sections of the body.

Finish drawing the hindlegs. These are long and strong, with big muscular thighs to power the cricket's mighty leaps.

A protective 'shield' lies behind the head, just in front of the wings.

6

Now add details to the head. The eyes are large, and so are the jaws, which are designed for chewing plant food. The mouth-parts are partly hidden by the front legs.

Wings and legs work together. The hindlegs provide power for the take-off, so the cricket is airborne before its wings have to start working.

As you ink in the long thin legs, mark in short stiff hairs on the edges of the lower sections.

7

You can tell the cricket family from the grasshopper family by the length of their feelers – true grasshoppers have short feelers. Bush Crickets form a large family. There are 16,000 different kinds, some small, some as big as a hamster.

Centipede

The name 'centipede' means 'a hundred legs', but that isn't quite right. Different kinds of centipedes may have as many as 170 pairs of legs, or as few as 15 pairs. This tells us at once that the centipede is not a member of the insect family, for all insects have six legs.

1 Start with a simple, long, worm-like shape.

Mark off the end of your 'worm' to form the head, which is distinct from the rest of the body.

2 The last pair of legs are extra long – and extra sensitive, so they work as a pair of extra feelers.

The head bears one pair of longish feelers. The centipede uses these both to taste things and to smell them.

3 Divide the long body up into many short sections, joined together like 'popper' beads.

The first body section contains special poison fangs for killing prey – slugs, insects and worms.

4

Each section of the body carries a pair of legs.

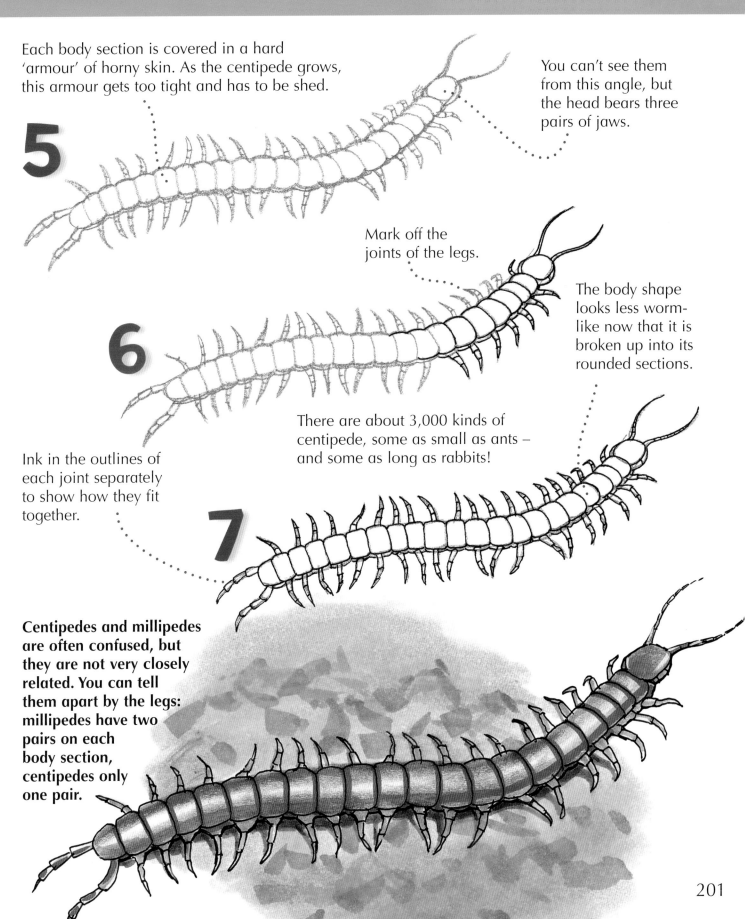

Each body section is covered in a hard 'armour' of horny skin. As the centipede grows, this armour gets too tight and has to be shed.

You can't see them from this angle, but the head bears three pairs of jaws.

5

Mark off the joints of the legs.

The body shape looks less worm-like now that it is broken up into its rounded sections.

6

Ink in the outlines of each joint separately to show how they fit together.

There are about 3,000 kinds of centipede, some as small as ants – and some as long as rabbits!

7

Centipedes and millipedes are often confused, but they are not very closely related. You can tell them apart by the legs: millipedes have two pairs on each body section, centipedes only one pair.

Stag Beetle

Beetles come in more different kinds than any other living creature. The Stag Beetle is one of the most handsome. It is a big, unusually powerful insect, about the size of a mouse (minus the tail!). It gets its name from the male's enormous jaws which look a bit like a stag's antlers.

1 Like all insects, beetles are made up of three sections: the head, and two body parts. Start with these two shapes for the body.

Add this shape for the head, and most of the beetle is completed.

2

These tough-looking jaws are actually too weak to bite with, and not even useful for eating. Their jaws are only used for wrestling with other males at mating time.

Now draw the enormous jaws that give this beetle its name.

3

Add the three pairs of long, slender legs.

The wings lie over this part of the body – but you can't see them. The front wings are not used for flight, but form a protective cover for the rear, flying wings.

4

Draw a feeler on either side of the head.

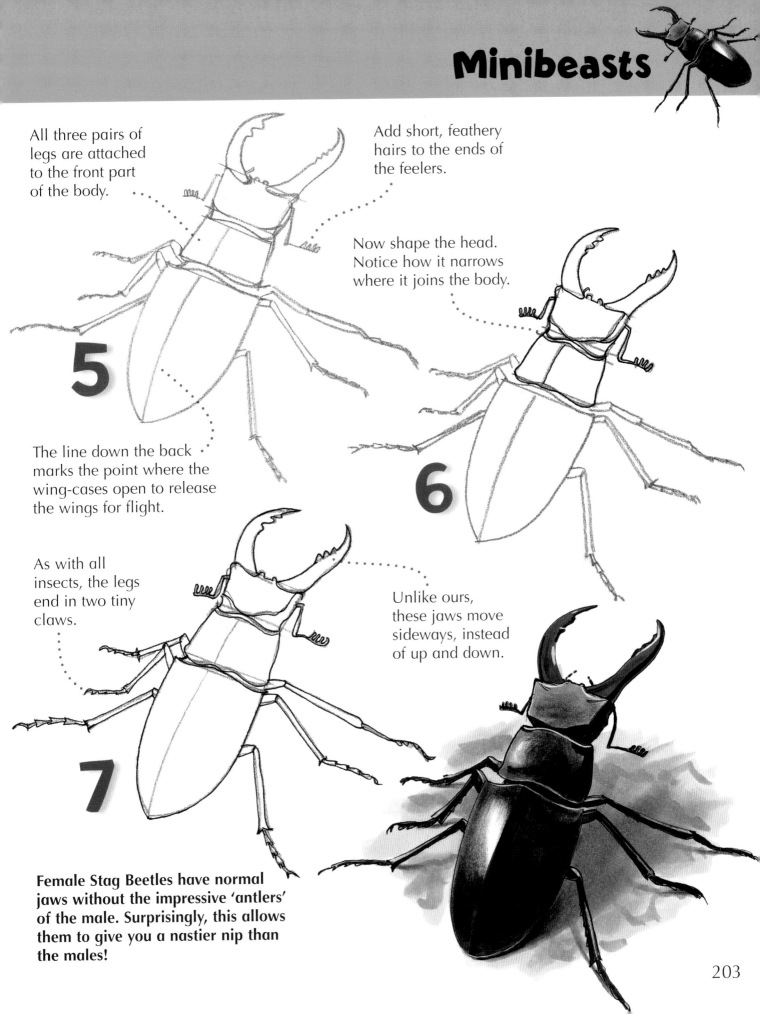

All three pairs of legs are attached to the front part of the body.

Add short, feathery hairs to the ends of the feelers.

Now shape the head. Notice how it narrows where it joins the body.

5

The line down the back marks the point where the wing-cases open to release the wings for flight.

6

As with all insects, the legs end in two tiny claws.

7

Unlike ours, these jaws move sideways, instead of up and down.

Female Stag Beetles have normal jaws without the impressive 'antlers' of the male. Surprisingly, this allows them to give you a nastier nip than the males!

Pond Skater

Pond skaters are common in pools and streams, where they hunt for small insect prey. They 'skate' over the surface of the water, without sinking or even getting wet. Only their feet touch the water, and these are too light to break through the surface.

1

Start your drawing with the long, thin body, which tapers at each end. Add two long feelers at the front.

2

These two triangles are guidelines to show you where to position the middle and back pairs of legs.

The front legs are much shorter than the back ones.

3

Now take a line beyond your triangles to add the next part of the long, slender legs.

The head is very small, so the large eyes bulge out on either side. Good eyesight is important to pond skaters, to help them spot their prey.

4

Add the last, short section to the legs. These are the only parts of the insect that touch the water.

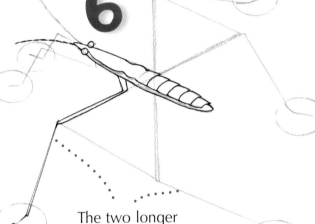

5

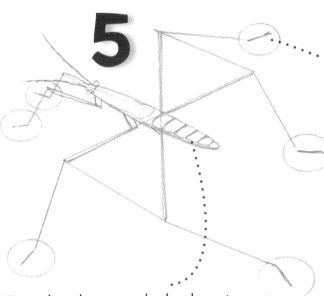

If you watch a pond skater, you will see the tiny dents in the water where the claws touch it without ever breaking the surface. Draw small ovals under the feet to mark these dents.

6

Draw bands across the back part of the body, to show how it is made up of several sections.

The two longer pairs of legs move the pond skater along. The middle pair work like oars, rowing the body forward, while the back pair are used for steering.

7

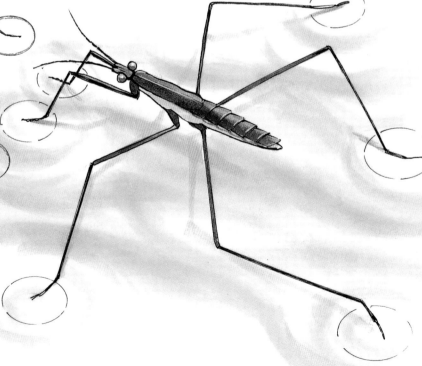

The shorter, front pair of legs are hunting weapons. They are used to grab and hold on to prey.

Pond skaters stay dry even if they dive under the water. Their bodies are covered with very fine, downy fur. This forms a waterproof suit, for it traps a thin layer of air which the water cannot pass through.

Spider

There are some 40,000 different kinds of spider, and they all spin silk. Most weave it into webs to catch insects. Webs range from the well-known round orb webs to simple tubes, complicated funnels, running trip-wires or even, in the case of the bolas spider, a 'lasso' to rope its prey.

These two shapes form the body. Like an insect, a spider's body is in two parts. But, unlike an insect, it has no separate head.

1

2

Add this half-moon shape to mark where the eyes and jaws fit on the front of the body.

Spiders have eight eyes, but most of them are very short-sighted and rely on their sense of touch.

3

4

Draw lines for the eight legs – another clue that spiders are not insects (which always have six legs).

Build up your lines into legs, marking out the joints. Just like our legs, the top sections are thickest, the lower ones more slender.

This spider has a pattern to break up its colour and help with camouflage.

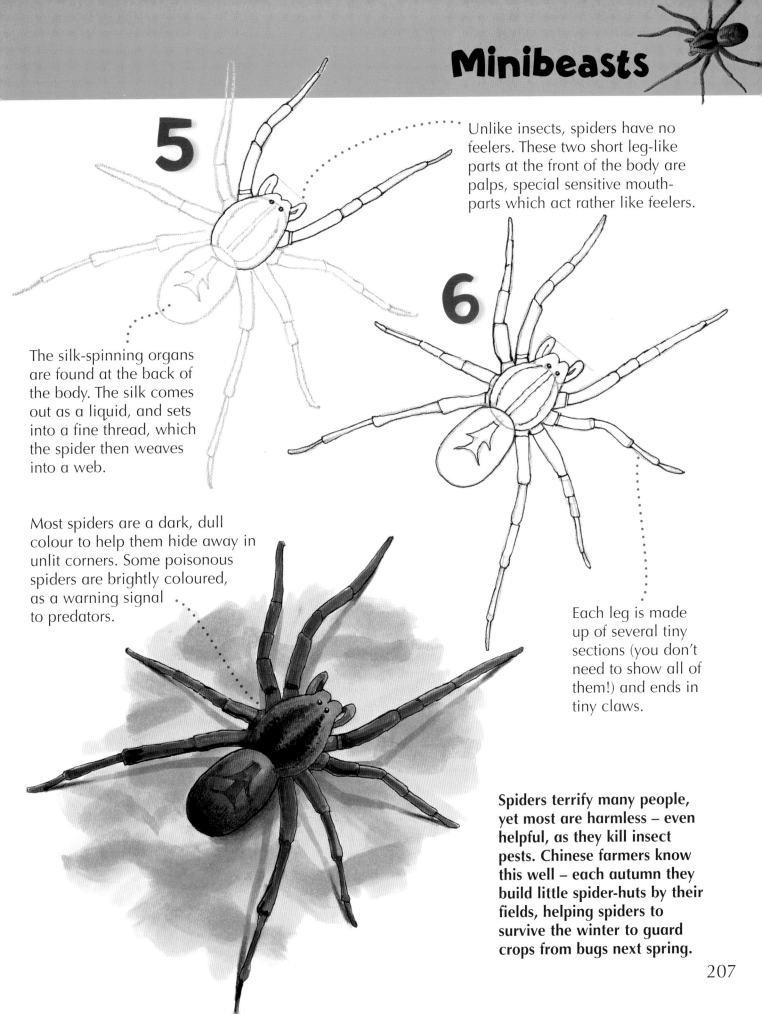

5

Unlike insects, spiders have no feelers. These two short leg-like parts at the front of the body are palps, special sensitive mouth-parts which act rather like feelers.

6

The silk-spinning organs are found at the back of the body. The silk comes out as a liquid, and sets into a fine thread, which the spider then weaves into a web.

Most spiders are a dark, dull colour to help them hide away in unlit corners. Some poisonous spiders are brightly coloured, as a warning signal to predators.

Each leg is made up of several tiny sections (you don't need to show all of them!) and ends in tiny claws.

Spiders terrify many people, yet most are harmless – even helpful, as they kill insect pests. Chinese farmers know this well – each autumn they build little spider-huts by their fields, helping spiders to survive the winter to guard crops from bugs next spring.

Bush Cricket in Flight

This is one of the champion athletes of the insect world. It can manage a high jump ten times its own body length, and a long jump 20 times its length. Not only that, but it can fly as well! We have already learned how to draw a Bush Cricket at rest. Now let's look at one in action.

1 Start with the body, pointing upwards. At rest, the body looks big; but, in motion, it is small compared with the long wings and legs.

2 This sail-like shape will form the lower pair of wings, spread wide to take to the air.

Add a small oval for the head.

Now draw the long feelers that are the 'trademark' of this insect.

3 Add the upper pair of wings. They are much smaller than the lower pair, but tougher and thicker.

The hind legs unfold in an almost straight line as the insect pushes off from the ground. Jumping like this, the cricket really gets off to a flying start!

4 Draw the other two pairs of legs. These are shorter than the hind-legs, because they are just for walking. It is the hind-legs that provide the power.

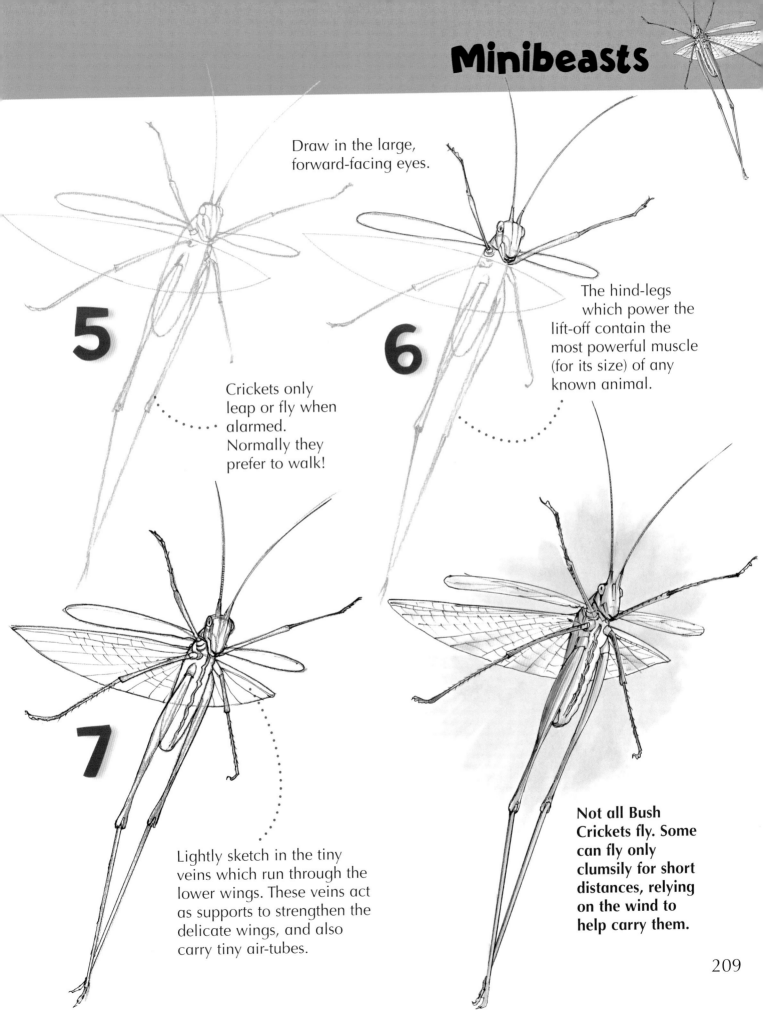

Draw in the large, forward-facing eyes.

5

Crickets only leap or fly when alarmed. Normally they prefer to walk!

6

The hind-legs which power the lift-off contain the most powerful muscle (for its size) of any known animal.

7

Lightly sketch in the tiny veins which run through the lower wings. These veins act as supports to strengthen the delicate wings, and also carry tiny air-tubes.

Not all Bush Crickets fly. Some can fly only clumsily for short distances, relying on the wind to help carry them.

Devil's Coach Horse

When this beetle faces a threat, it threatens back! It snaps its jaws (it can give quite a nasty nip), curves the end of its body upwards – and then fires a 'stink bomb' from its rear end. The way its body rises up reminded people of a rearing horse – which explains the name.

1

This shape forms the long, narrow body, with the back end raised ready for self-defence. This position also makes the beetle look bigger, helping to frighten off enemies.

2

Add an oval for the smaller front section of the body.

3

Another oval forms the head. Now you have the three basic parts that make up all insects.

4

Large eyes mean good eyesight and help this hunting beetle to find its prey.

The large jaws are shaped (and used) like a pair of pincers. When the beetle is alarmed, it opens its jaws wide and snaps at anything that approaches.

Like all insects, this beetle has six jointed legs – though you can't see all of them from this angle.

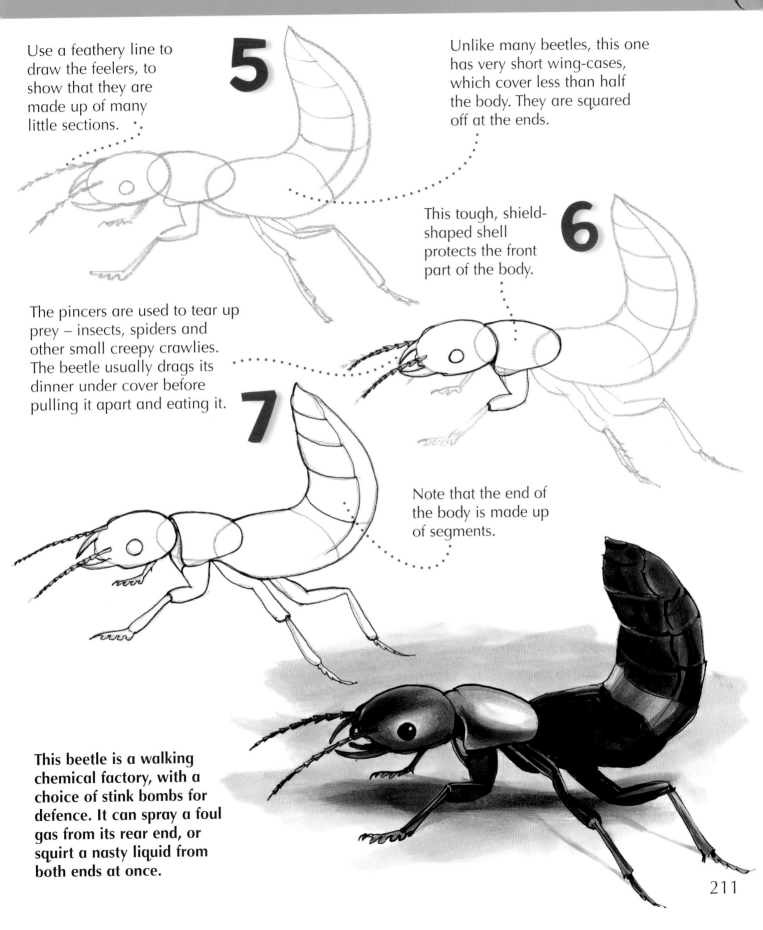

5 Use a feathery line to draw the feelers, to show that they are made up of many little sections.

Unlike many beetles, this one has very short wing-cases, which cover less than half the body. They are squared off at the ends.

6 This tough, shield-shaped shell protects the front part of the body.

The pincers are used to tear up prey – insects, spiders and other small creepy crawlies. The beetle usually drags its dinner under cover before pulling it apart and eating it.

7

Note that the end of the body is made up of segments.

This beetle is a walking chemical factory, with a choice of stink bombs for defence. It can spray a foul gas from its rear end, or squirt a nasty liquid from both ends at once.

211

Wasp

Everybody knows wasps, but not many people like them. They sting, and they get into the jam on picnics. But they do have their good points. They kill insect pests, such as flies, and they act as refuse collectors, eating up rubbish like rotten fruit and decaying flesh.

1

These two simple shapes form the two sections of the body.

2

A big triangle forms guidelines for the upper wing.

The head is fairly large and long, and can turn freely around.

3

Add guidelines for the legs, and make a line where the upper wing will end.

Wasps have two pairs of wings. Draw in the pair on this side. The upper wing is bigger than the lower one, and provides most of the power for flight.

Add two downwards-pointing feelers. These are very sensitive, and allow the wasp to smell food from a long way away.

4

A wasp's body narrows at the point where the two parts join. This is typical of wasps – so we call people with very slender waists 'wasp-waisted'.

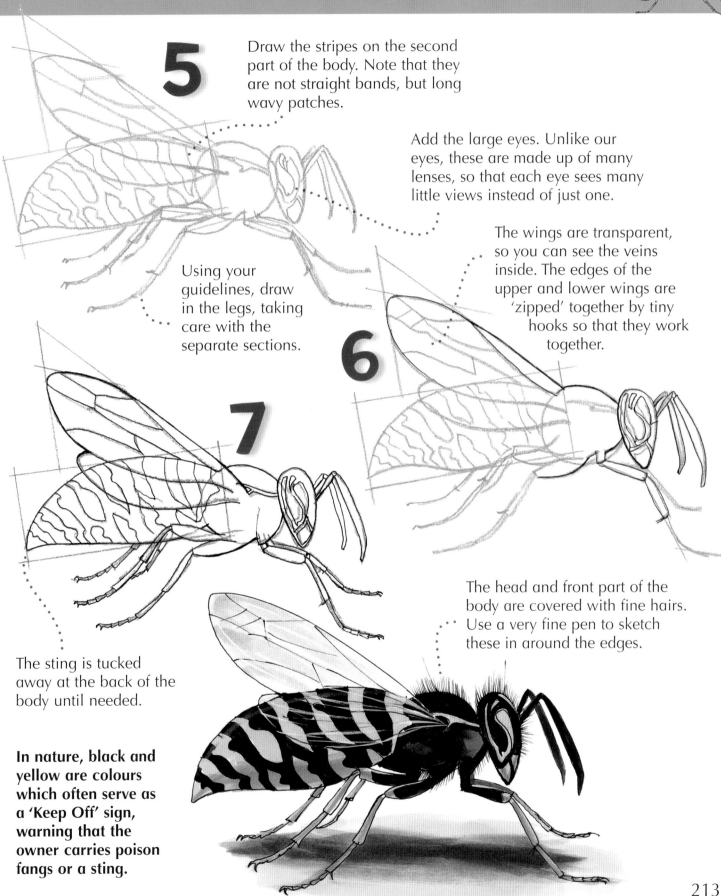

5 Draw the stripes on the second part of the body. Note that they are not straight bands, but long wavy patches.

Add the large eyes. Unlike our eyes, these are made up of many lenses, so that each eye sees many little views instead of just one.

The wings are transparent, so you can see the veins inside. The edges of the upper and lower wings are 'zipped' together by tiny hooks so that they work together.

Using your guidelines, draw in the legs, taking care with the separate sections.

6

7

The head and front part of the body are covered with fine hairs. Use a very fine pen to sketch these in around the edges.

The sting is tucked away at the back of the body until needed.

In nature, black and yellow are colours which often serve as a 'Keep Off' sign, warning that the owner carries poison fangs or a sting.

Praying Mantis

This striking insect takes its name from the way it holds its forelegs up, like hands in prayer. If anything, it may be praying for prey to come along! Its weird shape is a disguise, making it look like just another leaf or flower, while it lies in wait for passing insects – then grabs them.

1

The first part of the body is leaf-shaped.

The second part of the body is also flattened and shaped like a kite.

2

Draw guidelines for the outspread wings. Usually only the males fly.

These are the guidelines for the raised forelegs.

The main part of the upper body is slim and twig-like, lying between two 'leafy' flaps so that it looks like the stem of the leaf.

3

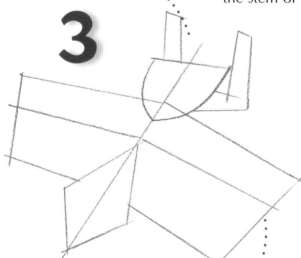

There are two pairs of wings, so divide these shapes into two sections. The upper wings are narrower than the lower pair.

4

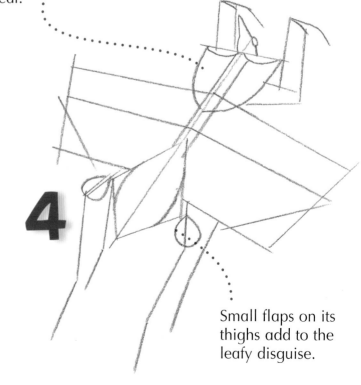

Small flaps on its thighs add to the leafy disguise.

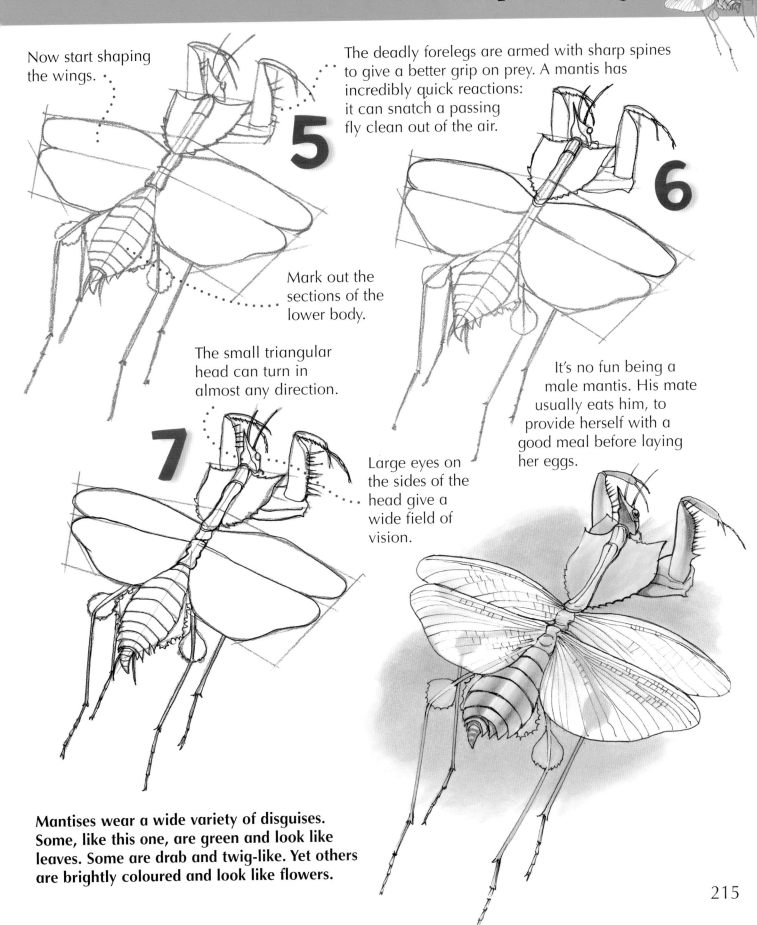

Now start shaping the wings.

The deadly forelegs are armed with sharp spines to give a better grip on prey. A mantis has incredibly quick reactions: it can snatch a passing fly clean out of the air.

5

Mark out the sections of the lower body.

6

The small triangular head can turn in almost any direction.

It's no fun being a male mantis. His mate usually eats him, to provide herself with a good meal before laying her eggs.

7

Large eyes on the sides of the head give a wide field of vision.

Mantises wear a wide variety of disguises. Some, like this one, are green and look like leaves. Some are drab and twig-like. Yet others are brightly coloured and look like flowers.

Scorpion

Scorpions are deadly hunters, with poisoned weapons. Their bodies end in a long 'tail' with a sting at the end. This is used to kill small prey, but it is also for self-defence, so people sometimes get stung. Scorpion stings are very painful, and a few are poisonous enough to kill humans.

1

Start at the end, with the curved 'tail' – actually the end of the body.

The 'tail' is held curved over the back, ready to bring its sting into action.

Add the front section of the body. Scorpions only have two body parts.

2

The sting at the end of the 'tail' ends in a fine curved point. It stabs a victim, then injects poison into the wound.

3

These are the tops of four legs, half-hidden by the body. Scorpions have eight legs, like spiders.

These four lines provide a framework for you to draw the large pair of pincers at the front.

4

The pincers look very much like a crab's claws. They are used to seize prey (insects and spiders). They also serve to cut up dinner afterwards.

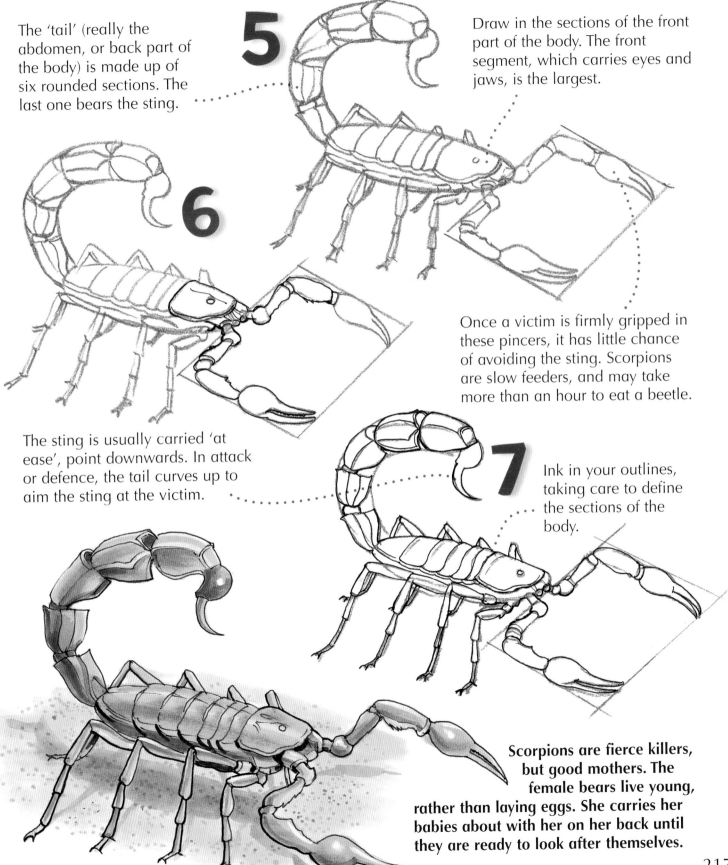

5

The 'tail' (really the abdomen, or back part of the body) is made up of six rounded sections. The last one bears the sting.

Draw in the sections of the front part of the body. The front segment, which carries eyes and jaws, is the largest.

6

Once a victim is firmly gripped in these pincers, it has little chance of avoiding the sting. Scorpions are slow feeders, and may take more than an hour to eat a beetle.

The sting is usually carried 'at ease', point downwards. In attack or defence, the tail curves up to aim the sting at the victim.

7

Ink in your outlines, taking care to define the sections of the body.

Scorpions are fierce killers, but good mothers. The female bears live young, rather than laying eggs. She carries her babies about with her on her back until they are ready to look after themselves.

Cockroach

The cockroach is a living fossil! One of Earth's oldest creatures, it has existed for 275 million years, hardly changing in that time. A true survival expert, it can live almost anywhere and eat almost anything. Some have adapted to live in human homes, and are major pests.

1

Start with this long 'sausage' shape, pointed at one end.

Divide the body into two unequal sections. The front part is much shorter than the rear one.

2

Add this small shape for the head, which is pointing downwards.

3

The front part of the body is protected by a hard, shield-shaped case.

4

The long, thread-like feelers are made up of up to 100 sections. They are used to feel the way through the dark, as well as to smell food, water – and a mate.

Like beetles, cockroaches have developed thick, tough front wings as protection for the delicate back wings.

Mark out lines for the long, jointed legs.

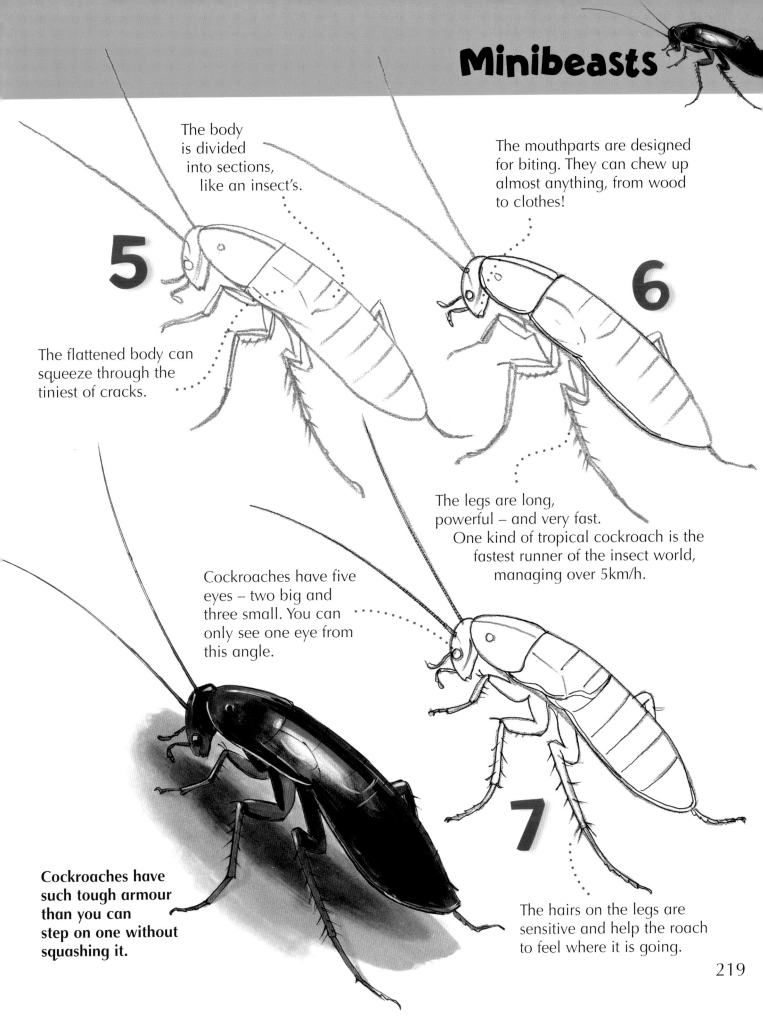

The body is divided into sections, like an insect's.

The mouthparts are designed for biting. They can chew up almost anything, from wood to clothes!

5

6

The flattened body can squeeze through the tiniest of cracks.

The legs are long, powerful – and very fast. One kind of tropical cockroach is the fastest runner of the insect world, managing over 5km/h.

Cockroaches have five eyes – two big and three small. You can only see one eye from this angle.

7

Cockroaches have such tough armour than you can step on one without squashing it.

The hairs on the legs are sensitive and help the roach to feel where it is going.

Assassin Bug

We often use the word 'bug' for any creepy crawly. But when scientists talk about bugs they mean a special group of insects with beak-like mouths that stab and suck. This one gets its name of Assassin (murderer) from the speed with which it seizes and poisons its victims.

1 These two shapes form the body.

Add this shape for the narrow head, which looks too small for the body.

2 Now draw the feelers, even longer than the body, and bending downwards at an angle.

Start drawing guidelines for the two hind pairs of legs.

3 The long curving beak of a mouth is used like a hollow needle to stab into the victim's body. It squirts in poison to break down body tissues into a liquid, which it sucks up.

The wings are partly spread, ready to fly. Most of the time they are hidden inside wing-cases, like those of beetles.

4 Now that the beak is in place, you can add the forelegs.

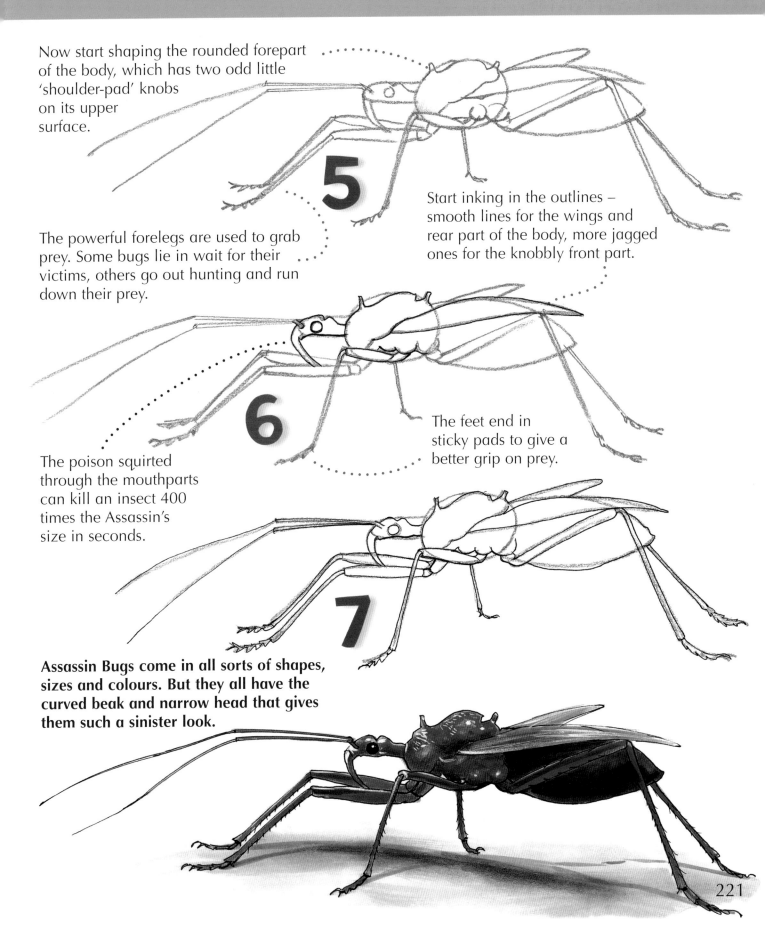

Now start shaping the rounded forepart of the body, which has two odd little 'shoulder-pad' knobs on its upper surface.

5

The powerful forelegs are used to grab prey. Some bugs lie in wait for their victims, others go out hunting and run down their prey.

Start inking in the outlines – smooth lines for the wings and rear part of the body, more jagged ones for the knobbly front part.

6

The feet end in sticky pads to give a better grip on prey.

The poison squirted through the mouthparts can kill an insect 400 times the Assassin's size in seconds.

7

Assassin Bugs come in all sorts of shapes, sizes and colours. But they all have the curved beak and narrow head that gives them such a sinister look.

Earwig

Earwigs like to crawl into small dark holes. They aren't particularly attracted to ears, but people feared they might be – and so they got their name. More suitable is their Latin name, which means 'little scissors', referring to the insect's pair of pincers.

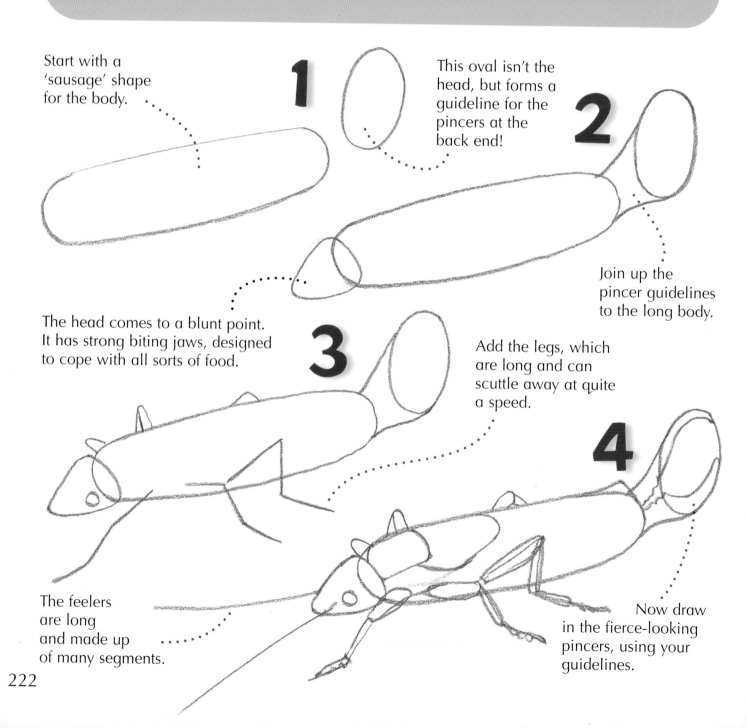

Start with a 'sausage' shape for the body.

1

This oval isn't the head, but forms a guideline for the pincers at the back end!

2

Join up the pincer guidelines to the long body.

The head comes to a blunt point. It has strong biting jaws, designed to cope with all sorts of food.

3

Add the legs, which are long and can scuttle away at quite a speed.

4

The feelers are long and made up of many segments.

Now draw in the fierce-looking pincers, using your guidelines.

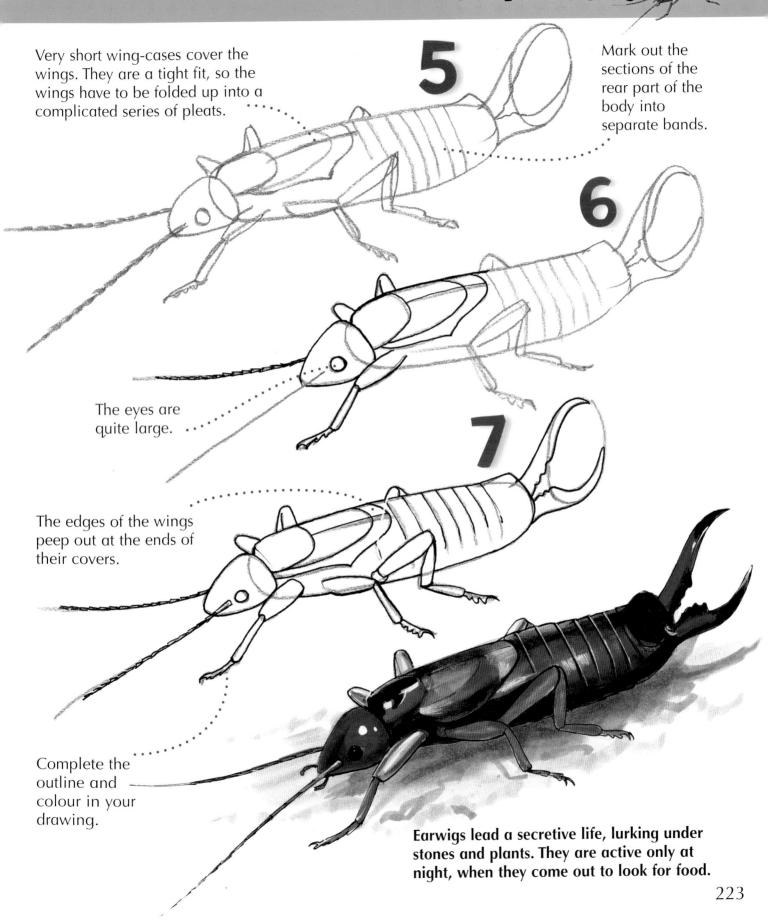

5

Very short wing-cases cover the wings. They are a tight fit, so the wings have to be folded up into a complicated series of pleats.

Mark out the sections of the rear part of the body into separate bands.

6

The eyes are quite large.

7

The edges of the wings peep out at the ends of their covers.

Complete the outline and colour in your drawing.

Earwigs lead a secretive life, lurking under stones and plants. They are active only at night, when they come out to look for food.

INDEX